CULTURAL

STUDIES

Volume 8 Number 1 January 1994

W9-ARM-529

EDITORIAL STATEMENT

C *ultural Studies* seeks to foster more open analytic, critical and political conversations by encouraging people to push the dialogue into fresh, uncharted territory. It is devoted to understanding the specific ways cultural practices operate in everyday life and social formations. But it is also devoted to intervening in the processes by which the existing techniques, institutions and structures of power are reproduced, resisted and transformed. Although focused in some sense on culture, we understand the term inclusively rather than exclusively. We are interested in work that explores the relations between cultural practices and everyday life, economic relations, the material world, the State, and historical forces and contexts. The journal is not committed to any single theoretical or political position; rather, we assume that questions of power organized around differences of race, class, gender, sexuality, age, ethnicity, nationality, colonial relations, etc., are all necessary to an adequate analysis of the contemporary world. We assume as well that different questions, different contexts and different institutional positions may bring with them a wide range of critical practices and theoretical frameworks.

'Cultural studies' as a fluid set of critical practices has moved rapidly into the mainstream of contemporary intellectual and academic life in a variety of political, national and intellectual contexts. Those of us working in cultural studies find ourselves caught between the need to define and defend its specificity and the desire to resist closure of the ongoing history of cultural studies by any such act of definition. We would like to suggest that cultural studies is most vital politically and intellectually when it refuses to construct itself as a fixed or unified theoretical position that can move freely across historical and political contexts. Cultural studies is in fact constantly reconstructing itself in the light of changing historical projects and intellectual resources. It is propelled less by a theoretical agenda than by its desire to construct possibilities, both immediate and imaginary, out of historical circumstances; it seeks to give a better understanding of where we are so that we can create new historical contexts and formations which are based on more just principles of freedom, equality, and the distribution of wealth and power. But it is, at the same time, committed to the importance of the 'detour through theory' as the crucial moment of critical intellectual work. Moreover, cultural studies is always interdisciplinary; it does not seek to explain everything from a cultural point of view or to reduce reality to culture. Rather it attempts to explore the specific effects of cultural practices using whatever resources are intellectually and politically available and/or necessary. This is, of course, always partly determined by the form and place

of its institutionalization. To this end, cultural studies is committed to the radically contextual, historically specific character not only of cultural practices but also of the production of knowledge within cultural studies itself. It assumes that history, including the history of critical thought, is never guaranteed in advance, that the relations and possibilities of social life and power are never necessarily stitched into place, once and for all. Recognizing that 'people make history in conditions not of their own making', it seeks to identify and examine those moments when people are manipulated and deceived as well as those moments when they are active, struggling and even resisting. In that sense cultural studies is committed to the popular as a cultural terrain and a political force.

Cultural Studies will publish essays covering a wide range of topics and styles. We hope to encourage significant intellectual and political experimentation, intervention and dialogue. At least half the issues will focus on special topics, often not traditionally associated with cultural studies. Occasionally, we will make space to present a body of work representing a specific national, ethnic or social tradition. Whenever possible, we intend to represent the truly international nature of contemporary work, without ignoring the significant differences that are the result of speaking from and to specific contexts. We invite articles, reviews, critiques, photographs and other forms of 'artistic' production, and suggestions for special issues. And we invite readers to comment on the strengths and weaknesses, not only of the project and progress of cultural studies, but of the project and progress of *Cultural Studies* as well.

Larry Grossberg
Janice Radway

* * *

Contributions should be sent to Professor Lawrence Grossberg, Dept. of Speech Communication, University of Illinois at Urbana-Champaign, 244 Lincoln Hall, 702 S. Wright St., Urbana, Ill. 61801, USA. They should be in triplicate and should conform to the reference system set out in the Notes for Contributors, available from the Editors or Publishers. Submissions undergo blind peer review. The author's name should not appear anywhere in the manuscript except on a detachable cover page along with an address and the title of the piece. Reviews, and books for review, should be sent to Tim O'Sullivan, School of Arts and Humanities, de Montfort University, The Gateway, Leicester LE1 9BH; or to John Frow, Dept. of English, University of Queensland, St. Lucia, Queensland 4072, Australia; or to Jennifer Daryl Slack, Dept. of Humanities, Michigan Technological University, Houghton, MI 49931–1295, USA.

CONTENTS

Special Section on Cultural Studies and the Environment
Guest edited by Jennifer Daryl Slack and Jody Berland

·INTRODUCTION·

JODY BERLAND AND
JENNIFER DARYL SLACK

ON ENVIRONMENTAL MATTERS

For a long time now we two have been meeting at conferences and talking about the environment. (Indeed, that is how we met. 'Oh, I know someone else who is interested in the environment. You should meet her!') It was an oddity then to compose environmental matters in the rhythms of cultural theory. But that is no longer true. How could it be? Environmental matters now touch too many of the notes that make up the (dis)harmonies of cultural studies: they are 'popular', in all the various (and problematic) senses of the term; they manifest differential relations of knowledge and power; they invite analyses of their representations and the role of representation; they are theoretically *interesting*, for they provide rich ground to consider the relations of science, technology and contemporary culture; they virtually demand intervention; and, finally, they 'matter'.

Environmental matters. Matter. Both verb and noun: to be of importance; to be that subject of importance; *and* to be the physical substance of which a physical object is composed. Cultural studies meets the environment rather well prepared to clarify the complexities of the interrelationship of the act of making the *subject* of the environment and of making it an *important* subject. It tackles the old debate about the relationship between nature and culture with a fairly easy response: 'Nature (and by extension, the environment) is semiotic . . . it is a cultural construction.' Hence the coding of culture and of environmental issues, coalitions, movements are understood to have registers in differential relations of power articulating to class, race, gender and ethnicity. Representation matters. Representations matter.

Cultural studies is, however, rather less prepared to handle the 'problem' of the 'physical substance'. The earth. The water. The weather. The

non-human. The biosphere. The *end* of the . . . To make that substance intelligible we necessarily take (and in speaking it, have already taken) as Guattari has put it, 'a pseudo-narrative detour through the reference systems of myth and ritual, or through self-professedly scientific analysis – all of which have as their ultimate goal the concealment of the *dis-positional* arrangement through which discourse is brought into existence and from which it derives, "secondarily" so to speak, its intelligibility'. (1989: 132) Representation matters. Representations matter.

But what then of the earth, water, etc? What of the apprehension of these, not just via concept, but – in addition – via affect? How do we speak of that which is not reducible to the mode in which we speak – both acknowledging the mode in which we speak *and* that which asserts itself apart from having a 'voice'? There *is* an earth after all. Species do die out. Rains do come down. Toxic wastes do damage. Organisms do attach to place.

We can feel some among you cringing: 'Here it comes . . .', the appeal to totality, to essentialism, to teleology. But as McKenzie Wark argues here, 'Perhaps . . . criticism has retreated a little too far from the problems of historical fate and social totality.' In these pages and elsewhere there is ample evidence of cultural theorists in search of new ways to let matter matter – without resorting to essentialist legerdemain. For example, while Donna Haraway acknowledges that nature is 'not a physical place to which one can go' (1992: 296), she insists on its artifactuality, that is, a recognition that 'nature for us is *made*, as both fiction and fact' (296–7). Artifactual 'nature' is conceived of as the relationship (the achievement) of many actors: human, non-human (organic and inorganic), technological. Laurie Anne Whitt and Jennifer Daryl Slack contribute to theorizing the context of environmental issues in terms of *particular* communities/environments – which are, through both unity and difference, variously articulated to relations of solidarity and significance. They insist, as does Barri Cohen, on the interpenetration of the human and the other than human in mapping those communities.

From a theoretical vantage point, environmental issues have a particular fascination. They not only challenge the contours of what it means to theorize in cultural studies (how can we understand something as discursive and non-discursive at the same time? nature and not nature? culture and not culture?), they also open up new and compelling ways to analyze contemporary culture. For example, the strange resonance of chaos theory, which emerged from the attempt to break down into mathematics the intricate structures of the weather, and whose conceptualization of structures-in-chaos now reverberates in the narratives of postmodernism, science fiction and economics, not to mention scientific and public debates about global warming (see Hayles, 1991). Or, in another vein, the way that critical discourses on gender intersect with ongoing debates about the relationship between biological and technological agency in the construction of the (post)human subject. Or the way that our urban/suburban culture has privileged certain styles of order and beauty in the managed landscape as a permissible index of 'Nature' (Wilson, 1991). Or how our problems and

affective alliances with 'Nature' seem to challenge our endless discoursing on the 'other'. Not only do these issues invite us to reconceptualize the boundaries between nature and culture; they also provide some useful agitation along the boundaries of science, culture and myth (Brody, 1981).

As we learn to incorporate the environment (or environments) in cultural theory, and as we learn new ways to understand contemporary culture through attention to the environment, there will be, of course, ongoing demands for intervention that both draw on and contribute to our theorizing. Several of the articles in this issue consider sites of ongoing struggle drawing on an expanded sense of the terrain of the environmental. Barri Cohen analyzes the proposed James Bay II project, designed to dam major rivers flowing into James Bay and Hudson Bay, which symbolizes to many not only a struggle over land, but also a larger cultural and political battle about Western and Native relationships with the land. Carol Stabile considers labor practices along the Mexican and US border as a challenge to the environmental preoccupations of North American ecofeminists. In each case, they draw attention to the multiple positions and/or articulations that demand consideration in order to inform the theory and practice of 'cultural' activists.

In characterizing and intervening in the nature of the interconnections that constitute environmental matters, we expect that more attention will be directed toward the media, consumption and technology. As Guattari has argued:

> It is quite simply wrong to regard action on the psyche, the socius, and the environment as separate. Indeed, if we continue – as the media would have us do – to refuse squarely to confront the *simultaneous* degradation of these three areas, we will in effect be acquiescing in a general infantalization of opinion, a destruction and neutralization of democracy. We need to 'kick the habit' of consumption, of television discourse in particular; we need to apprehend the world through the interchangeable lenses of the three ecologies . . . social ecology, mental ecology, and environmental ecology. (1989: 134)

In a similar spirit, Michael X. Delli Carpini and Bruce A. Williams offer a critique of the ways in which both fiction and non-fiction television covers environmental news and issues, focusing on representations of Earth Day. As they argue, such coverage works to exclude responses to environmental problems that might also challenge the simultaneous degradation of culture. Jody Berland offers us an analysis of a variety of ways in which 'the weather' is implicated in the social, ecological and mental fabric of our culture. As weather patterns appear increasingly remote, increasingly physical in nature yet increasingly unavailable to unaided human perception, we learn to rely on the military, technological and televisual innovations that bring us our daily forecasts. Then, in a bit of a twist on what you might expect, Wark offers the proposition that it is only in the utilization of new technologies (like computers, electronic mail, fax, etc.) – through which we become still

more estranged from nature than we already are – that we can grasp what there is 'out there' to grasp about our place in the 'natural' world.

Whether we will find ourselves in 'Nature', a 'Third Nature', or 'the end of nature' depends on the concepts we use to map our place in the historicized environments in which we live. There are many problems for cultural theorists to grapple with regarding environmental theory and practice, and we do not pretend to have presented an exhaustive introduction to the issues there are – already! – to deal with. But we bring these together with a renewed commitment to the importance of environmental matters, and with the hope that this issue opens the door to a continuing discussion about their relevance for cultural studies.

This issue is dedicated to Alexander Wilson, *in memoriam*.

References

Brody, Hugh (1981) *Maps and Dreams*, New York: Pantheon Books.

Guattari, Felix (1989) 'The three ecologies', *New Formations* 8: 131–47.

Haraway, Donna (1992) 'The promises of monsters: a regenerative politics for inappropriate/d others', in Lawrence Grossberg, Cary Nelson and Paula Treichler (1992) editors, *Cultural Studies*, New York: Routledge.

Hayles, N. Katherine (1991) *Chaos and Order: Complex Dynamics in Literature and Science*, Chicago: The University of Chicago Press.

Wilson, Alexander (1991) *The Culture of Nature: North American Landscape from Disney to the Exxon Valdez*, Toronto: Between the Lines.

LAURIE ANNE WHITT AND

JENNIFER DARYL SLACK

COMMUNITIES, ENVIRONMENTS AND CULTURAL STUDIES

Introduction

I t is difficult not to be pessimistic. About the environmental degradation of the planet, about the resurgence of the New Right and of the newly virulent racism of neofascism, and about the ability of cultural theorists to intervene effectively with respect to all of these. The tendency of Western societies to parse out humans as separate from and dominant over nature is a habit of thought and a pattern of action which buttresses the tendency to parse out certain humans as separate from and dominant over others. Similarly, capitalism's ready reduction of the natural world to exploitable resources for the growth of capital aids and abets a comparable reductivism with regard to human labour. Yet so well-entrenched are these buttressing effects that the nature and extent of their complicity has been overlooked by cultural theorists, whose critiques of the oppressive social formations of late capitalism are resoundingly silent about the relationship of human communities to the other-than-human world in which they are situated. This, despite the fact that the problematics of this relationship are manifestly in play at so many junctures of political and cultural struggle – from the imposition by the First World corporations of technology and development plans fashioned in their own interests on Third World peoples to their dumping of assorted toxic wastes on the lands and among the indigenous communities of the Fourth World.

5

Some 'pessimism of the intellect' is all the more in order given that cultural studies itself seems increasingly caught up in the pursuit of academic stature, in bending its applicability to increasingly rarefied exchanges of 'high (postmodern) theory' and away from generative strategies for intervention. Yet, just as Gramsci's revolutionary is also afflicted with an 'optimism of the will', so too there seems to be little option for cultural theorists. We have to proceed with a belief that there are significant ways in which we can intervene, with the conviction that critiques of contemporary cultural and social practices can be so formulated as to issue in effective change, in the transformation of existing structures of power. Though we may tangle with the thickets of theory, we can avoid immiring ourselves in them. We can avoid losing sight of the issues which motivate our project, and without which cultural studies would remain more /mere academic exercise.

In earlier work (Slack and Whitt, 1992), we contended that it is necessary for cultural studies to resist anthropocentrism, and to consider as integral to its normative concerns the other than human. We also suggested a direction for conceptualizing relationships between the human and the other than human: as 'multiple articulations of community' (587). In this paper, we explore in more depth the concept of community, intent on illustrating how, by contextualizing communities, by working in terms of multiple articulations of community based on notions of solidarity and significance, and by situating communities in their material contexts, there is some promise of eventually cutting through theory and making our way to basic strategies for action.

Why community?

If the concept of community evokes nothing else, it evokes images of connection. It is our contention that what needs re-examination – both within cultural studies and for use by cultural studies – are the kinds of connection through which we understand the relations between the human and the other-than-human world. By contextualizing communities, by probing the manner and significance of their situatedness in the material world (whether the immediate landscape be 'natural' or 'urban'), we hope to demonstrate how the other than human is a vital player in the construction of community. Geographical and ecological features of community are rarely incidental to political and cultural struggle: they contextualize – enable and constrain – relations of power.

To date, cultural studies has assumed a curious posture with respect to the concept of community. It tends to enjoy a somewhat subterranean existence in the research of cultural theorists. Neither wholly present nor wholly absent, 'community' has seldom been far from the surface as an object of inquiry or as a theoretical construct in terms of which we analyze and critique cultural, social and political formations. When treated explicitly as an object of inquiry (as in Raymond Williams's discussions of 'community of process' and 'community of selected emphasis and intention' (Williams, 1965; 1975), in Janice Radway's 'interpretive communities' (Radway, 1985), or in the analysis of a particular community such as the 'New Age

community' (Ross, 1992)), community is typically taken to refer to the existence of groups that produce – and processes of producing – common meanings, images, patterns, rhythms and modes of organization (Williams, 1965: 47). But such direct mention of the term is rare. More commonly, cultural theorists have taken as their objects of study groups and group processes – defined, for example, by state, nation, society, gender, race, class, ethnicity or subculture – without explicitly invoking or exploring the concept of community.

The discourse of community (as an explicit object of analysis) has traditionally been the purview of political science, sociology, history, philosophy and ecology. Not only is there a rich history of the term within these disciplines, but there is currently a resurgence of interest in community (e.g., Fowler, 1991). Such resurgence is due in part to a growing recognition of the ability of the term to rally the intellectual (both popular and academic) imagination and to infuse practice. As Robert Booth Fowler has put it:

> This journey in search of community is now too popular and too central to an understanding of contemporary political thinking in the United States for us to ignore the opportunity to study and learn from this powerful impulse. (Fowler, 1991: ix)

But it is also partly a proactive and reactive response to the fragmentation, atomization and displacement that riddles contemporary Western societies. In the compelling words of Hannah Arendt:

> What makes mass society so difficult to bear is not the number of people involved, or at least not primarily, but the fact that the world between them has lost its power to gather them together, to relate and to separate them. (Quoted in Sandel, 1984: 17)[1]

To engage these disciplinary discourses on community directly would draw cultural studies into the problematics of community as set by those disciplines. We wish to avoid this even while acknowledging and drawing from more traditional disciplinary approaches to community, and to address instead the concerns of community as they are posed from *within* the commitments of cultural studies. The literature on community is extremely fertile, and cultural studies will want to reap from such disciplinary discussions what is of value to its own unique project.

It might be tempting to try to present a taxonomy of conceptions of community. But that is not possible without obliterating the range of intentions, taxonomic criteria, and levels of analysis that have been brought to bear on the matter of community. As Fowler contends:

> No set of categories can capture the current range of conceptions of community which are part of a large and expanding conversation. The idea of community is now too alluring to be contained any longer within a discrete group of intellectual discussions. (1991: 39)

While it is not the project of this paper, there is clearly some interesting work to be done by cultural theorists on the relations of power expressed within the various taxonomies of community.

Having noted these caveats, it must also be stressed that cultural studies has much to gain from a close scrutiny of the concept of community. We contend that the research strategies of cultural theorists would be enhanced in at least three important respects by more direct consideration of the concept of community and the role – implicit or explicit – that it has played thus far in cultural studies, as well as of the valuable resources that it supplies for current and future work in the field.

The first of these is that by identifying communities as vital *sites of resistance* to which cultural studies must attend, a valuable middle level of theoretical analysis may be opened up. Research by cultural theorists has tended to emphasize one or the other of two rather divergent problem contexts. On the one hand there have been efforts to examine and critique practices of subject formation, a focus which has generated – in Martin Allor's (1989) terms – questions regarding 'the ways in which the individual is inserted into social positions.' Such microlevel concerns may be contrasted to theorizing at the macrolevel addressed primarily to the forces operative in social, political and economic formations.[2] Culture itself, according to Allor, has 'come to designate a problematic of mediation which attempts to link . . . practices of subject formation and the analysis of power or hegemony in the social formation' (1). If Allor is correct in this casting of culture in the middle or mediating ground between the processes of subject formation and those of social formation, then a strong case can be made for more explicit theorization of the concept of community within cultural studies.

Indeed, it may well be that we cannot fully understand culture without carefully attending to community since the latter seems so clearly to occupy just this middle ground. The processes of subject formation cannot be fully understood without reference to the context in which they occur – typically, communities – and to the ways in which communities shape, and reciprocally are shaped by, the individuals who inhabit, and conduct their lives within them.[3] Nor can we have a rich grasp of the effectivity of forces operative in the larger social formation without considering how they are mediated by communities. It is typically within and through communities that individuals experience and resist the oppressive forces which intrude on their lives. Moreover, we need to consider the not unlikely prospect that communities are themselves generative of unique and distinctive forces not reducible to those operative in the larger social formation, forces which may serve to buffer and/or exacerbate existing relations of power and dominance. Finally, to paraphrase Stuart Hall, it seems promising to explore the idea that communities can be regarded as complexly constructed unities, in which differing principles of articulation (e.g., along the lines of class, race, ethnicity, and gender) can be drawn together to analyze and critique differing configurations of community forces and differing types of both community development and subject formation (1986: 12).

There is a second compelling reason for cultural theorists to consider attempting a more explicit and thorough theorization of community. Since community (unlike, say, social formation) is a term that exerts so much

power in popular discourse, we would do well to better understand it. Given that people often understand their own social locations in terms of the presence or absence of community, it makes sense to work with the term rather than to try to excise it from popular discourse and replace it with another. It seems a far more promising project to reflect critically on the nature of community, to appreciate the value and danger of appeals to it, to describe and critique existing communities, and to rearticulate a conception of community – both theoretically and popularly – that seems worthy of allegiance. As Dick Hebdige, working the terrain between postmodernism and cultural studies, has suggested, we need ways to identify and talk about 'larger collective interests, . . . the belief in the capacity of human beings to empathise with each other, to reconcile opposing viewpoints, to seek the fight-free integration of conflicting interest groups . . . [and] the cultivation of consensus' (1986: 92). Attention to community can be a response to that need.

Moreover, the concept of community is uniquely suited to the project in which cultural studies is engaged. That project is at once normative and descriptive, committing us to the empirical description and explanation of cultural and social practices as well as to an interventionist strategy which aims to transform oppressive power relations. Similarly, appeals to community – whether they occur at the level of popular discourse, of social policy, or of theory – have typically assumed a simultaneously normative/ descriptive character, serving not only to describe and structure our social, cultural and political experience, but also as a means of critiquing and legitimating a wide range of policies and practices (Plant, 1978; Minar and Greer, 1969).[4] While the normative aspect of such appeals has not received the attention it deserves, it has not gone unnoticed by cultural theorists. Raymond Williams, for example, has noted that

> Community can be the warmly persuasive word to describe an existing set of relationships, or the warmly persuasive word to describe an alternative set of relationships. What is most important, perhaps, is that unlike all other terms of social organization (*state, nation, society,* etc.) it seems never to be used unfavourably, and never to be given any positive opposing or distinguishing term. (1976: 66)

Finally, it may only be by re-examining the concept of community in light of the distinctive commitments of cultural studies that we will be able to address effectively what is manifestly a site where intervention is needed, is demanded and is actively taking place – the natural world. Communities are embodied; they are materially embedded in specific physical environments. We need, in our analyses and strategies for action, to contextualize community. Without some consideration of how material, geographical and ecological conditions and interdependencies are partly constitutive of community, of how they figure in and configure relations of power, cultural theorists will have little to contribute – by way of substantive interventionist proposals – to political struggle in the next millennium.

The particular conception of community for which we argue is one that

encourages us to think about and theorize the reasons and practices that bring human communities and the other-than-human world together in relations of solidarity and significance. This effort to articulate a non-anthropocentric conception of community represents a marked departure from previous conceptions, which, however divergent, have for the most part assumed without argument the viability of anthropocentricism.[5]

A notable feature of the discussion that follows is our commitment to a view of community, not as a 'unity of sameness', but as a 'unity in difference', one characterized by what Iris Marion Young (1990) has referred to as an 'openness to unassimilated otherness'. Fred Dallmayr has argued that such an openness involves the cultivation of diversity:

> Community may be the only form of social aggregation which reflects upon, and makes room for, otherness or the reverse side of subjectivity (and inter-subjectivity) and thus for the play of difference – the difference between ego and Other and between man [sic] and nature. (1984: 142–3)

We should perhaps emphasize what we do not take ourselves to be offering here. We are not proffering a definition of community that is exhaustive. Nor is it our primary concern to map conclusive limits for some definitive 'ideal' of community, the kind of positively valorized conception of which Williams took note. These would be ambitious but largely academic exercises which would leave us estranged from the project of formulating strategies for action. We are engaging in a critique of some typical features of the concepts of community that already exist and are currently operative in real cultural and political struggles. The conceptual critique we offer is informed by the normative commitments of cultural studies and singles out several salient issues (unity and difference, solidarity and significance, and the material context of community) where those commitments are in play. The intent is to fashion an enriched and politically activated conceptualization of community that provides both a way of recognizing the effectivities of various commitments to community (whether ideal or not) and of grounding intervention. To the degree that the contours of a politically desirable ideal begin to emerge in this, we offer no apologies. There are moments, and we take this to be one, when strategies for intervention require the guidance of ideals.[6]

Unity and difference in communities

Community is often characterized in terms of unities, where people are connected by a variety of shared circumstances – interests, customs, traditions, commitments, etc. But just as unity can be understood as a way of imagining, practicing and acknowledging connection, it can also be a way to separate, assimilate and obliterate difference. Given cultural studies' commitment to understanding and intervening in the organizations of active domination and subordination within cultural formations, it is especially pressing to attend to the tense dynamics of unity and difference within (as well as among) cultures, for it is the effectivity of these features within

cultural formations that structure and animate oppressive relations of power. Hall, in a study of issues raised by racism and ethnicity in contemporary society, asserts that

> the work that cultural studies has to do is to mobilize everything that it can find in terms of intellectual resources in order to understand what keeps making the lives we live, and the societies we live in, profoundly and deeply anti-humane in their capacity to live with difference. . . . If you go to analyze racism today in its complex structures and dynamics, one question, one principle above all, emerges as a lesson for us. It is the fear – the terrifying, internal fear – of living with *difference*. (1992: 17–18)

Within communities, such fear of or inability to live with difference has typically taken the form of a flight into a homogenized unity, a unity of identity or a unity in sameness, which seeks either to wholly assimilate or wholly exclude those who differ. In some instances, both of these means to a homogenized end may be invoked simultaneously, as in the case of America's historically divergent response to the 'others' in its midst.[7] The indigenous population whose lands it expropriated were, and continue to be, subjected to vigorous and varying campaigns of assimilation, while the African population that it imported as slave labour was subjected to virulent exclusion. As Vine Deloria notes:

> The white man adopted two basic approaches in handling blacks and Indians. He systematically excluded blacks from all programs, policies, social events, and economic schemes. . . . With the Indian the process was simply reversed. . . . Indians were subjected to the most intense pressure to become white. Laws passed by Congress had but one goal – the Anglo-Saxonization of the Indian. . . . The white man forbade the black to enter his own social and economic systems and at the same time force-fed the Indian what he was denying the black. Yet the white man demanded that the black conform to white standards and insisted that the Indian don feathers and beads periodically to perform for him.
>
> The white man presented the *problem* of each group in contradictory ways so that neither the black nor Indian could understand exactly where the problem existed or how to solve it. (1969: 172–4)

In this section we analyze several aspects of this view of community as a unity in sameness – a conservative conception of community that seeks to eliminate the 'threat' of difference and an attempt to forge a unity wherein each member of the community 'perfectly recapitulates or reproduces or even "expresses" another . . . where each is reducible to the other' (Hall, 1980: 325). Raymond Plant has extensively critiqued this 'conservative' conception of community. Of particular importance here is the connection he notes between hierarchy and a unity that attempts to obliterate difference:

> The conservative conception of community is usually backward looking, its appeal connoting a return to a *Gemeinschaft* type of order, and thus may support attempts to resist change and to buttress the existing power

and authority structure. Community then is characterized by hierarchy, place, and mutual obligation between groups in different positions within the hierarchy. Its vision is one of organism and its ethic one of mutual service: the social order is an organic unity within which each individual has an allotted place and a part to play. (1978: 95)

This ideal of community valorizes the tightly knit, exclusive, highly structured, hierarchical small town or rural community, based on locale and face-to-face communication. It depends on 'an illusion of coherence and safety based on the exclusion of specific histories of oppression and resistance, the repression of differences even within oneself' (Martin and Mohanty, 1986: 196). Such a construal sets up bipolar oppositions between inside and outside, between individualism and community, between the separated self and the shared self (Young, 1990: 306). It can also be stretched to fascistic ends. The root metaphor of Mussolini's fascism was organic connectedness 'in which the ideals of internal relatedness led to the totalitarian extremes of Hitler's Nazi rule. The individual was to count for nothing' (Ferre, 1989: 237). Moreover, the conservative conception of community usually involves a kind of nostalgia – a desire to recapture a 'golden age' of community before *Gemeinschaft* became *Gesellschaft*. As Williams observed, community in this sense 'seems never to be used unfavourably' (1976: 66).

Marxist- and socialist-influenced conceptions of community have struggled explicitly against this conservative conception of community in a variety of ways, though often in terms of the hierarchy implied by it. In particular, Marxists have rejected the assumption that organically interdependent hierarchical communities simply reflect the 'natural order' (Plant, 1978: 95). In struggling to excise hierarchy, Marxist and socialist conceptions of community have sought to model a practical and theoretically defensible relationship of semi-autonomous individuals in communal structures. For example, Eugene Kamenka describes a concept of community that is self-consciously an ongoing process of finding a grounding of individuality in the communal:

> The concept of community in socialism has always been and remains a confused concept, bringing together a critique of Millian liberalism with an elevation of cooperation, a notion of self-expression and self-determination with an extreme ideal of an organic community in which individuals as individuals have no place. On the whole, the majority of socialists have shied away from elevating 'community' as a great organic totality. . . . They have wanted to hold that socialism will replace bourgeois individualism with something spontaneous, voluntary and uncoercive, which will in a sense be communal and yet preserve all the highest values of Enlightenment and bourgeois individualism, giving the individual greater freedom and greater opportunities for self-development and self-management than he [*sic*] has ever had before. (1982: 26)

The contemporary rejection of the conservative conception of community has been particularly vociferous in postmodern-influenced critique. Notable

examples are Biddy Martin and Chandra Talpade Mohanty (1986), Young (1990), and Jim Cheney (1989). Young, using conceptions of a feminist community, rejects the notion of community altogether in favor of a 'politics of difference'. She characterizes community as expressing an undesirably utopian 'desire for selves that are transparent to one another, relationships of mutual identification, social closeness and comfort ... a unity or wholeness in discourse [that] generates borders, dichotomies, and exclusions' (1990: 300–2).

In place of this unity, Young's 'politics of difference' suggests an 'understanding of social relations without domination in which persons live together in relations of mediation among strangers with whom they are not in community' (303). Martin and Mohanty, also concerned about the applicability of the concept of community within feminist practice, reject 'any notion of feminism [the community they consider] as an all-encompassing home [as well as] the assumption that there are discrete, coherent, and absolutely separate identities – homes within feminism, so to speak – based on absolute divisions between various sexual, racial, or ethnic identities' (1986: 192). Martin and Mohanty refuse to give up the term 'community', but insist on its redefinition as a shifting, unstable, historically discontinuous narrative among geography, demography and architecture (as opposed to the sense of community as the narrative of a linear, essentialized self). Cheney rejects the sense of community as unity in expressing the need to be vigilant against the discourse of any setting or landscape 'falling prey to the distortions of essentializing, totalizing discourse' (1989: 128).

What the postmodern critique opposes itself to is what we would describe as a conception of community as 'unity in sameness'. We draw here on the work of Karen J. Warren who, striving to develop a feminist environmental ethic, places herself in opposition to this unity that erases difference. She argues that a unity in sameness is based on 'shared experiences and shared victimization' (1990: 131), that it 'builds a moral hierarchy of beings and assumes some common denominator of moral considerability in virtue of which like beings deserve similar treatment or moral consideration and unlike beings do not' (137). Community based on a notion of unity in sameness promotes sexism, racism, classism or some variant thereof based on the imagined threat of some 'alien' otherness. Classic – and contemporary – manifestations of it can be seen in such ultra-right US groups as the Aryan Nation and the Posse Comitatus, as well as in their European neo-Nazi analogues. Such community is structurally unitary or reductionist, hierarchical and homogeneous. It is for good reason that the postmodern critique rejects such a notion of community. And it is for good reason that cultural studies should reject it as well.

But it is striking that even within the postmodern critique, a position that leans toward making a religion of the reverence for difference and 'the conversion of asociality into an absolute' (Hebdige, 1986: 92) there is so much evidence of the struggle to acknowledge and work with the idea of community. The critique works to make a space within postmodernism, within the rejection of a unity of sameness, for talking about a unity in

difference. Young, for example, who rejects outright the conception of community, persists in using the language of unities – though of a transformed sort – in the elucidation of her concept of a politics of difference. She writes:

> A politics of difference lays down institutional and ideological means for recognizing and affirming *differently identifying groups* in two basic senses: giving political representation to *group interests* and celebrating the *distinctive cultures* and characteristics of *different groups*. (1990: 319, emphasis added)

The very impetus behind Martin and Mohanty's work is 'to find ways of conceptualizing community differently without dismissing its appeal and importance' (1986: 192). They too are after a different kind of unity, a

> 'unity' of the individual subject, as well as the unity of feminism [as] situated and specified as the product of the interpretation of personal histories; personal histories that are themselves situated in relation to the development within feminism of particular questions and critiques. (Martin and Mohanty, 1986: 192)

Cheney builds on Martin and Mohanty's commitment to a sense of community. He extends the postmodern emphasis on contextualism and narrative to include the human community and its institutions as well as the land, 'one's community in a larger sense' (1989: 128). He embraces a contextualist ethic, one in which 'the land must *speak* to us; we must stand in *relation* to it; it must *define* us, and we it' (129). The result, he insists, is not an *identification* with nature, which he regards as an essentializing move. It is one in which humans *relate* to nature as 'satisfying other', and a 'unity in which an understanding of self and community *is* an understanding of the place in which life is lived out and in which an understanding of place *is* an understanding of self and community' (130).

The postmodern critique of community vacillates between the rejection of community and its reinscription in an altered form. It is unable to give up entirely on the idea of community as unity. The move characterizes much applied postmodern theorizing and is made particularly salient in the work of Hebdige (1985; 1987). For example, in 'The bottom line on Planet One', Hebdige describes a world (the postmodern world of Planet One) where a commitment to the flat surfaces of inexhaustible difference, irony, and the impossibility of representation are predictably interrupted by the assertions of order, unity and the necessity of judgement as being 'in the very nature of the human project' (1987: 48). The most vexing move in postmodernism is its tendency to insist on bipolar contrasts between unity and difference, utopia and irony, the impossibility of representation and the correspondence theory of representation, totalization and inexhaustible fragmentation. While these postmodern critics of community are concerned about the degree to which a particular conception of community creates exclusions, they struggle against postmodernism's tendency to exclude the possibility of

unity – even a unity in difference – as they respond to that which always returns to assert itself as 'the bottom line' – for better or for worse.

Cultural studies has been greatly influenced by the colonizing discourse of postmodernism, but it is far easier within the cultural studies project to consider the possibilities of unity or unities and of the concept of unity in difference (Hall, 1985). As Hebdige has noted, the 'we' within postmodernism is problematic, it is 'the imaginary community which remains unspeakable within the Post.' Yet the alternative is not some account of community as 'given, pre-existent, "out there" in the pre-Post-erous sense', but one in which community 'is itself the site of struggle. . . . [and] has to be made and re-made, actively articulated . . . at once "positioned" *and* brought into being' (1986: 95). Furthermore, the willingness of cultural theorists to entertain the discourses of sociologists, anthropologists, environmentalists and various social activists can provide them with new ways of conceiving of community that neither reject the idea of unity out of hand nor accept fragmentation as a theoretically pure ideal to which all of our theory and practice is expected to live up. A review of the traditional literature on community reveals that there are myriad possible definitions of community (Hillery, 1955; Plant, 1978; Clark, 1973) as well as the acknowledgement that different definitions of community entail profoundly different normative conceptions of value and responsibility (Leopold, 1949; Cragg, 1986). We hardly need rely on the conservative concept of community. As long ago as 1955, George Hillery (1955) identified ninety-four different definitions of community, many of which vary significantly in their distinguishing ideas or elements. Plant more recently illustrates that the conceptions of community already available to us are reflections of significant variations in 'our deepest assumptions about the basis of human nature, its capacities and powers, and about the possibilities inherent in human life' (1978: 88). Indeed, there is ample precedence for using and developing conceptions of community that do not rely on the idea of unity in sameness. We simply need not relegate understanding community to the hierarchical imposition of shared identity and experience.

Solidarity and significance

To value the communal as a non-assimilative 'unity in difference' is to embrace a 'plural' conception of community. It allows cultural studies to entertain the existence of hierarchical and non-hierarchical communities, of anthropocentric and non-anthropocentric communities, and of communities predicated upon difference where what is shared can nevertheless be acknowledged and can serve as the basis of strategies for action. The alternatives would seem to be either some variant of Hobbesian fragmentation – where there is no unity or community, but an accidental aggregate of random and discrete individuals, or the assimilative extreme that embraces cultural homogenization – a 'unity in sameness' rhetorically well-captured by expressions such as 'melting pots', 'naturalization' and '*e pluribus unum*',

which attempt to rationalize empire and colonial domination.[8] For cultural theorists, neither of the latter are options.

Having insisted on 'difference', we need to focus more attentively now on 'unity' in the communal. Part of the effectivity of appeals to community, of what Williams described as the 'warmly persuasive' quality of that term, is the connectedness which it connotes. It is these relationships among individual constituents of the community which are central to community; they are what constitute, and enable, a unity in difference within particular communities. We turn to them now. Our suggestion will be that relations of solidarity and significance are the articulating principles of the communal[9] and that these principles encompass both the human and the other than human. This position entails

> conceiving of oneself as fundamentally 'in relationship with' others, including the nonhuman environment. It . . . *takes relationships themselves seriously*. It thereby stands in contrast to a strictly reductionist modality that takes relationships seriously only or primarily because of the nature of the *relators* or parties to those relationships. (Warren, 1990: 135)

Can there be community where there is neither recognition nor awareness of community – in the absence, that is, of a 'sense of community'? Perusal of the two contexts in which the concept of community is most intensively deployed – the social scientific and the ecological – suggests there is no consensus on this question, and that there may be an ambiguity at the heart of community. Many social theorists would respond negatively. Clark, for example, maintains that a social structure is a community only to the extent that it embodies the *sentiments* of solidarity and significance (1973: 402–10). 'By far the most commonly accepted ingredient of community', solidarity is the

> sentiment which writers have in mind when they refer to social unity, togetherness, social cohesion or a sense of belonging. It encompasses all those sentiments which draw people together (sympathy, courtesy, gratitude, trust and so on), a river into which many tributaries flow. (Clark, 1973: 404)

K. Schmitz comments that community 'is one of those words whose felt sense among a people is a direct measure of the very reality and strength of community itself among that people' (1983: 246). Community has sometimes been characterized as the solidarity that is asserted in the stories we tell each other about our shared feelings, nature and interests (Maines and Bridger, 1992; Hummon, 1990). And Benedict Anderson, contending that nations are imagined political communities, argues that because a nation 'is always conceived as a deep, horizontal *comradeship*' (1983: 16, our emphasis), it is a community, and

> all communities larger than primordial villages of face-to-face contact (and perhaps even these) are imagined. Communities are to be distinguished not

by their falsity/genuineness, but by the style in which they are imagined. (Anderson, 1983: 15)

Yet others treat consciousness of community as incidental to community, emphasizing instead the presence of a common characteristic among the community's constituents, such as occupation of the same geographic area.[10] Moreover, in such contexts, community membership is invariably restricted to a single, human, species.

Among ecologists, by contrast, a community is typically regarded as an assemblage of species occupying a given area, or a network of interacting populations.[11] Ecological analyses of community proceed in terms of the interrelationships of species with one another and with the abiotic features of their environment, rather than in terms of sentiments, consciousness or imagination. Here, lack of a sense of community is no indicator of absence of community. Indeed, humans tend not to be regarded as genuine members of such communities, but as external influences which may impact a community's constituents.[12] This is at odds with the approach taken by social science, of course, where it is non-humans and abiotic features of the environment that are treated as external influences, furthering or frustrating the development of the community's proper, human, constituency.

There are valuable elements to be drawn from both of these contexts in fashioning a concept of community generative for cultural studies. First of all we should note that there are strong political reasons for denying that there can only be community where there is already a sense or sentiment of community, of solidarity and significance binding the community's members together. Communities are among the most effective forces of local political and social change. They typically become so via *appeals* to community, i.e., through the forging of relations of solidarity among community members on the basis of antecedent relations of significance – shared circumstances, interests, or commitments – which bind a given community together. Relations of solidarity may be activated in some communal contexts, but latent or dormant in others. Much social change and political activism originates with an affirmation that *there is* community, that relations of significance are present and must be sustained or protected. To constrain usage of the concept of community only to contexts where a sense of communality already flourishes is to radically undermine the nature and extent of viable strategies for political action.

It is our contention, then, that community may exist where recognition or awareness of community does not, in that relations of significance may be operative where relations of solidarity are not. The basis of community may be present – the fact of interconnectedness or interdependency, of commonality or mutuality of interests – but those bound together by these relations of significance may not recognize them as such; they may not perceive them *as* significant. To perceive them as significant is to affirm solidarity, to acknowledge that there is a relatedness in the midst of difference which binds the divergent members of the community together as a community.

Iadicola and Ashton, in considering the conception of solidarity within a

socialist/anarchist perspective, directly attempt to accommodate difference by contending that solidarity implies that

> only through mutual and reciprocal social interaction can humans actualize their potentials, i.e., recreate themselves in nature. Humans cannot grow in isolation or in an environment in which conflict and competition are the dominant characteristics. It is important to recognize that solidarity does not mean homogeneity of cultures, but . . . allow[s] for the flourishing of cultural pluralism, where one group does not dominate another. (1987: 98–9)

Iadicola and Ashton's restriction of solidarity to the human is commonplace. Anthropocentric accounts of relations of solidarity and significance are standard. The issue of which entities are capable of experiencing a sense of community, of entering into relations of solidarity, and which are bound together by relations of significance, is often not raised since their humanity tends to be assumed. At times, however, it is explicitly and rather emphatically stipulated, perhaps because, as Paul Hirst and Penny Woolley argue, 'social science has inherited an Enlightenment conception of man as "unique"':

> Modern social science is concerned with policing the 'boundary' between nature and culture, with limiting and excluding phenomena which threaten to challenge its account of the social determination of the attributes of human beings. . . . Human culture is regarded as different in quality from any possible form of animal association or attainment. (Hirst and Woolley, 1985: 151)

This much seems evident in Richard Rorty's essentialist gloss on the term:

> What we mean by 'human solidarity' is to say that there is something within each of us – our essential humanity – which resonates to the presence of this same thing in other human beings. . . . What can there be except human solidarity, our recognition of one another's common humanity? (1989: 189)

Dewey, too, defined community as the distinctively human form of association.[13] And, as we have already noted, for Clark significance is a matter of human sentiment, the sense that one fills a role in the reciprocal relations of the social scene and is thus 'contributing to the larger whole' (1973: 404).

By contrast, the account of solidarity and significance which we are proposing for cultural studies in not constrained to the human. In place of Clark's construal of significance as the sense of human 'meaningfulness', we offer a weaker but richer construal where relations of significance indicate the fact of interconnection and/or interdependence, perhaps of shared interests or circumstance. Such relations may hold among the different constituents of a community, be they humans, non-humans or abiotic features of the local environment. They are indeed what constitutes a given collection of diverse entities as a community, they are the 'unity in difference'

of which we spoke above. This is at odds with the customary treatment of community in both social scientific and ecological contexts; the human and non-human may both be vital players in, or proper constituents of, community. Neither need be relegated to the role of background or external 'influence'.

A non-anthropocentric account of solidarity accompanies this. Insofar as there are relations of significance joining the human and non-human components of a community, there *may* also be relations of solidarity among them. Whether or not there are relations of solidarity will turn not on (human) species membership, but on the degree to which the entities in question recognize, are aware of, or value, the relations of significance – the connectedness or shared interests – which bind them together. And, as Hirst and Woolley point out,

> The capacities humans have are what they have, but they are not of necessity unique to them. The supporters of the 'only humans can' view merely set their limits or boundaries at a higher level. . . . there is no *essential* differences [*sic*] between *Homo sapiens* and any other animal. This extends to the capacities which enable humans to constitute culture. (1985: 160)

This allows us to acknowledge that human infants, comatose or mentally disabled humans, many other species and much that is non-human can all participate in, or be part of a community in that they are bound together by relations of significance, although they are (actually or potentially) unable to affirm this, i.e., to enter into relations of solidarity. It also allows those of us (human or not) who can enter into such relations, who can recognize or experience community, to affirm solidarity with those who cannot. So, in response to Rorty's question, 'What can there be except human solidarity, our recognition of one another's common humanity?' (1989: 189), we would suggest *plenty* . . . whatever in fact we (those beings capable of entering into relations of solidarity) are interconnected within communal relations of significance.[14]

Once again, whether at the level of formulating theoretical analyses or practical strategies for action, there are political advantages to extending communal relations of solidarity and significance to the other than human. Certainly the failure to do so is central in most environmental problems and has greatly exacerbated many contemporary social struggles. Until we acknowledge that the land – in Aldo Leopold's (1949) expansive sense of that term – and humans are articulated in communal relations of solidarity and significance, our analyses and interventionist strategies will be frail and impotent. We will not, for example, be able adequately to address the role of land in the resistance struggles of indigenous peoples. It has been determined that 85 per cent of the 100 armed conflicts being waged in the world between 1985 and 1987 were being waged by indigenous peoples against the state or states that had claimed and occupied their territories (cited in Churchill, 1993: 411). Land theft is not some kind of disruption external to an indigenous community which impacts negatively on it. Land is an integral

part of such communities and to lay claim to it is literally to steal community. We cannot do justice to the nature or extent of such struggles, and the determination of the peoples engaged in them, without an understanding of community that permits us to conceive of the relations of solidarity and significance that hold not only among humans but between the human and the other than human. As Bonfil Batalla, the Mexican activist, set out in his 'six fundamental demands' of the Indian movement and theoretical perspective known as indigenism:

> First there is land. There are demands for occupied ancestral territories . . . demands for control of the use of the land and subsoil; and struggles against the invasion of commercial interests. Defense of land held and recuperation of land lost are the central demands. (Quoted in Ortiz, 1984: 85)

Nor will we understand how genocide, ecocide and expropriation by forces operative in the larger social, political and economic formations intermesh within, and are brought into play at the level of local tribal communities. The range of specific issues here is staggering within North America alone. They include a host of policies of 'radioactive colonization', ranging from the designation of the so-called 'Four-Corners' region (home to the Diné, Ute, Laguna, and several other Pueblo nations and the largest concentration of land-based indigenous peoples remaining in North America) as a 'National Sacrifice Area' in the interests of US economic stability and energy consumption, following extensive contamination by uranium mining and milling; to lucrative grants/bribes made by the Department of Energy to induce tribes to conduct feasibility studies for the storage of high-level radioactive waste in MRS ('monitored retrievable storage') sites on reservation lands.[15] They also include massive water-diversion projects such as James Bay I and II (undertaken by the Canadian government and Hydro-Quebec to profit from the voracious energy appetite of the north-eastern United States) which are flooding the lands, leaving in their wake mercury-contaminated fish and wildlife and destroying the lives and livelihoods of the Cree and Inuit peoples ('Readings on James Bay', 1991).

Our points here are varied. These policies and projects have their impact primarily at the community level. And it is at the level of communities and coalitions of communities that they are in fact, and perhaps most effectively resisted. For each of the above issues, grass-roots community organizations have sprung up, many of which have, by pooling their knowledge and energies with other such organizations, initiated various successful strategies for resistance and action. If cultural theorists are to support and advance these and other efforts, it is essential that we have the conceptual tools that will prepare us to do so. If we focus exclusively on microlevel intricacies of subject formation and on macrolevel meta-analyses of power and hegemony within the larger social formation, we will surely and inextricably embed ourselves in the thickets of theory and marginalize ourselves politically. It is from within communities – these complex articulations of the human and other than human – that effective political resistance is originating, and it is

within them that hegemony and oppression are experienced. We need to attend to them, to their mediating and catalyzing effects, to how they initiate, sustain and modify strategies of resistance.

Environments: the material context of community

It has been our contention that the traditional anthropocentric sense of community needs to be reconfigured along more inclusive lines, so that communities can be understood as sites where the human and other than human are drawn together in multiple articulations. To distinguish this alternative conception of community from traditional ones we will occasionally speak of 'mixed communities'.[16] In the preceding section we have seen how such communities are bound together – through relations of solidarity and significance, where the possibility of the former depends on the actuality of the latter. It is this fact of interdependency or interconnectedness, of shared circumstances or interests which constitutes the unity of community and which enables solidarity – the acknowledgement and valuing of relatedness in the midst of the differences within community.

In this final section we consider the need to contextualize community in a particular way, that is, to situate the relations of significance in the material contexts which give rise to them and which they, reciprocally, transform. To facilitate and foreground the mutual reciprocity of mixed communities with their material contexts, we propose that talk of 'the environment' itself be contextualized and that reference to that general abstract notion be supplemented by reference to specific, localized 'environments'. An environment particularizes or contextualizes a community, situating it within and bonding it to both the natural world and the larger 'containing' society.[17] It is a distinctive nexus of material factors, conditions and forces which are at play within, brought to bear on, and responded to by a particular community.

The ambiguity of 'material' is intended and welcomed in this description. While it connotes the physical surroundings (and it is this sense which will be emphasized below) it must also be understood more broadly, so as to include those political, economic and cultural forces within the larger culture which are material or relevant to communal activity. It offers a way of combining what Minar and Greer have characterized as the notion of 'community as the physical space where people live' with that of 'community as a set of social identifications and interactions' (1969: 47).

Mainstream social science has tended to separate (human) communities from their environments, alienating them from one another by drawing a clear line between them. Typically an environment is construed as no more than a geographic place, serving as a kind of inert receptacle shared by a set of human characters who are the central (often sole) interest. For example, as Minar and Greer explain

> place is important to community for certainly most of the social systems to which we would apply the concept are geographic entities of one sort or another. The human contacts on which feelings of commitment and

identity are built are most likely to occur among people sharing the same piece of ground. The mere fact that they live together gives rise to common problems that push them toward common perspectives and induce them to develop organizational vehicles for joint action. (1969: 47)

By contrast, what we are proposing is that, for both theoretical and practical purposes, communities be approached as conjoined to and interpenetrated by particular environments which they transform and partially construct and which in turn transform and partially construct them. Far from being mere passive backdrops or props in an essentially (or exclusively) human play, environments so conceived are the embodiment, or material extension of communities. Particular environments do not exist without, or apart from, the communities of which they are constitutive. To paraphrase R.C. Lewontin *et al.*, just as there is no community without an environment, so there is no environment without a community (1984: 273).[18] Communities 'do not simply adapt to existing autonomous environments; they create, destroy, modify, and internally transform aspects of the external world by their own life activities to make this environment' (273). Moreover, such environmental construction and transformation is a feature not just of the human constituents of a mixed community, but of its entire biotic constituency:

> Not only human beings but all living beings both destroy and create the resources for their own continued life. As plants grow, their roots alter the soil chemically and physically. . . . Animals consume the available food and foul the land and water with their excreta. But some plants fix nitrogen, providing their own resources; people farm; and beavers build dams to create their own habitat. (Lewontin *et al.*, 1984: 274)

In a species-specific manner, relevant bits of the physical world are selected, altered and related to one another as part of the dynamics of community. Habitats are created, materials are processed, energy needs provided for, wastes disposed of, resources destroyed and created.

Communities, then, are as much results as they are causes of their own environments. One practical political consequence of this is that discussions of development cannot proceed reductively, by divorcing communities from their material contexts. Mixed communities and their constitutive environments are inseparable; they are the unit of development and of change. All development is, for better or worse, co-development of communities and environments. And the relation between a particular community and its environment 'is not simply one of interaction of internal and external factors, but of a dialectical development' (Lewontin *et al.*, 1984: 275) of community and environment in response to one another. As William Cronon, arguing for an ecological approach to history, has noted,

> the *instability* of human relations with the environment can be used to explain both cultural and ecological transformations. An ecological history begins by assuming a dynamic and changing relationship between

environment and culture, one as apt to produce contradictions as continuities. (1983: 13)

In this view, environment and culture, moreover, are dialectically responsive to one another:

Environment may initially shape the range of choices available to a people at a given moment, but then culture reshapes environment in responding to those choices. The reshaped environment presents a new set of possibilities for cultural reproduction, thus setting up a new cycle of mutual determination. Changes in the way people create and re-create their livelihood must be analyzed in terms of changes not only in their *social* relations but in their *ecological* ones as well. (13)

As a concrete instance of the dialectical development of community and environment, consider the discussions of Jayanta Bandyopadhyay and Vandana Shiva (1987) and Shiva (1989) regarding the contemporary Chipko movement in India. India has traditionally been a 'forest culture', in which the 'forest is the context and condition of survival' (Shiva, 1989: 57). Large tracts of natural forests 'were maintained through careful husbanding by local communities; village forests and woodlots were also developed and maintained through the deliberate selection of appropriate tree species' (Bandyopadhyay and Shiva, 1987: 26). The indigenous forest science that characterized the relationship between humans and trees 'did not perceive trees as just wood; they were looked at from a multi-functional point of view, with a focus on diversity of form and function' (Shiva, 1989: 58).[19] But when the British colonized India, they also colonized the forests. They transformed common village resources into private property, forcing villages to exploit the natural forests; they viewed forests as a hindrance to the development of agriculture and cleared them; and they widely logged the forests for their commercial and military uses as timber. The virtually uncontrolled destruction of the forests and discontent with the lack of control over their exploitation led to the development of 'scientific forestry' in the 1860s. But, as Shiva points out:

Commercial forestry, which is equated with 'scientific forestry' by those narrow interests exemplified by western patriarchy is reductionist in intellectual content and ecological impact, and generates poverty at the socio-economic level for those whose livelihoods and productivity depend on the forest. Reductionism has been characteristic of this forestry because it sunders forestry from water management, from agriculture and from animal husbandry. Within the forest ecosystem it has reduced the diversity of life to the dead product, wood, and wood in turn to commercially valuable wood only. (1989: 63)

Because reductive forestry practices ignore the complex relations that constitute the forest community, Shiva finds that

this pattern of resource use generates instabilities in the ecosystem and leads to counterproductive use of nature as a living and self-reproducing

resource. The destruction of the forest ecosystem and the multiple functions of forest resources in turn hurts the economic interest of those groups of society, mainly women and tribals, who depend on the diverse resource functions of the forests for their survival. (63)

Resistance to the colonization of the forests has been taking place throughout India for over two hundred years involving women and tribals in a central role and has been influenced along the way by the Gandhian *satyagraha* campaigns. The current Chipko movement, an historical extension of these earlier movements, is committed to resistance to deforestation and to afforestation with (appropriate) trees.[20] According to one of its leading activists, Bahuguna, 'development, as practiced today in official programmes, is going to be unsustainable if ecology is not considered as an imperative. . . . The material foundation of economic development . . . cannot be divorced from the productivity of ecological systems and their stability' (Bandyopadhyay and Shiva, 1987: 33). Shiva adds to that an insistence on acknowledging diversity and interconnectedness, what we have called unity in difference:

> Diversity of living resources in the forest, natural or in an agro-ecosystem, is critical to soil and water conservation, it is critical for satisfying the diversity of needs of people who depend on the forest, and the diversity of nature's needs in reproducing herself. (1989: 95)

This case demonstrates how diverse communities and the complex power relations they manifest infuse and are infused by their environments. The political, economic, cultural, material forces that constitute community(ies) environments and the relations among them is not one of mere interaction but of a reciprocity integral to their unfolding. Given the alienation of community and environment in mainstream social scientific theory, an interactionist account of the relations between community and environment is the most that could be achieved. What distinguishes such an interactionism from the view of interpenetration of community and environment that we are advocating is the absence of reciprocity in the former. Community and environment are conceptualized as autonomous, closed systems that – when they are seen as related at all – are asymmetrically related. Plant, for example, observes that the conservative conception of community tries to 'mirror in community the order that inheres in nature, rather than . . . actively to impose order upon it' (1978: 98). Community and environment merely react to, or on one another; and taken individually they – and the relationships to which they give rise – are reduced to instrumental values:

> Liberalism seriously misconstrues the nature and function of communities. . . . this misconstrual lies in the implied requirement that only instrumental evaluations of the merit of communities and those things to which they give rise are justified. (Cragg, 1986: 34, 35)[21]

In the view advanced here, community and environment constitute a single, integral and open system; they are mutually responsive to, reciprocally

constructed and informed by, one another. As an integrated system they, and the relations of significance and solidarity which instantiate them, are valuable as ends in themselves. As Warren notes in a different connection: 'recognition of the relationships themselves as a locus of value is a recognition of a source of value that is different from and not reducible to' the value of the related beings (1990: 135). Thus, the value of mixed communities and the material contexts which partially constitute them cannot be measured solely in terms of their potential to satisfy individual (or corporate) self-interest.

Recent efforts to renew urban communities by means of regionally adaptive, ecologically sound architecture provide an illustrative case of how such a conception of community can be embraced within specific strategies for intervention. Noting that 'the built world has been far more a part of the problem than the solution', James Wines maintains that rather than design buildings as isolated compositions of abstract geometry, architects must

> see their structures as narrative fusions of ideas that connect shelter to the earth. . . . It basically means that architecture, as a sculptural object, is not as important as the contextual data it absorbs and communicates. This places the building arts much nearer their historic role, where . . . admired integrations of nature and buildings were the result of consensus beliefs concerning the relationship of society to the earth. (1993: 22)

Activist artists and architects are also revitalizing inner cities by transforming degraded environments into public parks. Patricia Johanson's work, for example, revitalizes natural ecosystems and introduces them to urban dwellers. Her 'Leonhardt Lagoon', in Dallas, literally returned to life a fouled, algae-suffocated lagoon, replete with dead fish and serious shoreline erosion. After convincing the Dallas Parks Department to stop using synthetic fertilizer, and researching native plants, fish and reptiles, she replanted delta duck-potato and Texas fern to purify the lagoon and shelter small animals. 'For the first time since its construction in the 1930s, people could actually wander out and over the lagoon, from shore to shore, exploring micro-habitats that are now home to a variety of life' (Couture, 1993: 25) on the wandering pathways Johanson integrated into the lagoon.

While such urban renewal projects are ostensibly addressed to environments in the sense of the physical setting of communities, they decidedly bring into play the broader sense in which environments must be construed as including the material social forces within the larger culture which impact on and are operative within the community. Accordingly, their identification, initiation and completion raise a host of concerns which must be simultaneously assessed: Who will inhabit, or enjoy, the structures created by Wines and Johanson? How were the decisions made to undertake these particular projects, and how will they impact other renewal efforts? Were community members active participants in their design and construction? etc.

The point we wish to stress is that the approach to community proposed

here entails the interpenetration of *both* the physical space which community members inhabit and the political, economic and cultural relations operative among them. This is all the more vital in the wake of the development of a world capitalist system in which increasing numbers of individuals and communities are brought into trade and market relations that lie well beyond the boundaries of their local environments. 'This erasure of boundaries,' Cronon suggests, 'may itself be the most important issue of all.' (1983: 14)

Environments play integral roles in the construction and maintenance of community and their presence within communities is, as much as that of humans, a vital one. They are part of the sum of material conditions which enable and are constitutive of community. As one commentator has observed:

> Humans are who we are in large part by virtue of the historical and social contexts and the relationships we are in, including our relationships with nonhuman nature. Relationships are not something extrinsic to who we are, not an 'add on' feature of human nature; they play an essential role in shaping what it is to be human. Relationships of humans to the nonhuman environment are, in part, constitutive of what it is to be human. (Warren, 1990: 143)

Conclusion

Cultural theorists tend to be blinkered by the prevailing intellectual community – predominantly urban, generally privileged, arrantly 'academic', and widely smitten with PostModernSyndrome. And it is perhaps this which best explains certain omissions in the cultural studies agenda: the neglect of community, the 'overlooking' of the environment, and the lack of concerted attempts to responsibly reconfigure community/environment relationships. All these may simply have fallen outside cultural studies' field of vision. The rigors and expectations of academic realities also militate against communal/environmental activism, and (possibly more so) against the interdisciplinary intellectual work required to engage in it effectively. Moreover, the theoretical edifice of academic (even of extra-academic) cultural studies has a way of keeping our noses in our books, our books in our hands, and our hands in our offices, working to unravel the intricacies of theory. It is in fact the decidedly anthropocentric orientation of that theory that keeps us still further from making connections to the material environment in the broadened sense proposed here.

There is compelling reason to redirect and enhance our vision and commitments. What we stand to lose is a largely unreflective narrowness. What we stand to gain is much: a new context for some old issues, a material context for others, a host of comparatively new (to cultural studies) issues, more politically potent interventionist strategies, and more culturally attuned analyses. We have proposed that community be granted a substantive role in cultural theory, that communities themselves be reconfigured along non-anthropocentric lines as multiple articulations of relations of

solidarity and significance, and that they be contextualized within the material environments that they transform and are transformed by. As cultural theorists engage environmental issues, as seems inevitable, cultural studies will be reshaped. At the very least, part of our project will be to locate communities in the natural world – the environment or material context of culture. The 'land' and struggles for the land will figure in our reflections, and demand that theorizing issue in appropriate action.

Notes

1 It may well be that the resurgence of interest in community is an especially American phenomenon, for as David Hummon observes, 'conceptions of community life are fundamental elements of American culture' (1990: 5). However, given the conception of community we propose here, its applicability is clearly broader.
2 Allor speaks of these as the 'sociological' and 'productivist' pulls within cultural studies (1984; 1989).
3 Habermas (1979: 93ff), in particular, has drawn attention to the fact that the kinds of associations we inhabit define the kind of individuals we become.
4 As Minar and Greer have observed: 'For community is both empirically descriptive of a social structure and normatively toned. It refers both to the unit of a society as it is and to the aspects of the unit that are valued if they exist, desired in their absence. Community is indivisible from human actions, purposes, and values' (1969: ix).
5 See Hillery's (1955) survey of ninety-four different definitions of community and Fowler's (1991) survey of the contemporary debate about community in political science. Further discussion of a non-anthropocentric perspective in cultural studies may be found in Slack and Whitt (1992).
6 Hall (1990: 29) makes a similar argument with respect to taking an essentialist position.
7 Although the term 'other' has become current, it is seriously problematic. As Benhabib notes:

> The view that all these groups of individuals represent the 'other' of reason is fraught with difficulties, for in stating this, we are defining their identity only with regard to what they are not. I believe this kind of categorization of the 'others' of reason is just as imperialistic in its cognitive attitude as the instrumental reason it criticizes. For any definition of a group's identity not in terms of its own constitutive experiences but in terms of its victimization by others reduces that group's subjectivity to the terms of the dominant discourse and does not allow for an appreciation of the way in which it may challenge that discourse. I think this is the Janus face of postmodernism as far as movements like feminism and cultural autonomy are concerned. The postmodernist appreciation of otherness is framed in terms of the 'guilty conscience' of the dominant, western traditions of rationality. (1992: 83)

8 For more discussion of this process, see Blauner (1972); Forbes (1979); and Smith (1965).
9 Clark (1973) draws attention to the importance of solidarity and significance in a consideration of community. While our discussion is indebted to his, our

treatment and understanding of the role of these concepts in community differs markedly.

10 For examples, see Hillery (1955).

11 This is the type of account that would be given by population-community ecologists. See Saarinen (1982) and Smith (1986).

12 Such a role for humans is particularly true for an earlier generation of ecologists who construe communities along lines of superorganisms, rather than of ecosystems. Their functionalist emphasis on equilibrium states and ideal climax communities 'tended to remove ecological communities from history ... implying that humanity was somehow outside of the ideal climax community' (Cronon, 1983: 10) and the central source of 'disturbance' in the dynamics of community change. With the abandonment of the organism metaphor in the mid-twentieth century, 'ecology was prepared to become at least in part a historical science . . . [and] began to express a stronger interest in the effects of human beings on their environments' (11). However, the ecological 'location' remains problematic. As Cronon notes, 'admitting that ecosystems have histories of their own still leaves us with the problem of how to view the people who inhabit them. Are human beings inside or outside their systems?' (12). For more on this, see Cronon (1983).

13 For a valuable critique of Dewey in this regard, see Singer (1985).

14 For a review of some of the recent work in ethology that challenges the anthropocentric concept of community on empirical grounds, see Singer (1985) and Hirst and Woolley (1985).

15 For a detailed analysis of these and many other similar struggles, see Churchill (1993) and the numerous articles in the Native press, including *The Circle*, and *News From Indian Country*.

16 Midgely (1983) uses this term for similar, though not identical, ends.

17 This expression derives from Goode. See Minar and Greer (1969).

18 Although Lewontin's *et al.* (1984) remarks are not directed to communities, but to organisms, our discussion here is greatly indebted to their comments in this connection. See especially pp. 266–77.

19 The interconnected life of community/forest environment is described at length in Shiva (1989: 55–95).

20 Shiva discusses the inappropriateness of trees such as the eucalyptus:

> 'Greening' with eucalyptus is a violence against nature and its cycles, and it is a violence against women who depend on the stability of nature's cycles to provide sustenance in the form of food and water. Eucalyptus guzzles nutrients and water and, in the specific conditions of low rainfall zones, gives nothing back but terpenes to the soil. These inhibit the growth of other plants and are toxic to soil organisms which are responsible for building soil structure. . . . Eucalyptus as an exotic, introduced in total disregard of its ecological appropriateness, has thus become an exemplar of anti-life af-forestation. (1989: 81–2)

21 Similarly, for Hobbesian social contractarian theories, all communal relation-ships

> are implicitly contractual in nature and arise out of a desire on the part of individuals to advance interests that are 'presocial, nonsocial and fixed' in human nature. (Cragg, 1986: 37)

> Individuals should only come together in association when it is mutually

beneficial and only for as long as it remains profitable for all participants. . . . the marketplace is the community. It is the arena for contractual relationships to be formed when they mutually benefit the actors. (Iadicola and Ashton, 1987: 90)

References

Allor, Martin (1984) *Cinema, Culture, and the Social Formation: Ideology and Critical Practice*, unpublished dissertation, University of Illinois at Urbana-Champaign.

—— (1989) 'In private practices: rearticulating the subject/audience nexus', *Discours Social/Social Discourse* 2(1–2): 1–7.

Anderson, Benedict (1983) *Imagined Communities: Reflections on the Origin and Spread of Nationalism*, New York: Verso.

Bandyopadhyay, Jayanta and Vandana Shiva (1987) 'Chipko: rekindling India's forest culture', *The Ecologist* 17: 26–34.

Benhabib, Seyla (1992) *Situating the Self: Gender, Community and Postmodernism in Contemporary Ethics*, New York: Routledge.

Blauner, Robert (1972) *Racial Oppression in America*, New York: Harper & Row.

Cheney, Jim (1989) 'Postmodern environmental ethics: ethics as bioregional narrative', *Environmental Ethics* 11: 117–34.

Churchill, Ward (1993) *Struggle for the Land*, Maine: Common Courage.

The Circle: News From a Native Perspective, Minneapolis, MN: American Indian Center.

Clark, David B. (1973) 'The concept of community: a re-examination', *The Sociological Review* 21: 397–416.

Couture, A. M. (1993) 'Art for Earth's sake', *The Amicus Journal* 15(2): 24–7.

Cragg, Wesley (1986) 'Two concepts of community or moral theory and Canadian culture', *Dialogue* 25: 31–52.

Cronon, William (1983) *Changes in the Land: Indians, Colonists and the Ecology of New England*, New York: Hill & Wang.

Dallmayr, Fred (1984) *Language and Politics*, Notre Dame, IN: University of Notre Dame.

Deloria, Vine Jr. (1989) *Custer Died for Your Sins: An Indian Manifesto*, New York: Macmillan.

Ferre, F. (1989) 'Obstacles on the path to organismic ethics: some second thoughts', *Environmental Ethics* 11(3): 231–41.

Forbes, Jack D. (1979) *A World Ruled by Cannibals*, Davis, CA. DQ University Press.

Fowler, Robert Booth (1991) *The Dance with Community: The Contemporary Debate in American Political Thought*, Lawrence: University Press of Kansas.

Grossberg, Lawrence (1989) 'The formations of Cultural Studies: an American in Birmingham', *Strategies: A Journal of Theory, Culture and Politics* 2: 114–49.

Grossberg, Lawrence, Nelson, Cary and Treichler, Paula A. (1992) editors, *Cultural Studies*, New York: Routledge.

Habermas, Jurgen (1979) 'Moral development and ego identity', in *Communication and the Evolution of Society*: 69–94. Trans. Thomas McCarthy. Boston: Beacon.

Hall, Stuart (1980) 'Race, articulation and societies structured in dominance', in UNESCO, *Sociological Theories: Race and Colonialism*: 305–45. Paris: UNESCO.

—— (1985) 'Signification, representation, ideology: Althusser and the post-structuralist debates', *Critical Studies in Mass Communication* 2(2): 91–114.

—— (1986) 'Gramsci's relevance for the study of race and ethnicity', *Journal of Communication Inquiry* 10(2): 5–27.

—— (1990) 'What is this 'Black' in Black popular culture?' in Gina Dendt (1990) editor, *Black Popular Culture*: 21–33. Seattle: Bay Press.

—— (1992) 'Race, culture, and communications: looking backward and forward at Cultural Studies', *Rethinking Marxism* 5(1): 11–18.

Hebdige, Dick (1985) 'Some sons and their fathers: an essay with photographs', *Ten-8* 17: 30–9.

—— (1986) 'Postmodernism and "The Other Side"', *Journal of Communication Inquiry* 10(2): 78–98.

—— (1987) 'The bottom line on Planet One: squaring up to *The Face*', *Ten-8* 19: 40–9.

Hillery, George A. Jr. (1955) 'Definitions of community: areas of agreement', *Rural Sociology* 20: 111–23.

Hirst, Paul and Woolley, Penny (1985) 'Nature and culture in social science: the demarcation of domains of being in eighteenth-century and modern discourses', *Geoforum* 16(2): 151–61.

Hummon, David M. (1990) *Commonplaces: Community Ideology and Identity in American Culture*, Albany: State University of New York.

Iadicola, Peter and Ashton, Patrick J. (1987) 'What is community? A comparison of perspectives', *Humanity and Society* 11(1): 80–110.

Kamenka, Eugene (1982) 'Community and the socialist ideal', in Eugene Kamenka (1982) editor, *Community as a Social Ideal*: 3–26. New York: St Martin's.

Leopold, Aldo (1949) *A Sand County Almanac*, New York: Oxford University.

Lewontin, R. C., Rose, Steven and Kamin, L. J. (1984) *Not In Our Genes: Biology, Ideology and Human Nature*, New York: Pantheon.

Maines, David R. and Bridger, Jeffrey C. (1992) 'Narratives, community and land use decisions', *The Social Science Journal* 29(4): 363–80.

Martin, Biddy and Mohanty, Chandra Talpade (1986) 'Feminist Politics: What's home got to do with it?' in Teresa de Lauretis (1986) editor, *Feminist Studies/Critical Studies*: 191–212. Bloomington, Indiana: Indiana University.

Midgely, Mary (1983) *Animals and Why They Matter*, Athens, GA: University of Georgia.

Minar, David W. and Greer, Scott (1969) *The Concept of Community: Readings with Interpretations*, Chicago: Aldine.

News From Indian Country, The Journal, Lac Courte Oreilles: WI.

Ortiz, Roxanne Dunbar (1984) *Indians of the Americas: Human Rights and Self-Determination*, London: Zed.

Plant, Raymond (1978) 'Community: concept, conception, and ideology', *Politics & Society* 8(1): 79–107.

Radway, Janice (1985) 'Interpretive communities and variable literacies: the functions of romance reading', in M. Gurevitch and M. R. Levy (1985) editors, *Mass Communication Review Yearbook* Vol. 5: 337–61. Beverly Hills: Sage.

'Readings on James Bay' (1991) *Akwe:kon Journal* (formerly *Northeast Indian Quarterly*) Winter.

Rorty, Richard (1989) *Contingency, Irony, and Solidarity*, Cambridge: Cambridge University Press.

Ross, Andrew (1992) 'New Age technoculture', in Grossberg, Nelson and Treichler (1992): 531–55.

Saarinen, E. (1982) editor, *Conceptual Issues in Ecology*, Boston: Reidel.

Sandel, Michael J. (1984) 'Morality and the liberal ideal', *New Republic* 190(18): 15–17.

Schmitz, K. (1983) 'Community: the elusive unity', *Review of Metaphysics* 37 (December): 243–64.

Shiva, Vandana (1989) *Staying Alive: Women, Ecology and Development*, London: Zed.

Singer, Beth J. (1985) 'Dewey's concept of community: a critique', *Journal of the History of Philosophy* 23 (October): 555–69.

Slack, Jennifer Daryl and Whitt, Laurie Anne (1992) 'Ethics and Cultural Studies', in Grossberg, Nelson and Treichler (1992): 571–92.

Smith, M. G. (1965) *The Plural Society in the British West Indies*, Berkeley: University of California.

Smith, R. L. (1986) *Elements of Ecology*, New York: Harper & Row.

Warren, Karen J. (1990) 'The power and the promise of ecological feminism', *Environmental Ethics* 12: 125–46.

Williams, Raymond (1965) *The Long Revolution*, Harmondsworth, Middlesex, England: Penguin.

—— (1975) *Television: Technology and Cultural Form*, New York: Schocken Books.

—— (1976) *Keywords: A Vocabulary of Culture and Society*, New York: Oxford University Press.

Wines, James (1993) 'Architecture in the age of ecology', *The Amicus Journal* 15(2): 22–3.

Young, Iris Marion (1990) 'The ideal of community and the politics of difference', in Linda J. Nicholson (1990) editor, *Feminism/Postmodernism*: 300–23. New York: Routledge.

BARRI COHEN

TECHNOLOGICAL COLONIALISM AND THE POLITICS OF WATER

Quebec is a vast hydroelectric plant in the bud, and every day, millions of potential kilowatthours flow downhill and out to sea. What a waste! (Quebec Premiere, Robert Bourassa, 1985: 18)

Facing as we do our various Armageddons, they [Inuit] are a good people to know. (Barry Lopez, 1986/7: 181)

We do not believe. We fear. (Aua, Inuit Shaman)

I n a recent lecture in Toronto, Gayatri Spivak posed a set of questions concerning the limits and possibilities of 'countering' dominant discourses.[1] What are the practical, self-conscious fictions necessary for the creation of a 'counter' discourse or practice from those in positions of oppression? How can 'countering' disturb and displace the binary power relations of dominant/oppressed or centre/margin? Spivak suggested that counter discourses can be usefully viewed as participating in a form of political theatrics. The notion of 'theatre' in turn (reminiscent of *theatrum mundi*) requires the act of 'countering' in strategic though risky ways – involving, unavoidably, a kind of play with referents that, theoretically speaking, deconstruction has taught us to critique. In the most problematic sense, these 'risky ways' may involve articulating a discourse stitched from (re)appropriated Eurocentric notions of subjectivity, rights and justice, but which does not retain a critical consciousness about the treacherous and violent legacy with which these very terms are historically complicit.[2] But in a more strategic and politically efficacious way, 'countering' may involve deconstructive strategies or what Spivak called a kind of 'discursive homeopathy', where the Other takes up and makes visible the failed promises of the Enlightenmental discourse of rights and the public use of reason.

For the Other to claim a right to speak, for the land and one's historical relation to it (and to have that right recognized) no doubt involves a representational logic and a discourse of rights even when such invocations dovetail with known and often specious referents held, contained and regulated by dominant power. Those in relative positions of power and privilege, however, have a moral obligation to learn and attend to the

'theatre's' discourse of the Other through positions of what Spivak named 'ethical similarity', which I take to mean points of identification arising out of certain experiential encounters with the Other. This allows for ways of negotiating power relations and for ways of devising strategic political and cultural practices and alliances that may precisely aid and abet the necessary act of 'countering'.

I begin with this theoretical summary because I want to offer in this paper a critical engagement around my own attention and learning about a complex and over-determined environmental struggle that contains a particular set of 'counter' discourses. Specifically, I am referring to the contemporary struggle for cultural, political and environmental rights being waged in public and legal forums by native Cree and Inuit communities in Northern Quebec. Positioning themselves as traditional stewards of the land, these communities are attempting to defend the land against flooding by a vast hydroelectric project begun in the 1970s – a project now entering a large second phase of construction within their territory. It is a struggle that has unravelled a complex braid of conflict between radically different knowledge systems and representations about land and territory, progress and survivability, rights and justice – the latter two couplets hitched to differing commitments of nationhood and its attendant cultural and political desires. My intention here is to critically describe different sets of linked discourses and political strategies as they clash over a real place/space – the 350,000 square kilometres of land in Northern Quebec on the east coast of James and Hudson Bays. This place/space is crisscrossed with representational struggles: what the land means in public discourse to the Cree and Inuit differs significantly from what it means to the state of Quebec and its hydro utility, Hydro-Québec. It is a difference which will have real, material and historical implications for what may be done with the land and its 'resources' and by whom. It is also a difference that calls into question human and technological relations to and with the 'environment', 'nature', or the 'earth'.

Often called the 'Great Whale' (the Great Whale river system is slated next for damming), or 'James Bay II', this project is part of a larger and very costly ($45–60 billion) three-phase system of hydro-development. If all phases are completed (planned for 1998), it will reduce 'to servitude every major river flowing from Quebec into James Bay and southern Hudson Bay' (McCutcheon, 1991: 4). By the end of the century, the project may completely displace over 15,000 Cree and Inuit people, and flood an enormous area of land roughly the size of France. I will seek here to situate and describe native articulations which bring forth a self-conscious cultural-historical claim (as a natural and legal 'right') to the land. I am not referring here to arguments or claims and defenses of and for the land that simplistically rely on well-trodden logics of salvage, preservation and protection. Rather, I will seek to draw attention to the culturally specific epistemologies and desires that have arisen out of different historical claims to the land – claims which continue to place the Cree and Inuit, who have lived in Northern Quebec for some 5,000 years, against the descendants of seventeenth-century European

explorers, adventurers and settlers who have come to dominate and incorporate the land and its living things into the federal state of Canada, and into the provincial state of Quebec.

My texts here are pulled together from media, scientific, historical and cultural and ethnographic sources. From these I will describe a series of public statements, arguments and strategic tactics from which the Cree and Inuit[3] have stitched together a hybrid discourse premised on a number of terms: popular and romanticized notions of the earth, essentialist tropes of native culture and 'traditional' knowledge, and on claims to nationhood and cultural specificity enabled by the moral and judicial right to control the pace of social, cultural and technological change. My task here will be to try and tease apart the dense entwinement of competing identities, histories and knowledges that comprise the force fields surrounding James Bay – 'the biggest artificial environmental change in the history of the Western Hemisphere' (Vogel, 1991: A1).

Understanding this complex site and the nature of Cree and Inuit 'counter' discourses will require grasping some sense of the overdeterminants that bring this struggle into being: (1) the double colonial history of both English conquest of the French, and the Canadian state's century-old apartheid-style system of enclosing native cultures in reserve villages; and (2) the nation-state's economic histories and their link to rhetorics of nation-building. A brief tracing of these determinants is in order for this marginal area of the North, residing as it does within the borders of Canada, a country that has so aptly been described by Michael Dorland as 'thoroughly hidden' (1988).

Great Whale the river and place, is not its only name. A glance at most maps will not bear the language traces of its other names. In the practice of imperial cartography, power has a way of ensuring that those in governance not only literally claim and incorporate the territory, but erase pre-existent names given by its inhabitants. Signifying all that is bound up in the clash over rights to the land and its use, four names hover uneasily: Great Whale, Post-de-la-Baleine, Kuujjuaraapik, and Whapmagoostui. These are the English, French, Inuktitut and Cree names respectively, referring to 'great whale' or, as in the French, to 'whaling station'. The latter two names designate a place of nomadic occupation, a history and culture of hunting before the arrival and ensuing imperial English and French contests.

Great Whale is found on the map on the coast where Hudson Bay and James Bay meet, just south of the Arctic treeline in a transitional zone giving way from sub-Arctic forests to northern tundra. The two bays are the largest bodies of water in the world that freeze over each winter and become ice-free each summer. The watershed of the bays covers over one-third of Canada, 'from southern Alberta to central Ontario to Baffin island, as well as parts of North Dakota and Minnesota in the United States' (Canadian Arctic Resources Committee, 1991: 3). Together with the Great Whale river, the bays are integral to a large ecosystem comprised of boreal forests, lakes, bogs, muskeg. Beluga whales, freshwater ringed seals, over sixty species of fish, and countless habitats of migratory birds, caribou, beaver and bear are

all sustained in the region. In turn, the Inuit and Cree have been traditionally sustained there by 'country food' – marine mammals, fish and birds, and caribou and beaver. Great Whale the river and the place, marks a zone where the geography, ecosystems and ideas of the 'north' meet those of the 'south'. Despite 5,000 years of Inuit and Cree nomadic occupancy, and despite the unrelenting 'civilizing' influences in the region by a steady and subtly insidious influx of European culture and technology, the land is typically imagined as 'barren' or as a 'wasteland' by those south of the 55th parallel.[4] The Arctic and sub-Arctic regions have always been described this way, a practice that continues to mark the Arctic as ruggedly 'uncivilized' in the Canadian imaginary. The advance of power north and northwestward dates from, at the very least, the travels of imperial explorers and adventurers in the seventeenth century in search of the North-west Passage to China and India, and continued on to the mid-twentieth century *echt*-Canadian triumvirate presence in the North of the Hudson Bay company, Anglican missionaries, and the Royal Canadian Mounted Police (in essence: capital, religion and law). This colonial incursion has found its more contemporary expression in a range of government-led regimes of power that intractably presume ownership and control of the vast Arctic and sub-Arctic peoples, land, sub-surface minerals, and waters.

Using descriptions like 'emptiness' for the North reveals a necessary fiction required by power to precisely carry out the above-sketched catalogue of manoeuvres.[5] The material resources marshalled by the proponents of the Great Whale project (the Quebec state, trade unions, and the state-owned power utility) extend from Hydro-Québec's offices and snake down like its own river of influence to the financial houses of Wall Street and Washington. The state's hope is that electrical power will produce economic and political power for the province of Quebec, chiefly through the sale of over $20 billion worth of power to the north-eastern United States (New York, Maine and Vermont).[6] Undoubtedly, such resources are daunting in their political and affective pulls on the people of Quebec. They dwarf the resources and capacities used by the aboriginal peoples strenuously opposed to the project.

But before detailing such capacities, one must understand how the south and North have meaning for each other. The common use of 'north and south' in global environment-speak, stems from the United Nations division of the world as such. This dualistic framework represents the North en masse (principally North America and Europe) as (over)developed, mixed capitalist economies which exploit every human and non-human dimension of the apparently underdeveloped ('Third World') south. This configuration, however, becomes utterly meaningless when thinking about Canada, because the descriptive terms and their values are inverted: the North is the place of exploitation. Its presumed emptiness is mapped over and displaces the sparsely populated occupants. The very word 'North' (which demands its own critical commentary) is capitalized as a proper name in most native, Canadian government, land-claim, public policy, scientific and geographical texts, signifying it as an object of knowledge and surveillance in the

spatio-political consciousness of Canada if not North America. The south, on the other hand, bears a lower-case, connoting that its power is dispersed across the nation, and hence dominant.

Crucial to the history of northern exploitation is the enabling ideological portrait of the native occupants as 'noble savages' – a representation ascribed to 'Eskimos' since before Robert Flaherty's 1922 documentary, *Nanook of the North*. It is founded on the explorers' fascination with the Inuit ability to survive with what appeared to the Europeans as simple, even crude tools, in what they took to be the harshest climatic conditions on earth.[7] Noble or not, however, Anglican missionaries, military personnel and developers henceforth went into the region under the paternalistic guise that *'they* need *us.'*[8] Given the structure of twentieth-century neo-colonialism, it isn't at all surprising that this 'need' did not produce any opportunity for Inuit and Cree, along with other native groups (Dene, Inuvialuit and Innu) to obtain sovereign political and economic power.

But there is another history of domination, another set of power relations that undergirds the site of James Bay. For the south also contains the wounds of Quebec's struggle for independence from anglophone Canada. In other words, the province of Quebec has claimed itself to be the colonial victim of British colonizers. Its political desires have fashioned a seemingly homogeneous quest: the state must sustain itself economically, and, in doing so, it will secure its cultural and national survival. Quebec's nationalism, however, does not comprise a fixed, unified discursive field; rather, it is fraught with competing visions and arguments for ways in which state sovereignty or independence is to be achieved. These are too variegated and complex to be described here. What is important to observe, however, is that in its dominant, contemporary form, sovereign power is ideologically presumed by the state to be possible only by engineering the economy through development projects like James Bay/Great Whale. Entwining technology, power and nationalism in this way has been the singular mission of Robert Bourassa's liberal government since first elected almost twenty-five years ago. The banality of this fact was once expressed by a CBC television journalist: 'For Bourassa, supporting James Bay is like a form of Quebec patriotism' (CBC, 23 April 1990). As Bourassa himself said in an interview to writer Sean McCutcheon:

> If we want to be a proud, strong people . . . it's not with independence we will achieve that goal, it's with economic strength. Where [could] Quebec increase its economic strength? It's with its natural resources, which are almost illimitable. Where [are] those natural resources? . . . the North. (1991: 30)

Within the logical terms of this entwinement, opposing the project is *ipso facto* tantamount to a traitorous act against the province's nationalist communitarian aspirations.[9] The structuring absence at the heart of these aspirations has been that of the native communities. A grim illustration of this: Cree and Inuit only learned about the James Bay project in the 1970s by listening to the radio and reading news reports. For others, learning about

the project came about through discovering Hydro-Québec engineers and surveyors working on the land one day. For instance, Sappa Fleming, Inuit Mayor (former) of Kuujjuaraapik remarked on the effect this had on his community:

> Hydro-Québec was just the government at that time – we thought it was a government . . . we didn't know it was a utility, it was a corporation. We thought it was a big government coming in, wanting to work on the land. But it was an organization quite different from the government, and – coming in, being dominant, having their corporation do research, bringing [in] a lot of money, [they said] that, 'sorry, you have to start another life, another way of life, and that you have to leave in order for us to work.' It's done a lot of damage to our culture – just too much that we say 'no', we've had enough of that. We thought at that time that since they are the boss, that they have a right to do that. We didn't know at that time that we have a right to say 'no'.[10]

At the time of the project's initial phase (at La Grande river), the Cree and Inuit deployed the public use of reason in the form of legal recourse. This resulted in a temporary injunction against the project. It also created a legitimation crisis for the province. Quebec was compelled – both legally and pragmatically – to negotiate a land-claim agreement with the Cree and the Inuit (known as The James Bay-Northern Quebec Agreement, 1975). It was the first modern land-claim agreement in Canadian history, one completed at great speed (eighteen months, compared to what has now become the usual length of time, five to ten years) (Diamond, 1990). It is a document that discursively and legally constituted the Inuit and Cree as distinct peoples and communities. Indeed, not unlike most native groups in Canada, the Cree and Inuit did not think of themselves as constituting a 'community' (as distinct from 'people') – the literal translation of the word 'Inuit' – prior to signing this document – let alone one which permitted them to speak collectively about rights as an abstract possession. Thus, amongst the contentious benefits of the Agreement was the involvement of Inuit and Cree in precisely such a discourse. As Fleming is quoted above, 'we didn't know at that time that we have a right to say "no".' In return for monetary compensation and the promise of 'modernizing' the newly constituted communities (with schools, health clinics, regional councils), the natives ceded right to 80 per cent of their land – the very concept of possession and ownership being a necessary condition of entering into the negotiations at the outset. As well, Inuit and Cree negotiated the right to have some unspecified, consultative role in future development projects.

My narrative here greatly truncates and collapses a complicated set of histories and struggles. The myriad contradictory cultural, political and social effects stemming from the outcomes of the Agreement alone would require extensive analyses, far beyond the scope of this paper. For the purposes here, it is enough, I hope, to have provisionally traced some of the positions of power and interest at stake, where they have arisen and why. What I want to underscore at this point, is *not* that the Cree and Inuit were

constituted as existent 'communities' ontologically as such, as though they were not 'communities' in the everyday sense prior to their negotiations with Quebec, but that they were so constituted – and abstractly so in Euro-centric discourses of reason and justice – precisely *for* the benefit of dominant power. Without such a construction of a homogeneous, native community with recognized rights, the province of Quebec and Hydro-Québec could not have entered into a negotiated land-claim agreement called The James Bay-Northern Quebec Agreement. In turn, without this legal instrument, state power could not have secured – 'legitimately' so from the perspective of the state – the right to deploy its power over the Northern peoples and territory. But as I will later argue, this constitution of a native community has had an unintended, strategic effect: it has become a crucial representational, ingredient or tool in the oppositional politics and articulations designed and deployed by Cree and Inuit, their various leaders, dissidents and spokespersons.

There is, finally, another level of determination in the force fields of James Bay II/Great Whale, and it is one which concerns Canada's own history as a colony with a staple-dependent economy. Expressed in the oft-cited phrase, 'hewers of wood, drawers of water', the nation-state has restructured whole ecosystems through large-scale public-works projects in order to produce energy for private capital. Michael Keating tells us, for instance, that 'Canada diverts more water than any country in the world, but very few of us realize it' (1986, cited in Nelson, 1992: 177). Prior to James Bay, the most significant feat of North American engineering occurred with the Kemano project, built in 1954 within northern British Columbia. In this instance, the BC provincial government did not build Kemano, Alcan Aluminum did, but the government had to first give the company – *gratis* – all water, land and sub-surface rights (mineral, oil, etc.). Alcan secured in return a ready supply of cheap power for their aluminum smelting plant located upriver from Kemano, as well as *carte blanche* to develop BC's north. Post-war ebullience with expansion and progress captured the BC government's imagination, enthralled as it was by the man-machine dynamo of gutting, digging, cutting and reshaping the 'wilderness'. This reshaping included forcing the Nechako river's easterly flow backwards west to the Kemano project.[11] Native villagers along the Nechako river were relocated, their lands flooded. There were no negotiations with the government; no promises, no land-claim agreements. One must be accorded the status of a subject with rights and claims to enter into such a discourse. It would be nearly four decades before such recognition was even countenanced by the current BC government.[12]

To provide some provisional closure around this history, it is important to note that post-war expansion in Canada led to the military, technological and ideological enclosure of the North, specifically through the frontierist adventure of extracting its delicately nestled minerals and oils, plumbed for their status as 'resources' for production. As Alexander Wilson has described it, such public-works projects, and the military complex to which it bears intimate connection, can be thought of as 'environmental architectures'

which have restructured the North as one of the last 'frontiers of capital' (1991: 282). He goes on to catalogue the signs of this restructuring:

> The North is a crucial site for the conflict between industrial society and everything pitted against it. . . . Now it too is highly technologized, its natural features overlaid with oil-drilling platforms, pipelines, military communications facilities, jet airfields, NATO and NORAD practice-flight ranges, lead, uranium, and asbestos mines, hydroelectric projects, as well as radioactive garbage dumped from space. . . . In this new and perhaps last colony of industrialism, modern resource extraction has restructured entire environments. (Wilson, 1991: 282)

The plans of Hydro-Québec and the will to power of the Quebec state are entirely consistent with this Canadian history of a staple-dependent economy and the frontier capture of the North.[13] Such plans, of course, bear excruciating resemblance to pan-imperial practices carried out by other nations of the West. But they are also expressive of another dimension of Canadian specificity, and this concerns nationalist discourses and their relation to technology and the land. I refer here to what Maurice Charland has described as the fundamental ways in which technology in Canada has been historically constitutive of nationhood. Charland contends that Canada is ideologically valorized as a nation precisely 'because it is the product of a technological achievement', principally through transportation and communication. It is an 'achievement' accomplished by a 'rhetoric of technological nationalism' that is 'insidious, for it ties a Canadian identity, not to its people, but to their mediation through technology' (1986: 197). Charland is careful to locate this rhetoric in the anglophone imagination, but I would argue that the goal of James Bay, if it is not to bring into existence a *polis*, certainly is to create a self-sufficient, economically viable nation. Indeed, Quebec's determination to wrest sovereignty from federal state power has preceded construction of the project. With emphasis on collective will through conquest, Premiere Bourassa re-tools Quebec's historical status as Canada's dominated 'other' into a discourse demanding, as a right and destiny, the legitimate expansion of power. As he has written with stunning imperial clarity in his manifesto on James Bay:

> [T]he conquest of northern Quebec, its rushing, spectacular rivers, its lakes so immense they are veritable inland seas, its forests of coniferous trees . . . the whole history of Quebec must be rewritten. Our ancestors' courage and will must live again in the twentieth century. Quebec must occupy its territory; it must conquer James Bay. We have decided the time has come. (1973: 10)

For Charland, the technological mediation of nation-building has been specifically tied to a Canadian articulation of European liberal pragmatism. Technology is conceived as a neutral medium, which is fused to an entrepreneurial spirit, heralding expansion and progress for its potential to bring the state into being. Crucial to its liberal form is the presumption that

collective interests are served, while the fundamental tenant of liberalism itself 'ideologically conceals a set of power relations' (Charland, 1986: 216). On this point, it is no mere historical coincidence that Quebec Premiere Robert Bourassa leads a liberal government which has often been described in the critical press as 'technocratic' in its drive to seek sovereignty and secure cultural identity (and French-language rights) by whatever techno-logical and social-engineering means necessary.

With respect to the James Bay development, opening up the region to the technological gaze of Hydro-Québec produces the nation not only in Harold Innis's space-binding sense (1951), but also in a space-displacing way. Both modes have their contradictory and overlapping influences. To elaborate, with phase one of the project already operating over 1,400 kilometres north from Montreal, peoples and places once spatially remote are now brought into purview in several ways: juridically and ideologically (in The James Bay-Northern Quebec Agreement); economically, through both the estab-lishment of a land-as-commodity exchange with the Cree and Inuit, and through the influx of labour from the south; and geographically, through the constitution of a place (e.g., La Grande river at Radisson) as a destination for workers via the newly created roads, airports and related transportation infrastructures. Above all, the apparatus of James Bay has thus far brought into tenuous being those who had been thoroughly marginal: real people, villages, communities, burial grounds, hunting and trapping lines and scores of living forms that have not yet been fully categorized by official science (Makivik Corporation, 1991). I write 'tenuous' because the displacement of all of these things, organic and inorganic, is consistently courted by hydro-development and its proponents. Displacement, profound reorganiz-ation and, quite possibly, erasure.

Locus of the irreparable[14]

> We played the *Dances with Wolves* card. (Mathew Mukash, Cree Chief, Whapmagoostui)[15]

I referred above to the contradictory effects of bringing the James Bay region and its peoples into purview and dominant discourse. For something else came into public discourse and into scopic view. By this I mean a 'counter' discourse that entailed the Native construction of themselves as stewards of, and hence activists for, the land, environment and its diverse ecosystems. It is a construction that gathered about itself wide print and television news coverage (not to mention at least four international documentaries), almost entirely sympathetic. As well, Native 'counter' discourses brought into public purview the historical fact of their colonial status, a fact that was articulated to the widely perceived need to 'save the land'. This, at the precise conjunctural moment when a plethora of popular films, like *Dances with Wolves* and *Thunderheart*, books and magazine articles, as well as a set of political and environmental contests, all attested to dominant power's *rapprochement* over the marginalized history of North and South American colonialism and the violence perpetrated against Native cultures. In other

words, a central condition of possibility for Native discourses was the framing of ethics and justice in a historically situated way. Spivak's invocation of 'theatre' is useful here, for it captures the various complex roles, interests and power struggles at work at any particular moment of oppression. It also suggests the very conscious act of role-playing, however partial; of donning a kind of dramatistic mask and strategic 'script' through which collective interests might be met.

As measured by the popular sentiments expressed in north-eastern United States college campuses and concerts led by Jackson Brown in New York's Washington Square, the Cree initiatives created a vast network of strategic alliances between two conceptual geographies: North America's 'North' and 'south', and the United Nations' North and South. The alliances extended from the UN Working Group on Indigenous Populations in Geneva, International Indigenous Commission, to environmental groups and coalitions across Europe and North America. These initiatives simul-taneously made possible and were made possible both by this conjunctural moment, and by the extent to which ideological assumptions bound up in the Native/earth equivalence held central, persuasive purchase. As McCutcheon has put it, 'the hope [was that] if the Crees and other indigenous peoples were to exercise control over more of the land they claim, they might slow the growing despoliation of the planet' (1991: 157). Indeed, similar sentiments have been expressed by the International Indigenous Commission:

> Systems [of knowledge] are based on a spiritual connection with the Earth and an understanding of the interconnectedness of all nature. . . . The Indigenous Peoples share their knowledge of the Earth that is based on an understanding developed over thousands of years. We need to *project and share this information, before these ecologically fragile systems are destroyed*. . . . Indigenous Peoples are the bridge between the traditional wisdom of Earth stewardship and modern technology and science. (Ahiaba, 1991: 1–2; my emphasis)

'Playing' as Mathew Mukash claims, the '*Dances with Wolves* card' allowed the Cree and Inuit to articulate their discourses strategically to concerns about the global environment and its relationship to critiques of industrialism and colonialism. Since plans for the second phase of develop-ment were formally announced by Robert Bourassa (8 March 1988), the Cree have threatened to block the project's construction in a variety of ways; for example, lying down in front of bulldozers, shooting at helicopters, toppling transmission lines, occupying substations. However, much of the opposition has been waged rhetorically. In meetings with United Nations Human Rights committees; through world court addresses; and countless travels to the south's environmental and university forums and Earth Day events, the young, telegenic Grand Cree Chief, Mathew Coon-Come, has forged a discourse that pits good against evil: the Cree and Inuit against Quebec and Hydro-Québec, and with it, implicitly, 'nature' versus capital and the West. 'Bourassa's dream is our nightmare,' he has said over and

over, forewarning listeners of irreparable harm to 'his people' and 'Mother Earth'. What more properly is at stake here and how has it been framed? It is a rich set of discourses, which I will loosely organize into three main areas: the meanings and values of the land (acquisition versus occupation); the construction of 'traditional' knowledge versus Western science, and the different ways 'nature' and physical and cultural survival have been framed. I draw my sources henceforth from arguments and questions Cree chiefs have posed publicly to 'whites' in the south, and upon Inuit public hearings about Great Whale conducted for themselves.[16]

No doubt, my turn here is fraught with epistemological pitfalls. After all, who am I to speak about aboriginal peoples, the Other of Canadian history *par excellence*? But to not write or speak about something which Inuit and Cree themselves have publicly written and spoken (and in ways suggestive for thinking differently about 'nature', 'justice' and 'progress') is to put too fine a deterministic point on the strictures of identity politics. Epistemological determinism of this kind also forecloses on the possibility of thinking through a set of articulations posed by the very marginal and environmentally threatened communities with which people not of these communities are prevailed upon to enter an alliance, recognize common desires and claims, or hold something as old fashioned as solidarity. As Jennifer Daryl Slack and Laurie Anne Whitt argue, in the conceptual frame of environmental ethics 'the other is never completely "other"' when the concept of a 'biotic community' is countenanced (1992: 586). The concept of a biotic community itself challenges the differential logic of singular identity, same/other self/other, since, by definition, we are all, at the very least, implicated in 'the semiotic place called earth' (Haraway, 1992: 315).[17]

In many ways, this was the initial message delivered by the Inuit and Cree in 1990 when they first appeared on the television screens and in newspapers as diverse as the *Montreal Gazette* and *The New York Times*. In the spring of that year, Inuit and Cree activists from Kuujjuaraapik and Whapmagoostui respectively, fashioned a hybrid craft – a canoe/kayak they named Odeyak, which they paddled down the Hudson to arrive in New York City for Earth Day (23 April). It was an 'event' occasioned by the Cree and Inuit awareness that to counter Hydro-Québec's plans and arguments they would have to have in place a coherent and simple set of public messages.[18] Once on the shores of the toxic Hudson harbour, Mathew Coon-Come and Sappa Fleming issued a warning to Premier Bourassa, carried by major US television networks and Canada's CBC and CTV networks: 'Our future is in your hands.' Referring to the impact the first phase of development had on Cree land south of Great Whale, Coon-Come further stated that 'hydroelectric power is flooding the land, destroying wildlife and killing our people . . . eventually, we will all be victims.' New Yorkers were told by Robbie Dick, former Chief of Whapmagoostui, that 'when you turn on your switch, you're killing us' (cited in McCutcheon, 1991: 186).

This linkage of mutual implication and responsibility between North and south, between industrial development and capital – across cultures and

expanses of land – has Coon-Come and others advancing arguments to prove that life forms on which they have depended and with whom they feel connected, have died, are dying, will die. What has been lost, what will be lost, what may never be attained. First, Coon-Come is careful to draw attention to what is environmentally at stake for the region. I quote verbatim, from one of his addresses:

> In our own backyard we have the largest hydroelectric project and it's flooded 11,000 kilometres of land, and it's displaced and relocated our people. It's diverted and dried up rivers; destroyed the spawning grounds of our fish and our fish are contaminated with mercury. It's destroyed nesting grounds of our water fowl. The land is sacred to us and we had fought to stop James Bay I, and we are now fighting James Bay II. We have not had time to get used to the destruction, the re-shaping of our landscape; we need to heal the land.[19]

He then roots this sense of the irreparable in a narrative of Cree cultural history, and in a conception of nature, distinct from that of Western practice. It is a narrative that bears points of correspondence with a long-standing conception of Native culture as 'closer to the earth', predicated not on acquisition, but on ownership through stewardship and a harmonious relationship with other organisms:

> These projects will destroy our hunting lands and destroy animal habitats forever. My people are people of the land. They have occupied the land since time immemorial. We depend on the land for our substance and our resources. It is our territory; it's our homeland. . . . It's not easy when you get off a plane like I did and I saw my young nephew, who is only 15 years old. He was taken out of school because our people believed they could teach him a way of life different maybe – that he could live off the land to hunt, fish, and trap. That he too can carry on the customs, that there may be someone who can carry the old values and the tradition. When I got off that plane, he had just come back from the hunting ground, and he handed me a fish with a nice smile, and he said, 'this is for you uncle because I know you will have a feast for your child.' And he turns over to his aunt, and says, 'here is a beaver for you, 'cause you're gonna have a walking-on ceremony in the spring.' When you kill an animal there is a whole ceremony, you give back what nature has given you. It may be difficult for you to understand.

Coon-Come's rhetoric also directly links the condition of threat to a neo-colonial framework:

> The rivers are 900 miles away from Montreal, if these dams were proposed for the Ottawa river or for the rivers in southern Quebec, they would be stopped by public outcry. It is only because these rivers are so far away, on Cree and Inuit land, that Hydro-Québec has been able to

proceed so far. We are the only people there. What we have in northern Quebec is a form of environmental racism.[20]

The contradiction courted here, however, is that 'environmental racism' has a legacy that can be located precisely in the same set of implicit equivalences of native/earth/non-civilized upon which the Crees' moral highground is based. This, I maintain, is the risk of articulating a politics of resistance to Eurocentric referents. It is risky because harkening back to a real or imagined harmonious time permits power to counter with an overly familiar narrative of its own: you were once 'traditional', now you are not. As Virginia Dominguez tells us:

> Canadian Indian/First Nations activism seeks to expedite resolution to their land claims and push for greater political control. What happens, probably unplanned and unintentionally, as Evelyn Legare has insightfully noted, is that 'in order to legitimate their claims to Indianness, both in their own eyes and those of other people with whom they share national boundaries . . ., aboriginal peoples must maintain and retain their aboriginal cultures'. (Dominguez 1991: 15, citing Legare, 1991: 60)

The problem here is that activists are continually forced to deny any influence of Euro-Canadian modernity on their culture. In analyses of the European animal rights movement, George Wenzel argues that their rhetorical and material attacks on Inuit hunters derive from an inversion of the traditional, anthropological telescope. Native groups are judged and their attempts to argue and defend some link to their history are silenced because they are now 'just like us southerners', since artifacts of, say, Inuit history are not part of 'the visible present'. He states:

> Images of dogteams and snowhouses, harpoons and predator-prey ratios, and wardrobes of 'traditional' sealskin clothes are established and then compared to the snowmobile and rifle that equip Inuit today. . . What is distant is good, what is contemporary is bad because it has been tainted by modernity. (1991: 6)

Cree and Inuit, however, both insist against a static reification of cultural identity. Their identity need not be vanquished by the occurrence of a hybrid assimilation of certain Euro-Canadian influences. That they are in constant negotiation with the positivities, tools, technologies and strategies of dominant power should not be used as grounds to deny them the right to assume the role of sovereign subjects on behalf of historically determined systems of meaning. Donna Haraway illustrates this point when she describes, for instance, an incident of the filming practice of an Amazonian Kayapó man protesting hydroelectric development in Kayapó territory as the engagement of an 'entertaining contradiction – the preservation of an unmodern way of life with the aid of incongruous modern technology.' She goes on to argue that indeed this contradiction renders nonsensical the categories of unmodern/modern since, if there 'is no nature and no society, there is no pleasure, no entertainment to be had in representing the violation

of the boundary between them' (1992: 314). Pointing out the possibility of 'no nature and no society', Mathew Coon-Come tells us that:

> For Cree society, the task that lies ahead of us is to find a way to reintegrate our old value systems into the modern context . . . I'm not anti-development, but I am against irresponsible development, and diverting eight more rivers is unacceptable and irresponsible.

Mary Simon, former president of the Inuit Circumpolar Conference goes a little further:

> My people think that it's important to be comfortable, that they don't really want to go back to living in snowhouses. It was a harsh way to live. But when you're talking about your culture you're talking about your very being . . . it doesn't matter whether we have a nice house. We still spiritually and otherwise identify very closely to the land and the environment and the resources that we depend on to live. So it's not one or the other. We have something to contribute in terms of trying to maintain a balance between preservation and development.[21]

The complex specificities of experience and situated knowledge Cree and Inuit name as 'traditional' are positioned front and centre against attempts by the state to forge a technological colonialism demanding acquiescence. It is a kind of knowledge that, as Ahiaba argues, 'must be shared' and taken into account when making judgements about environmental degradation. Central to the struggle in 1990 and 1991, for instance, was the public emergence of radically different views aligning the Cree and Inuit against Hydro-Québec over what constitutes 'appropriate' environmental impact studies and how they are framed.[22] This implicitly drew attention to the fundamental faultlines of Western epistemology, involving the displacement of nature as an object of study distinctly apart from humans. This legitimation problem arose over, more specifically, which 'biotic' communities should be studied and how, because the land and waters in question are so vast.

A concrete example of the Native critique brings the tensions into focus. Hydro-Québec informed the public (in December 1990) that two separate environmental impact studies would be conducted by their own engineers and scientists prior to the damming of rivers, which were, at the time, slated for construction in 1993. One general study would be of the roads and related access infrastructure, and the other would examine the impact of large-scale damming and diverting of rivers around Great Whale. This divide and conquer logic was meant to trigger an initial phase of research into infrastructure construction, which they were certain would meet environmental standards (i.e., those of the Quebec government). Should a separate review of the damming itself lead to calls for suspension of the project, Hydro-Québec could claim that it should proceed in any case, since, after all, construction of roads and airports had commenced. In other words, why build roads and airports in the region if they do not lead anywhere?

This atomistic logic, and the kinds of practices and procedures that would flow from them were strenuously fought by the Cree and Inuit who demanded a total, interconnected approach to looking at the diverse ecosystems involved – one, moreover, that would privilege their own knowledge of the land, animals and waters, since, they argued, '[we] know this area very well', having been here 'even before the white man came hunting – living and hunting in the area' (Charlie Sappa, Inuit hearings). This critique of dominant power's mode of knowledge production was not only focused on the question of territory and geography (which region is the primary region of impact?), but in terms of looking at the natural, cultural and social cumulative impacts of every aspect of the project – from researchers 'leaving their garbage on the land' (as Sappa Fleming among many others contended at the Inuit hearings), to what happens to a community when it is opened up to the south by roads and airports, to the impact on sea mammals and Cree and Inuit travel routes when changes in the sea currents and the timing of winter freeze-up take effect. 'No one really knows what exactly will happen, and yet they want to proceed anyway,' Mary Simon claims. Questioning the very notion of boundary and ownership. Mathew Coon-Come argues that:

Whatever they do there, we are not bound by boundaries of what happens to the environment, or by voters, or by provinces, or by Canada and the US. You know, when the geese come flying up from the US to their nesting grounds in James Bay, they don't say, 'oh, oh, we are now in Canada.'

Land, territory, the sense of place and experience – these are expressed in relational terms. They are common-places and constructs which run together in a double articulation – not unlike, perhaps, the sense in which Donna Haraway means when she argues that nature can be articulated as both '*topos* and *tropos*' (1992: 296). Things, that is, which are publicly espoused and claimed by Natives to organize their experience. Land is something one belongs to and with. Willie Tooktoo's remarks at the public hearings are instructive here:

It's really the wildlife that is going to be affected. We know it is going to be affected. Sometimes the river, the universe itself, has its own natural way of destroying things. We are aware of this. When they make the reservoir, it's going to destory our wildlife, our food chain, our vegetation, seals, affect the sea currents. And also the contaminants and the trees . . . once the trees are drowned they will build up poison. I hunt a lot, I rely on country food only. That's my way of life and that's what I grew up with. I eat it daily. Those people, especially in my age group are going to cry for this food. All our youth and our future generations – we have to make good plans for our future and respect our land and keep it clean.

The most singular consequence of flooding land, the one most easily grasped by those in the south, is the verified problem of mercury poisoning.

Drawing on lived experience with the first phase of hydro-development in the region, Pauloosie Angutiguluk tells the public hearings:

> The fish near the project [first phase] were rendered inedible by the mercury contamination of the reservoir. We now have to travel about an hour by plane before we can fish for fish that has not been poisoned. (August, 1991)

Angutiguluk is referring here to the large-scale decay of drowned trees which releases a deadly methyl mercury that moves through the food chain.[23] This was an occurrence that Hydro-Québec did not predict. It is here that the Cree and Inuit drive their wedge of doubt. As Isaac Anawak asks, 'regarding the endangered species, the ranger seal, the beavers . . . what's going to happen to them? Are they going to be contaminated by mercury? . . . or are they going to be exported like people are always relocated?' To these concerns, Hydro-Québec has responded that technical, pragmatic solutions can be implemented. Part of Hydro's technical solutions in fact do involve relocation plans, as well as the shipment of fresh fish. In addition, the problem of mercury poisoning is contained as the 'cost' of development, which will, they predict, drop off over a twenty-year period.[24]

This struggle over knowledge made manifest a 'crisis' that had to be 'managed' by the politico-legal institutions of the federal state. In the summer of 1991, the Cree and the Canadian Arctic Resources Committee (along with Makivik Corporation as intervenor), argued in Federal Court that the Quebec government had broken the law by flagrantly ignoring provisions in The James Bay-Northern Quebec Agreement for a global review of environmental impacts – one which would take into account 'direct' and 'indirect' (social and cultural) impacts. 'Global' as well, in the sense of combining research into cumulative impacts caused both by setting up roads and airports and building dams and reservoirs. In September of that year, the Court ruled in favour of the Crees, thus compelling the federal government to take over from Quebec and combine all assessment procedures and public hearings (Makivik Corporation, 1991: 5).[25]

The division of life worlds into social, political, cultural and environmental categories is a taken-for-granted practice in discourses of the West. But for the Native opponents of James Bay II/Great Whale, these categories run together in an inextricably linked web of necessity, survival and knowledge. Resistance can be measured by their refusal to reproduce these categories as separate objects of reified inquiry. This, I believe, is what Ahiaba intends when she says that '[s]ystems [of knowledge] are based on a spiritual connection with the Earth and an understanding of the interconnectedness of all nature.' (1991: 2)

Repeated demands by the Cree and Inuit for cumulative impact studies can be thought of as 'counter' strategies that explicitly contradict Euro-Canadian epistemological assumptions about the land in three related ways. First, what is suggested by the spectre of such studies is that, of course, they could well be useful in demonstrating a dizzying array of biotic effects, yet

the Cree and Inuit simultaneously caution that it is not possible (or even desirable) to actually attain full, certain truth or knowledge about their land (as Mary Simon intimates above). In other words, they have used, in part, the discourse of science to underscore its very epistemological limits, claiming to speak for the land in a representational logic, while denying the very possibility of a complete 'real' representation. Secondly, by articulating a concept of 'cumulative', the Cree and Inuit implicitly call on 'us' in the Euro-Canadian/American south to re-think how we conceive of 'nature' itself – the objects and things bounded by it and their complexly linked relations. This line of questioning and critique puts into sharp focus the investment dominant power and capital has in maintaining and managing the constructed boundaries between separated life worlds, with nature overdetermined historically, discursively and technologically as 'other'. Thirdly, Cree and Inuit 'counter' discourses made explicit reference to 'our land' in ways suggestive of concepts of acquisition and ownership – referents dominant power would immediately grasp. Yet, they disrupted the stability of the conventional concept of ownership (in terms of public or private property rights). An analogy was drawn quite clearly, particularly in Coon-Come's rhetoric: total mastery of biological systems we call 'nature' – mastery in knowledge of and technological application to humans, animals, lakes, rivers, and land – is a dangerous impossibility, much as the fantasy of limitless production and consumption is.

In analyzing this dense site and attempting to travel through its various tributaries, I have taken for granted that 'nature' and our relations within it are socially, culturally and technologically mediated. This is now a commonplace stance within cultural studies. As Richard Ashby states:

> Neither fully a positive entity nor an unmediated object of knowledge and experience, 'nature,' notwithstanding its noumenal substrate, is first and foremost a political and epistemological category, a vector for inter-penetrating regimes of power/knowledge: science, religion, economics and industry, technology, morality, gender, nation and so on. (1993: 61)

The systems of knowledge brought into the Cree and Inuit theatre of counter discourse used referents that dominant power would instantly recognize: marshalled around competing notions and claims for and about 'nature'/nature, they derive from an over-determined social and colonial history that presently constructs Great Whale/Kuujjuaraapik/Whapagoostui/Poste-de-la-Balaine as a place of indeterminacy. The territory is a place of Cree and Inuit habitation, history, myth and technology, while for southern power it is 'barren land' and 'wilderness', passively awaiting further conquest.

I refer here, and finally, to nationalist discourses. One of the obvious ironies of this struggle is that Quebec's claim to cultural and economic sovereignty uses a dated, industrial strategy to disempower similar claims advanced by northern Quebec Natives. That the Cree and Inuit seek to possess more juridical power at the federal level, as protection against that very industrial strategy in all aspects of their lives, is the complicated and

contradictory outcome of a treacherous dialectical process. As for Quebec's nationalism, Ernest Gellner is correct, Edward Said argues, when he says that 'having a nation is not an inherent attribute of humanity, but it now has come to appear as such' (Gellner, 1983: 6, cited in Said 1993: 192). Indeed, no humanity, to use that hoary old term, nor recognition of an 'ethical similarity' in Spivak's sense, exist in the political and environmental mediations between the state and northern Quebec Natives.

Those who have access to naming what 'nature' is, usually do so, Ashby points out, in ways 'coextensive with the power to define how things ought to be' (1993: 28). Struggles over 'how things ought to be', however, can involve much more than what is to be done on behalf of the intrinsic connectedness of human and non-human organisms. A way of understanding the complex meanings and potential environmental, political and ideological effects of the James Bay bioregion, has been enabled by Native strategic discourses and articulations, which have displaced the power of the state to name and claim 'nature' and what is to be done with it. In other words, the Cree and Inuit have countered multiple efforts of disempowerment with historical, ethical and practical claims about the hidden entwinement of nature, culture and power.

Notes

I am grateful to Jody Berland, Kevin Dowler, Shonagh Adelman and David Ellis for their encouragement and critical attention throughout the preparation of this article.

This article is, in part, the outcome of research initiated in 1990 for a documentary film project on environmental degradation throughout the circumpolar regions.

1 Gayatri Spivak, 'Can discourses be countered?', public lecture, Toronto: York University, 25 February 1993.
2 Think here, for instance, of the rise in fundamentalist discourses and practices that are politically and historically contradictory: both violent and critical of Western imperialism, but which quite evidently make use of notions of cultural specificity and collective rights.
3 The alliance of Cree and Inuit communities is quite complicated. While Cree have developed a representation of themselves as homogeneous and united vis-à-vis the Great Whale project, the Inuit response has been, in fact, split between official, represented power and what could be called 'grass-roots' representation. Official Inuit political/economic representation is retained by Makivik Corporation which was formed out of the $90 million compensation they received for their aboriginal land claim. Because Makivik is negotiating with the Quebec state for more compensation, they have tried to intimidate grass-roots Inuit to silence their opposition. This has caused a painful set of effects on those living in the communities and villages of Kuujjuaraapik, Inukjuak, Umiuaq, Povungnituk, amongst others, most prominent of which is the extent to which Inuit solidarity with their Cree neighbours has been alternatively misrepresented and muted. Certainly such alliance has been virtually absent in news-media stories, so eager have the media been to perpetuate the long-standing fictive distinction between the 'smiling, innocent Eskimo' and 'the savage, cunning Indian' (Brody, 1987: 21). The historical

relationship between Cree and Inuit themselves is quite complicated and beyond the scope of this paper. For a few indications however, see Cree Chief Billy Diamond's article, 'Villages of the dammed: The James Bay Agreement leaves a trail of broken promises' (1990).

Emphasizing the notion of 'Inuit practicality', Makivik leader Charlie Watts has made it clear that the Corporation is technically opposed to building the project, but if it is to go ahead, then the Inuit people should be positioned (i.e., should not alienate the Quebec government and Hydro-Québec) to 'get something out of it.' The contradictions of this position have not deterred many Inuit from speaking out anyway, but it has prevented a level of opposition similar to that of the Crees. My interpretation of this stems from many sources, foremost of which is personal communication with Mary Simon and her colleagues at the Inuit Circumpolar Conference; remarks made by former Makivik information officer, Emanuel Lowi, both to me and in Eleanor Brown's informative article (1991); personal communication with many Inuit, like Mary Mikeyook (James Bay Information Office), Josie Weetalituk (Kativik Regional Council), and Martha Grieg (Pauktuutit, the Inuit women's organization); and Cree Chief of Whapmagoostui, Mathew Mukash. For a readily accessible source, see confirming analysis in Sean McCutcheon's last two chapters of *Electric Rivers* (1991).

4 'It is barren land, that's what our geography textbooks taught us and that's what it looks like to me' (Richard Le Hir, Vice-President, Quebec Manufacturing Association, interview with author, 16 March 1992). In his capacity as leader of a coalition of Quebec business groups, Le Hir is also known to have said that the natives are a thoroughly marginal group – 'the interests of a few hundred people cannot supersede those of millions of Quebeckers' (Picard, 1991: A3).

5 In relation to imperial phenomenon in other lands, similar fictions or lies have been reproduced, over and over (Said, 1993: 201–2).

6 Through successful opposition by the Cree, in alliance with environmentalists, New York cancelled its $17 billion contract with Hydro-Québec in March, 1992; deals with Maine and Vermont, worth less, were also overturned.

7 See for instance, Hugh Brody's *The Living Arctic* (1987), Kevin McMahon's *Arctic Twilight* (1988), and George Wenzel's *Animal Rights, Human Rights: Ecology, Economy and Ideology in the Canadian Arctic* (1991) for critical descriptions of explorer and ethnographic texts produced out of encounters with Inuit. As Charles C. Hughes has written, 'rarely has so much been written by so many about so few' (1963: 452), the first and most famous study, of course, being Franz Boas's 'The Central Eskimo' (1888). As Wenzel says:

> The ability of 'The People' to live, and live well, in the polar environment spawned a literature, both popular and scholarly, of its own. . . . Perhaps because of the harsh starkness of the northern ecosystem, these writings have come to embody a degree of idealization so large that the basic attribute of Inuit survival, their remarkable and innovative culture, has been obscured and replaced by a Rousseauian image of natural man [*sic*] tenuously holding primeval nature at arm's length. (1991: 11)

See also John Moss's critique of contemporary writing about the Arctic (1991).

8 Of what the Inuit, Dene and Cree thought of the initial and succeeding encounters, there is now a growing body of literature published by cultural institutions in the North-west Territories (now called Nunavit), as well as by Nortext in Iqaluit, NWT. For those specific to the region under discussion here,

Avataaq Cultural Institute's publications have been most useful, as are those from the Grand Council of Cree. Kevin McMahon's *Arctic Twilight* (1988) reproduces long verbatim interviews with Northern natives, reciting what their parents and elders have reported. It is a complex set of narratives, which are likely conditioned by the type of relationship with the (usually white) interlocutor. The consistent thread in this literature is the extent to which Northern peoples' experience was initially validated by the explorers precisely because Northern peoples' skills kept the explorers alive.

9 In a report issued by the Canadian press (*Toronto Star*, 17 August 1991: A9), Jacques Parizeau, Leader of the Parti Quebecois, Quebec's separatist party in opposition, stated that the Cree are undermining the province's independence movement internationally by 'threatening to take their lands and join Canada if the province separates.' This threat was strategically posed as a way of stopping the Great Whale phase of James Bay project. According to Cree Chief Billy Diamond, the logic was that the 1975 land-claim agreement would be null and void in the event of provincial succession. Parizeau makes explicit the threat posed by Cree and Inuit opposition to the presumption of a nation constituted by land seized, then bounded under statehood and regulated as such. He states:

> One of the main criteria by which countries recognize a new country is the *undisputed* character of the borders. And if the general idea can be spread abroad that the borders of Quebec could be disputed on legal grounds, it might create some problems . . . It could certainly have the effect of complicating the international recognition of Quebec as a sovereign nation. [My italics]

10 Personal communication with Sappa Fleming, August 1991, Kuujjuaraapik.

11 No critical history exists of this project. Alcan Aluminum's engineers have been the only authors of anything remotely resembling a history. Visual records of the project's construction were also produced under the auspices of Alcan. See for example, the promotional documentary, *The Man with a Thousand Hands* (1955), National Film Archives of Canada, NFA #: 13-0047/1183. The film's narrator (Raymond Massey) elegiacally metaphorizes bulldozers and tractors as man's 'thousand hands' which are contradictorily, 'the new race of Giants' and 'man's new race of slaves . . . in the conquest of nature.'

12 I am indebted to Kevin Dowler's primary research on the Kemano project, conducted in 1992 on behalf of the Haisla Native Development Corporation, British Columbia.

13 The resemblance to Kemano consists as well in relationships to aluminum smelters. In 1991, Hydro-Québec struck contractual deals to offer highly subsidized power rates to thirteen international smelters. The companies sought and won an injunction against media publication of the deals. See McCutcheon (1991: 184–5), MacPherson (1991) and Wells (1991).

14 This subtitle is taken from J. Robert Cox's useful analysis of the use of a rhetorical commonplace derived from the irreparable nature of choice or action. The kind of discourses it gives rise to, especially those which relate to unique, urgent or timely and precarious circumstances, involve arguments about the preferable course of action to take. He states: 'Claims that a decision cannot be repeated or that its consequence may cause an irreplaceable loss are invoked at strategic moments in almost every aspect of our personal and public lives' (1982: 227).

15 Personal communication with Mathew Mukash at environmental impact hearings, Montreal, March 1992.

16 Kativik Environmental Quality Commission's first phase of Inuit public hearings, Imuijaq and Inukjuak, August 20–22, 1991. All subsequent references to these hearings are taken from transcripts recorded by the Kativik Regional Government and by Breakthrough Films. Translations for the latter are by Martha Grieg, Pauktuutit, Inuit Women's Association.

17 It is little wonder, for instance, that such diverse groups as the Inuit Circumpolar Conference (of Alaska, Greenland, Canada's North-west Territories and Nunavik), the Nordic Saamis, and the 26 aboriginal nations of the (former) Soviet Union's Arctic have formed an Arctic Leader's alliance. As Pekka Aikio has argued, on behalf of the Saamis:

> The aim of the indigenous peoples to strengthen their cultural self-determination may be quite similar all over the circumpolar regions. . . . It is due to the history of colonization of Arctic marginal areas that the indigenous cultures are regarded as users of resources rather than owners. The Western World has quite recently started to realize that the way arctic peoples use their land can be interpreted as owning the land . . . according to the principles of the Nation State's ideas of justice. (1990: 201, 211)

My argument is not intended to suggest a coherent, enunciative stance that presumes a universal plight or subject, as though we are all somehow knowable to each other. Rather, I want to underscore the possibility opened up by this conjunctural moment of discovering necessary points of identification and alliance, which, of themselves, are as fraught with risk and paradox as the practice of articulation itself (Haraway, 1992: 315).

18 Mathew Mukash and David Masty from Whapmagoostui have both helped me understand the strategies used by the Cree.

19 This and successive references to quotes of Mathew Coon-Come are taken from my transcripts of his speeches, delivered in Toronto, 23 and 24 April 1991.

20 This racism has also taken several recent forms directly related to the planning of the development project. Inuit and Cree on environmental review panels (set up under the land-claim agreement) have lodged complaints to the government that all documents and studies distributed by Hydro-Québec have been in French, with no adequate financial provision forthcoming for translations into English, Inuktitut and Cree. Moreover, the alleged promise of jobs for the project is a ruse: Hydro-Québec has made it clear that only French-speaking Quebeckers will be granted them; many Inuit and Cree over the age of thirty know French a little, if at all. See Diamond (1990) and McCutcheon (1991). Inuit leader Mary Simon has also corroborated this in personal communication with me (April 1991). Referring to her work on the Inuit-led commissions, mandated to examine the impacts of the Great Whale project, she stated that:

> None of the documents were translated into English – I told the commission and the government that I was not prepared to sit on the commission to review the project if I wasn't given the proper tools to do it; maybe only six weeks after did they agree to translate the five volumes [of studies] released by Hydro-Québec in December [1990]. (my transcript)

Some racist attacks were less subtle. Sandro Contenta quotes a representative of the Syndicat des Matallos (the union of 50,000 Quebec steelworkers), who said that 'what they're really after is the control of the natural resources of the

territory, which would make the Crees the sheiks of the North.' The same report quotes the head of the Manufacturing Association, who accused the Crees of being undemocratic 'social parasites holding the people of Quebec hostage' (1992: A2).

21 Transcript from interview with Mary Simon, 7 November 1991: 12–13.

22 Those in the scientific community have decried the extent to which Hydro-Québec, the chief proponent of the project, has firmly controlled all research – creating a vast amount of 'grey' literature that has not been independently reviewed, assessed or replicated (Canadian Arctic Resources Committee, 1991). See also John Holman and Marina Devine (1992: 3).

23 According to the Canadian Arctic Resources Committee, and the Rawlson Academy of Aquatic Science, 'in 1984, two of every three people in Chisasibi, a community of 2500 at the mouth of the La Grande river, had unacceptably high levels of mercury in their bodies; some elders had 20 times the level deemed acceptable' (CARC, 1991: 7).

24 This was revealed in interviews with Stella Leney, spokesperson for Hydro-Québec, 16 March 1992. As well, David Suzuki's documentary, *James Bay: The Wind that Keeps On Blowing* (CBC, *The Nature of Things*, 1991), contains interviews with Hydro-Québec officials who claim that such problems need not stand in the way of development. The most telling comment in the film is Gaetan Guertin's, director of Hydro-Québec. Referring to a range of environmental impacts that cannot be predicted in advance, David Suzuki asks: 'Surely one of the lessons of science is that you don't know anything?' Guertin: 'Yes, but if we wait until we have all the information you won't be doing anything.'

25 A highly complex structure of consultation procedures and hearings have now been instituted. As of this writing, these processes are ongoing, with construction plans significantly delayed.

References

Ahiaba, Beatriz (1991) Conference Brief, International Conference of Indigenous Peoples of the Environment and Development, *International Indigenous Commission*, Geneva: 1–4.

Aikio, Pekka (1990) 'The Circumpolar Peoples and the Protection of the Arctic Environment, A Saami Viewpoint', proceedings from the Finnish Initative conference, Yellowknife, NWT, 17–23 April, Annex II: 18, 1990: 197–213.

Ashby, Richard (1993) 'Deconstructing nature', *Borderlines* 28: 61–3.

Boas, Franz (1888) 'The Central Eskimo', *Sixth Annual Report of the Bureau of American Ethnology for the Years 1884–1885*. Washington, DC: The Smithsonian Institution: 399–669.

Bourassa, Robert (1985) *Power From the North*, Toronto: Prentice Hall.

—— (1973) *James Bay*, Toronto: Harvest House, cited in Sean McCutcheon, *Electric Rivers* 34.

Brody, Hugh (1987) *The Living Arctic: Hunters of the Canadian North*, Vancouver/Toronto: Douglas & McIntyre in collaboration with the British Museum and Indigenous Survival International.

Brown, Eleanor (1991) 'Misleading the people?' *Montreal Mirror* 6 June: 11.

Canadian Arctic Resources Committee (1991) 'Sustainable development in the Hudson Bay/James Bay bioregion', *Northern Perspectives* 19(3) Autumn: 2–8.

Canadian Press (1991) 'Cree campaign called a threat to separatism', *Toronto Star* 17 August: A9.

Charland, Maurice (1986) 'Technological Nationalism', *Canadian Journal of Political and Social Theory* X (1/2): 196–220.

Contenta, Sandro (1992) 'Native mega-project foes hit by Quebec backlash', *Toronto Star* 20 March: A2.

Cox, Robert J. (1982) 'The die is cast: topical and ontological dimensions of the *Locus* of the irreparable', *Quarterly Journal of Speech* 68(3): 227–39.

Diamond, Billy (1990) 'Villages of the dammed: The James Bay Agreement leaves a trail of broken promises', *Arctic Circle*, 1 (November/December): 24–34.

Dominguez, Virginia R. (1991) 'Theorizing culturalism: from cultural policies to identity politics and back', paper presented at *Art as Theory: Theory and Art* conference, Ottawa, December 1. Forthcoming in Jody Berland *et al.*, editors, *Theory Rules*, Toronto: YYZ/University of Toronto Press.

Dorland, Michael (1988) 'A thoroughly hidden country: *Ressentiment*, Canadian nationalism, Canadian culture', *Canadian Journal of Political and Social Theory* XII (1–2): 130–64.

Gellner, Ernest (1983) *Nations and Nationalism*, Oxford: Basic Blackwell.

Grossberg, Lawrence, Nelson, Cary and Treichler, Paula (1992) editors, *Cultural Studies*, New York/London: Routledge, Chapman and Hall.

Haraway, Donna (1992) 'The promise of monsters: a regenerative politics for inappropriate/d others', in Grossberg, Nelson and Treichler (1992): 295–337.

Hawkes, Suzanne (1991) 'Unheard voices: James Bay II and the women of Kuujjuaraapik', *Canadian Arctic Resources Committee* 19(3): 9–11.

Holman, John and Devine, Marina (1992) 'Keewatin, Sanikiluaq want a say in Great Whale review', *Nunatsiaq News* 3 July: 3.

Hughes, Charles Campbell (1963) 'Review of James Van Stone: Point Hope: an Eskimo village in transition', *American Anthropologist* 65(2): 452–4, cited in George Wenzel, *Animal Rights, Human Rights*: 6.

Innis, Harold (1951) *Bias of Communication*, Toronto: University of Toronto Press.

Katavik Environmental quality Commission (1991) transcripts from Inuit public hearings into Great Whale project. Kuujjuaq, Quebec, August.

Keating, Michael (1986) *To the Last Drop*, Toronto: Macmillan, cited in Joyce Nelson (1992) *Sign Crimes/Road Kill: From Mediascape to Landscape*, Toronto: Between the Lines Press: 177.

Legare, Evelyn (1991) 'The Indian as Other in a multicultural context', conference paper presented at the Annual Meetings of the American Ethnological Society, cited in Virginia R. Dominguez (1991) 'Theorizing culturalism', forthcoming in *Theory Rules*.

Lopez, Barry (1986/7) *Arctic Dreams: Imagination and Desire in a Northern Landscape*, New York: Bantam.

Makivik Corporation (1991) 'Full environmental review delays hydro project', *Makivik News* 20 (Fall: 5–7.

MacPherson, Don (1991) 'Hydro's gag makes Quebec look silly', *The Montreal Gazette* 13 April: B3.

McCutcheon, Sean (1991) *Electric Rivers: The Story of the James Bay Project*, Montreal/Toronto: Black Rose Books.

McKenzie, Robert (1991) 'Great Whale plunged into depths of secrecy', *Toronto Star* 24 August.

McMahon, Kevin (1988) *Arctic Twilight: Reflections on the Destiny of Canada's Northern Land and People*, Toronto: James Lorimer & Company.

Moss, John (1991) 'The imagined Arctic', *Arctic Circle* 1 (March/April): 33–40.

Nelson (1992) *Sign Crimes/Road Kill: From Mediascape to Landscape*, Between the Lines Press.

Picard, Andre (1991) 'Crees criticized over hydro project', *Globe and Mail*, 3 July: A3.

Said, Edward W. (1993) 'Nationalism, human rights, and interpretation', in Barbara Johnson (1993) editor, *Freedom and Interpretation: The Oxford Amnesty Lectures*, New York: Basic Books: 175–205, 214–15.

Slack, Jennifer Daryl and Whitt, Laurie Anne (1992) 'Ethics and cultural studies', in Grossberg, Nelson and Treichler (1992): 571–92.

Vogel, Mike (1991) 'Massive Quebec power project reshapes Earth', *Buffalo News* 6 November: A1, A14.

Wells, Paul (1991) 'No dirt-cheap subsidized rates in secret contracts, hydro insists', *The Montreal Gazette*, 13 April: A5.

Wenzel, George (1991) *Animal Rights, Human Rights: Ecology, Economy and Ideology in the Canadian Arctic*, Toronto: University of Toronto Press.

Wilson, Alexander (1991) *The Culture of Nature: North American Landscape from Disney to the Exxon Valdez*, Toronto: Between the Lines Press.

'A GARDEN INCLOSED IS MY SISTER': ECOFEMINISM AND ECO-VALENCES[1]

Dead creek, for example, a creekbed that received discharges from the chemical and metal plants in previous years, is now a place where kids from East St. Louis ride their bikes. The creek, which smokes by day and glows on moonless nights, has gained some notoriety in recent years for instances of spontaneous combustion. The Illinois EPA believes that the combustion starts when children ride their bikes across the creekbed, 'creating friction which begins the smoldering process'. (Kozol, 1991: 17)

In 1986 a ruptured pipeline at the Purex Corporation's bleach plant in South Gate sent a green cloud of deadly chlorine over nearby Tweedy Elementary School. Seventy-one students and faculty were hospitalized and the school site was eventually abandoned. The next year, teachers in Bell Gardens discovered a possible 'miscarriage cluster' associated with toxic chromium emissions from adjacent plating plants, and eighteen months later Park Elementary in Cudahy was closed after analysis revealed that the 'gook' oozing from the playground for the previous quarter-century was highly carcinogenic residue from an old toxic landfill. (Davis, 1992: 68)

Our cabin, which sits high on a knoll overlooking a narrow mountain valley, has a wide verandah around two sides. We often find ourselves sitting here, reflecting on our work, our lives, the state of the world. Sometimes we are simply sitting – listening to the sounds of birds, feeling the breath of warm winds, healing ourselves in the midst of the natural world. (Plant, 1989: 1)

In Rhode Island, the environmental group Save the Bay has long been at the forefront of campaigns to clean up and preserve Narragansett Bay. The group has spearheaded efforts to enforce restrictions on industrial waste disposal and has supported extensive research into the effects of this waste on the bay.[2] Although Save the Bay's efforts have resulted in concrete improvements for certain Rhode Islanders (quahoggers, for example, have been able to harvest quahog beds

that have been closed for years due to contamination), its political interests and projects seem to be remote from the political struggles occurring in working-class and poor communities in Rhode Island, many of whose constituents are Latino, African-American and Asian-American.

Whether these perceptions are accurate or not, in US popular culture environmentalism does seem to have no connection to issues of race and class. On television, for example, environmentalists are usually portrayed engaged in clean-up efforts in parks, beaches or other conservation areas, or in the protection of endangered species. Although the media (driven as it is by corporate interests) is extremely selective in its representations of environmental activism, the success of its often anti-environmentalist coverage points to the mobilization of certain classist and racist anxieties and fears.[3] Radio talk-show host Rush Limbaugh, to take one example, has manipulated the common-sense notion that environmentalism is inextricably bound up in class privilege to great conservative success, further deepening divisions among progressive political groups. The past decade bears witness to the material results of conservative interventions: often in the form of violent confrontations between environmentalists and local communities.

Environmentalists and ecofeminists in the US acknowledge and to an extent problematize the fact that their coalitions are more often than not composed of white, middle-class people and there is a great deal of cause for hope in critiques emerging from communities of color.[4] But while it is certain that divisions have been nurtured by governmental policies and corporate interests, conspiracy theories offer little help in the way of generating strong political opposition or theorizing strategies for shifting the disabling terms of environmental debates. In this essay, I unpack the ideologies and strategies undertaken by ecofeminists in particular that promote such divisions and in many cases prevent the formation of powerful coalitions across a wider sector of the left. By analyzing the manner in which certain ecofeminist strategies circulate in regressive fashions, I hope to point toward the possibility of more progressive forms and formats; to point toward, in effect, a feminist and socialist environmentalism that is committed to a global understanding and formulation of the concept of an ecosystem: one that is more cognizant of, and attentive to, the complexities of that term.

The quotations with which this text opened form the basis of a polemic about rooms of one's own, rooms with (or without) views, rooms overlooking gardens (and rooms overlooking dump sites); about who occupies certain rooms and who continues to be locked out. Criticizing feminism as a feminist is never an easy or enviable task to undertake, particularly within a culture where feminism continues to evoke mostly negative reactions outside the academy. This analysis is motivated by a deep concern about the problems currently besetting many environments and those who inhabit them (humans and non-humans alike) in the belief that the situation is indeed dire but, as Cornel West puts it, it is also 'a situation that can change in the near future depending in part on what some

intellectuals do' (1991: 35). I want to focus on the possibilities for shifting the terms of debate through an examination of ecofeminist philosophy and practice; most explicitly by reference to articulations of 'women' and 'nature', consumerist models of political practice, and the concomitant failure to sustain a critique of multinational capitalism.

Designing women

In *Rethinking Ecofeminist Politics* (1991), Janet Biehl describes the manner in which ecofeminist reliances upon the naturalized connection between 'woman' and 'nature' reify dominant ideologies of female nature – the hegemonic affects and effects of what ecofeminist Ynestra King celebrates as 'woman's bridge-like position between nature and culture' (1989: 22).[5] Consequently, the central tenets of ecofeminism might well be theorized within the trajectory of what Katha Pollitt describes as 'difference feminism' (1992: 801) – or a theory of 'a world that contains two cultures – a female world of love and ritual and a male world of getting and spending and killing' (806). Despite its claims to comprise a new and radical version of feminist thought, one that specifically responds to modernity and its multifaceted problems, like many historical versions of feminism (not to mention dominant ideologies about femininity), ecofeminists ground their critiques in the belief that contemporary social problems can be traced directly to gender difference. The historical specificity of ecofeminism consists in the premise that changes brought about by technological advances, ascribed variously to patriarchy, capitalism and even Marxism, have resulted (and can *only* result) in the domination of both women and nature. The quest for a feminist originary narrative thus terminates in some misty feminist or matriarchal past, the values of which, once recuperated and restored, form the recipe for utopia.

For founding ecofeminists like Mary Daly and Susan Griffin, the solution to contemporary social problems (for women, at least) resembles that of Sarah Connor in *Terminator 2*: women must destroy technology and reject the modern world in order to realign themselves with their true and essential source of strength: a pre-patriarchal affinity with nature. So Daly's theory of 'patriarchy' depends upon the binarism between technology, as the monstrous, phallic present, and the environment, as matriarchal past. Women inhabit (or should more completely inhabit) a realm absolutely distinct from the death-loving province of masculinity.[6] Such an approach is analytically and politically suspect for reasons that have long been cause for debate within feminism.

Foremost among these is the invocation of women as a class, or uniform category of analysis. As Audre Lorde observed, moreover, such a universalizing perspective 'serves the destructive forces of racism and separation between women – the assumption that the herstory and myth of white women is the legitimate and sole herstory and myth of all women' (1981: 96). By insisting that women – across race, class and national lines, across history – have a more intimate and stable relationship with nature

and the natural, ecofeminism flattens out and ultimately ignores race and class distinctions.

The universalizing underpinnings of the notion that technology has uniformly and necessarily oppressed women further relies upon a reductive model of social relations, a model that can neither account for the contradictory aspects of this process at different historical moments nor adequately analyze intersecting yet structurally different forms of oppression. In view of the complexity and interrelatedness of the global environmental situation, and in respect of power structures that transcend, or ignore, such boundaries, the universalizing equivalence between women and nature can be expected to effect certain erasures and invisibilities. When technology stands in opposition to 'women' who by virtue of their anatomical configuration have special links with the environment and nature, technology functions like the term patriarchy, which, as Michèle Barrett reminds us, is far too often used to name 'a system of domination completely independent of the organization of capitalist relations . . . hence the analyses fall into a universalistic trans-historical mode which may shade into biologism' (1988: 15).

Ecofeminists tend to dismiss or disregard the lengthy and two-edged history of the naturalized connections between women and the environment. Women's natural and moral superiority to men exists within an ideological and historical vacuum. As Pollitt observes:

> The vision of the morally superior woman can never overcome the dominant ethos in reality but exists alongside it as a kind of permanent wish or hope: If only powerful and powerless could change places, and the meek inherit the earth! Thus, it is perpetually being rediscovered, dressed in fashionable clothes and presented, despite its antiquity, as a radical new idea. (1992: 800)

Such a 'new' version of feminist theory was fitted out and influentially re-presented as early as 1973 by Jane Alpert. In 'Mother right: a new feminist theory', Alpert asked:

> Could it not be that just at the moment that masculinity has brought us to the brink of nuclear destruction or ecological suicide, women are beginning to rise in response to the Mother's call to save Her planet and create instead the next stage of evolution? (1973: 94)

Kenneth Pitchford, husband of feminist Robin Morgan (currently editor of the 'new' *Ms.* magazine) similarly argued that, 'To be shockingly blunt, it is the male principle in human beings that has brought us historically to the verge of extinction; if we are to survive it will be because the female principle, once omnipotent in pre-history, is returned to power' (Echols, 1989: 253). A more recent example of this oddly nostalgic essentialism occurs in *The Rape of the Wild: Man's Violence Against Animals and the Earth*, where Andrée Collard claims that 'As with women as a class, nature and animals have been kept in a state of inferiority and powerlessness in

order to enable men as a class to believe and act upon their "natural" superiority/dominance' (1989: 1). Such an uncritical essentialism similarly motivates Daly's work

> Phallic lust is seen as a fusion of obsession and aggression. As obsession it specializes in genital fixation and fetishism, causing broken consciousness, broken heartedness, broken connections among women and the elements. (1984: 1)

The modern condition, positioned by default against an elusive, prepatriarchal state of organicism, results from exposure to 'a manipulative and deadening technology' (Daly, 1984: 228). Daly's strategy for opposing the 'technological fixers', concurs with that of Rachel Carson: ' "discovering our deep sources, our spring. . . . finding our native resiliency, springing into life, speech, action" (Daly, 1978: 21). Needless to say, within Daly's cosmos, only 'women' are biologically qualified to make these discoveries.[7]

Ignoring realities of political power and strategies for radical social change, and positioning both women and nature outside of existing structures of power, ecofeminism reassociates the female with the primitive or the pre-modern. To put it slightly differently, both Daly and Griffin accept a stereotypical rendering of femininity, disingenuously believing that social constructions (which never apply to women and nature because this connection is presumed to be natural and real) can be reworked and differently valued from within.[8] The separatism proposed by ecofeminists disguises the fact that, as Bernice Johnson Reagon has observed, 'There is no hiding place' from technology and modernity (1983: 357). Worse yet, it depends on the totalitarian belief that women – if freed from the contaminating effects of phallocentrism – would 'naturally' choose to disengage themselves from technology to return to some more 'natural' form of existence.

Feminist strategies based on essentialized gender differences encourage coercive and self-defeating connections with conservative logic. The Chodorovian belief that women are intrinsically non-hierarchical, nurturing, emphatic and consensual as opposed to men, who are competitive, emotionally aloof, selfish and aggressive, upholds the ideological status quo by ceding power (invariably defined as negative) to men while arrogating moral superiority to women. Ecofeminism thus claims to challenge 'the dualistic belief that nature and culture are separate and opposed. . . . [and] finds misogyny at the root of that opposition' (King, 1989: 19). For philosopher Karen Warren, 'An ecofeminist perspective is . . . structurally pluralistic, inclusivist, and contextualist, emphasizing through concrete example the crucial role context plays in understanding sexist and naturist practice' (1988: 151). This perspective is effected, in Warren's viewpoint, 'by identifying the prototype of other forms of domination: that of man over woman'. Nevertheless, attempts to avoid this dilemma by claiming to be able 'to step outside of the dualistic, separated world into which we were all born' (Plant, 1989: 5) remain lodged within a immanently conservative logic.

By accepting (indeed, celebrating) the logic that posits a special connection between women and nature, ecofeminist philosophies maintain hazardous ties with anti-feminist, anti-environmentalist, and racist conservative ideologies. Judith Williamson claims that 'If ideology is to represent differences while drawing attention away from social inequality and class struggle, what better than to emphasize differences which cut across class . . . [such as] the "eternal" sexual difference' (1986: 101). Williamson carries this argument further, asserting that:

> Women who protest 'as women' against the bomb are either engaging in a very effective use of society's own values against itself or accepting society's ideological definition of themselves as inherently more caring. Whatever their uses, the values of interpersonal relations, feeling, and caring are loaded onto women in direct proportion to their off-loading from the realities of social and economic activity. (110)

The line between protesting ideological definitions and accepting them is a fine one indeed, particularly within an historical and political context that continues to be dominated by conservative forces.

When ecofeminists uncritically invoke the articulation between 'woman' and 'environment', whether they intend to do so or not, they fail to escape from a terrain more tenaciously and popularly inhabited by hegemonic forces. As Biehl remarks:

> It actually changes very little to propound certain metaphors about women – and then attempt to elude their consequences by claiming that they are social constructions. Ecofeminism's attachment to its own metaphors leaves the movement itself without any clear understanding of women's and men's actual relationship to nonhuman nature, let alone women's and men's actual relationship to each other. (1991: 26)

Political strategies, in short, cannot be reduced to intentionality or individual agency, but need to be viewed as harnessing pre-existing, historically resonant articulations that operate within often rigidly particularized circumstances. For example, in 1989, Andrée Collard claimed that 'Nothing links the human animal and nature so profoundly as woman's reproductive system which enables her to share the experience of bringing forth and nourishing life with the rest of the living world' (1989: 106)[9] Mindful of Gayatri Spivak's assertion that she remains 'troubled by anything that claims to have nothing to do with its opposition' (1988: 195), I want to suggest that one of the weaknesses of ecofeminist philosophy involves its limited ability to contextualize, and the resulting inattentiveness to intersections between ecofeminist arguments and those made by conservatives. A fairly stark example of this problem appears in Collard's statement that '*Whether or not she personally experiences biological mothering*, it is in this [woman's reproductive system] that woman is most truly a child of nature and in this natural integrity lies the wellspring of her strength' (1989: 106; emphases added). The link between this claim and anti-abortion politics is obvious.[10] The problem inherent in celebrating

'woman's reproductive system' at a moment in time when reproductive rights were massively under attack by conservative forces such as Operation Rescue points not only to a remarkable inattentiveness to the political context, but a lack of consideration about women's varied and variable relationships to their reproductive systems.

Constructing environments

I want to push Biehl's argument about ecofeminist metaphors a bit further at this point, in order to describe how the articulation of woman and nature results in narrow and exclusive constructions of the environment at risk. Of the symbiosis between women and nature, Susan Griffin wrote:

> *We are the rocks, we are soil, we are trees, rivers, we are wind, we carry the birds, we are cows, mules, we are horses . . . We are flesh, we breathe, we are her body: we speak.* (1978: 46; original emphases)

Clearly, the construction of nature herein linked with woman is a straightforwardly traditional rendering of a 'natural' world. This is symptomatic of what has counted as an 'environment' in need of preservation and protection within ecofeminist thought. The quotations with which this essay began offer important insights into the problematic, and often alienating, endorsement of 'environmental protection'. In Plant's opening lines, her primary concern is with the effect of the logging industry on her home and the surrounding forest. While this is not a negligible concern, it is worth noting that the view from her cabin does not include a vista of East St Louis or South Central Los Angeles. In ecofeminist thought as well as mainstream environmentalism, what counts as an environment generally does not extend to urban, inner-city areas. Nor, it should be added, does it extend to the often toxic workplaces in which adults spend much of their lives. The general association of environmental concerns with leisure-time activities is legitimated through a representational framework that distinguishes between the environment and those environments inhabited on an everyday basis.

In 'The promises of monsters,' Donna Haraway describes what she calls a 'political semiology of representation' in which 'the only actor left is the spokesperson, the one who represents' (1991b: 312). In her critique of representational politics, Haraway further observes, 'Permanently speechless, forever requiring the services of a ventriloquist, never forcing a recall vote, in each case the object or ground of representation is the realization of the representative's fondest dream' (311). Haraway details with great precision the consequences of this form of representation – the decontextualization in which 'Everything that used to surround and sustain the represented object . . . simply disappears or re-enters the drama as an agonist' (312). However, Haraway ignores the connections between a 'political semiology of representation' undertaken by the New Right and that advocated by ecofeminists. Ecofeminists, in other words, also engage in 'distancing operations' in which the 'represented must be disengaged from

surrounding and constituting discursive and non-discursive nexuses and relocated in the authorial domain of the representative' (312). On one hand, the distancing operations result in radical decontextualizations when employed by ecofeminism: spotted owls, dolphins, trees are all disengaged from their cultural and political surroundings, often with drastic consequences for local peoples.

For example, while Native American cultures and spiritual beliefs are frequently invoked by ecofeminists (including Haraway), the situation of Native Americans living on reservations seldom factors into the analysis. The recuperation of spiritual beliefs and myths from historically remote Native American cultures consequently operates at a suspicious distance from the environmental issues besetting Native Americans at this historical moment. For example, for Navajo teenagers reproductive cancer is seventeen times the national average. According to Elizabeth Martínez and Louis Head, 'About half of all Asian/Pacific Islanders and Native Americans live in communities with one or more uncontrolled toxic waste sites' (1992: 29). The US government has long been tempting economically devastated Native American communities with the location of toxic waste sites on tribal land. For the US government and its corporate cronies, the benefits of this arrangement are staggering: EPA regulations do not apply to tribal lands. The benefits for the community, aside from the immediate profit, are virtually nonexistent. Tribes would be held solely accountable for the integrity of storage facilities, as well as health risks, for an undetermined period of time.

Furthermore, ecofeminist philosophies often posit an unmediated, visceral connection between individuals and nature (not to mention a fairly extensive knowledge of flora and fauna), but the accessibility to such naturalized relationships is seldom questioned. For example, for those residing in urban settings, does 'Nature speak to us and in us' (Griffin, 1989: 17) in uniform ways? The intimate experience of nature adduced by Griffin and other ecofeminists seems limited by class position, but questions about class and race are avoided by ecofeminists through the claim that women – as gatherers and farmers – have historically had closer connections to the earth (which results from a social, rather than 'natural' division of labor). While this argument has validity in regions where women still retain primary responsibility for subsistence farming, and are consequently among the first to witness the effects of environmental degradation and pollution, it seems an improbable argument in relation to the predicament of urbanized poor women. Similarly, the US ecofeminist privileging of the Chipko movement in India (in which women successfully prevented deforestation and the destruction of their means of subsistence by refusing to allow the cutting of trees) loses its entire political and historical context when uncritically mapped on to a US context.

Many of the most urgent environmental problems confronting African-American women, Latinas, and poor white women (and since class is not a category of analysis for most ecofeminists, these women are more or less invisible), involve urban environments and poverty. For these communities,

the problem cannot be avoided by boycotting 'male culture'. In addition, even if such a boycott was universally desirable, the problem cannot be reduced to 'male culture', for male members of impoverished communities are also being affected by environmental pollution. This is not, of course, to suggest that communities of color are not concerned about environmental degradation. As Martínez and Head remark:

> Communities of color have always been concerned about contaminated water, poisoned land or animals, and all manner of deadly effects on their daily lives. But they may not have called these problems 'environmental' – a problem with the scope of the term as used by the media, not with the consciousness of people of color. (1992: 30)

Manning Marable recently observed that socialism only becomes meaningful to oppressed peoples 'when it explains how capitalism perpetuates our unequal conditions and when it gives us some tools to empower ourselves against an unfair, unjust system' (1993: 23). A similar argument could be made in relation to ecofeminist politics. Why isn't ecofeminist philosophy meaningful to working-class and poor people in the United States? Why haven't ecofeminists taken on the issue of environmental racism (which even Al Gore names in *Earth in the Balance*)?[11] Precisely whom, in short, does ecofeminism purport to empower?

In part, the ignorance around environmental racism results from the ecofeminist and deep ecologist critique of 'anthropocentrism', or 'species-ism'. Constructing a monolithic version of humanity, in which human beings uniformly enjoy a privileged status over nature, the critique of anthropocentrism maintains the illusion, but not the critique, of the ways in which the humanist paradigm operates in US culture. In effect, it ignores how certain subjects (by virtue of skin color, economic status, gender, or erotic orientation) do not have access to such centrality within existing structures of power. Collard's assertion that 'Re-connecting in kinship to the non-human world around us is the first real step toward saving the earth and all its species from destruction' (1989: 28) is therefore meaningless without a recognition that 'kinship' relations within the human world must simultaneously be salvaged.

Consumerism

The elision of political contexts for ecofeminist arguments and interventions is not only linked to class-specific interests, it also ties into the increasing privatization and consumerization of environmentalism. L.A. Kauffman explains the problem of 'this New Left intertwining of the personal and the political' as

> an end-run around real politics . . . Divorced from its original collective context, the personalized politics of the 1960s has turned into an effective means for would-be radicals to hold onto the sense of being political – a commitment to principled daily life, an engagement with far-flung and

disparate causes, a will to 'think globally and act locally' – without ever engaging in actual contests over power. (1991: 296)

This 'commitment to principled daily life' is reflected in King's statement that:

> Direct [ecofeminist] actions include learning holistic health and alternative ecological technologies, living in communities that explore old and new forms of spirituality which celebrate all life as diverse expressions of nature, considering the ecological consequences of our lifestyles and personal habits, and participating in creative public forms of resistance. (1989: 25)

The problematic aspects of King's ecofeminism are clear in this comment: individualism and a focus on personal healing which only partially occludes the fact that the 'direct actions' she endorses depend on certain privileges (e.g., education, choice in housing/community, not to mention a healthy dose of cultural capital). Anne Cameron takes this one step further, suggesting that: 'Every decision a person makes in her life is a personal, political, and spiritual decision' (1989: 58). From such a relativizing perspective, it becomes difficult to make crucial distinctions between levels of political action and commitment which often results in a fragmented, micropolitical vision of the problem at hand.

A commonplace symptom of this nearsightedness is the presumption not only that political action is solely possible at the level of the local, but the power mobilized in most direct actions depends on one's ability to consume, or one's status as a consumer. Such variants of ecofeminism, moreover, *emphasize* consumption rather than conservation, completely sidestepping one of the central causes of environmental degradation: first world overconsumptionism.[12]

This model further presumes that political power is wielded only by consumers (and at a micropolitical level). In *Ms.* magazine, T.J. Ford's 'Earth-friendly ecotips' offer the following advice:

> Try to reduce or eliminate meat from your diet. . . . If you do eat meat, try to ensure that it was not raised on lands where rain forests were cleared for grazing. If possible, eat organically grown food; join your local grocery cooperative. Boycott irresponsible or unethical corporations – it really works. Good examples are the United Farm Workers of America (UFW) boycott of table grapes and the tuna boycott to protest nets that killed dolphins. (1990: 17)

In this excerpt, the politics of the meat industry, and the capitalism that drives this industry, is effaced by a concern for the meat's originary narrative. Political action is reduced to consumerism, with an emphasis on buying the appropriate environmentally sanctioned products. Even more troubling is the conflation of the UFW 'boycott of table grapes and the tuna boycott to protest nets that killed dolphins.' While Ford gives an explanation for the tuna boycott, she never describes the primary objective of the UFW

boycott: to protect mostly migrant farm workers from oppressive employ-
ment conditions and lethal agricultural chemicals. Leaving such equivalen-
ces aside, Ford does not mention the macropolitical organization necessary
for the success of such boycotts.

In many ways, environmentalism has become an intrinsic part of
bourgeois culture, marketed side by side with high-tech accessories.[13] This is
'the personal is the political' with a vengeance: a space where environ-
mentalism is reduced to another form of commodity fetishism, where
decisions about buying environmentally correct paper products and diapers
define the limits of what counts as 'political', and where saving endangered
species in distant lands provides an alibi for ignoring both local ecosystem
destruction and human suffering. The commodification of environmental-
ism also erases the human and environmental consequences of development
in third-world countries: the World Wildlife Federation markets ties
emblazoned with endangered species (and donates a percentage of the
proceeds to environmental groups – products manufactured in Taiwan,
Singapore, or the Philippines. Multinational corporate offenders also use
environmentalism to sell a more benign image. 'Nature' programs on
television are often sponsored by multinationals (especially oil corporations)
and a recent television commercial shows frolicking dolphins and whales,
while the voice-over extols the environmental integrity of the company that
also brought us Agent Orange.[14]

Multinational capitalism

> [A]ll progress in capitalistic agriculture is a progress in the art, not only of
> robbing the labourer, but of robbing the soil; all progress in increasing the
> fertility of the soil for a given time, is a progress towards ruining the
> lasting sources of that fertility. The more a country starts its development
> on the foundation of modern industry, like the United States, for example,
> the more rapid is this process of destruction. Capitalist production,
> therefore, develops technology, and the combining together of various
> processes into a social whole, only by sapping the original sources of
> wealth – the soil and the labourer. (Marx, 1984: I, 474–5)

In order to illustrate the problems and possibilities confronting environ-
mentally concerned feminists, I want to conclude by speculating about the
implications of ecofeminism's decontextualization for an event that will
have its most devastating consequences in the United States and Mexico: the
controversial North American Free Trade Agreement (NAFTA). Environ-
mentalists have only begun to detail the environmental consequences of the
maquiladora industry that operates along the south-western border of the
United States. Yet a single-minded attention to the environment may very
well deflect attention from the structurally diverse range of oppressions
congealed in NAFTA. The maquiladora system was not solely created for
the purpose of avoiding US regulations governing the disposal of toxic
waste. Rather, capital's continuing search for cheap sources of labor yielded,
as it is wont to do, a complicated and systemic array of oppressions. Given

President Clinton's and particularly Vice President Gore's, commitment to the environment, as well as their commitment to NAFTA, we might expect an emphasis (particularly in the media) on the environmental issues surrounding NAFTA, rather than an accounting of the human costs on both sides of the maquila.

In order to bring the various critiques together, and to form more powerful and effective coalitions (between workers and environmentalists, Mexican women and US ecofeminists, environmentalists and socialists, and so forth), we need a broader definition of the environment – one attentive to the deep structural problems.

Hence, a critique of NAFTA must take into account the number of interlocking and oppressive environments that comprise the maquila industry. Hazardous waste dumping by corporations such as Dupont, Stepan Chemical, General Motors, and Zenith is one part of larger structural problems poisoning inhabitants of Mexico. In the workplace, inadequate information is offered to employees regarding the toxic chemicals with which they daily work. Employees, moreover, start at twenty-seven US dollars per week and top out at forty-seven, thus being consigned to an unending cycle of poverty. On the other side of the border, US workers will most certainly lose jobs (a loss that will undoubtedly be explained in racist terms). The only winners in this game are multinational corporations. I think that I speak for many socialist-feminists when I say that I want no part of a social movement that will foreground only environmental issues without addressing the equally horrendous labor practices along the maquila. That the work force in question is two-thirds female makes such an exclusion all the more disturbing.[15] NAFTA, which encompasses a knot of social problems and concerns (oppression, like groundwater contamination, has no respect for borders), might serve as a particularly useful basis for coalitions among previously antagonistic groups like labor and environmentalists. The possibilities, however, depend in large part on the strategies undertaken by environmental groups and coalitions.

Daniel Faber and James O'Connor's critique of environmentalism offers a useful reminder about the problems of single-issue approaches:

Environmentalism's single issue, legislative approach, has led capital to displace costs in different forms from one site to another. The movement's weak analysis of capitalism has helped lead to unintended, adverse effects on the well-being of people and their environments. While environmentalists respond to ecological dangers, capital responds to its own iron laws. Regional and local movements and coalitions by and large have not looked beyond their own areas to assess the effects elsewhere of their own local or regional successes. (1989: 28)

Ecofeminism's 'weak' or fragmentary, analysis of capital and 'its own iron laws' – itself a result of the refusal of modes of analysis like historical materialism that are construed as inescapably patriarchal – through its universalizing and essentializing claims, consequently contributes to re-inforcing the very system it disavows. The 'feminist matristic vision' that

Orenstein defines as being 'about politics in the feminist sense, rather than about political systems as such' (1990: xvii) is a vision that exists in and for an imaginary and privileged environment, which exists apart from the realm of capital and environments much more brutally devastated by capitalism.

We further need to be mindful that, legitimated by a biologism such as a notion of 'ecological memory' (Orenstein, 1990: 23) specific to women, this authorization has time and time again proved particularly congenial to conservative politics. Such authorization guarantees that while ecofeminists may act as ventriloquists for their mute sister (nature), because of their intermediary status, they will always be spoken for and through by the paternalistic voice of reason and true authority. In other words, although ecofeminists may serve to protect 'nature', both ecofeminism and the environment will always only occupy the status of 'the protected', or perennially potential victim. So women are permitted to participate in the management and development of their environments (in terms, of course, set and controlled by 'the protector'), and this permission is celebrated on the basis of its recognition that, as in the Rio de Janeiro environmental summit's terms, 'Women have a vital role in environmental management and development' ('Draft of environmental rules', 1992: A10). Nevertheless, this participation must always be acknowledged and controlled by those who are truly in power: the corporate protectors of the environment.

Not only does the belief in a special connection between women and nature feed into sexist and profoundly misogynistic ideologies, it is, as feminists like Audre Lorde have noted, very much a class- and race-based claim.[16] And, as Pollitt eloquently puts it:

> Although it is couched in the language of praise, difference feminism is demeaning to women. It asks that women be admitted into public life and public discourse not because they have a right to be there but because they will improve them. Even if this were true, and not the wishful thinking I believe it to be, why should the task of moral and social transformation be laid on women's doorstep and not on everyone's?.... Peace, the environment, a more humane work place, economic justice, social support for children – these are issues that affect us all and are everyone's responsibility. (1992: 806)

For ecofeminists, the implications of this argument are instructive: as long as we accept a gender-based moral and discursive responsibility for tending the garden, we will continue to be denied input into its sowing. And if we can see no further than the limits of our own gardens, then our so-called public resistances – however creatively packaged – will continue to be isolated and containable.

Groups to contact for further information:

Coalition for Justice in the Maquiladoras, Benedictine Resource Center, 530 Bandera Road, San Antonio, Texas 78228

Environmental Health Coalition, 1717 Kettner Boulevard, Suite 100, San Diego, CA 92101

National Toxics Campaign, 1168 Commonwealth Avenue, Boston, MA 02134

The Native American Women's Health Education Resource Center, P.O. Box 572, Lake Andes, SD 57356, Contact: Charon Asetoyer

Texans United Education Fund, 12655 Woodforest Boulevard, Suite 711, Houston, TX 77015

Notes

1 I am grateful to the following people for their assistance with this essay: Anthony Arnove, Julian Halliday, Penny Lewis, Elizabeth Terzakis and Dave Westcott. Thanks are due, as usual and above all, to Mark Unger. The quotation in the title comes from *Solomon's Song* 4:12.
2 Some Rhode Islanders have argued that these restrictions have only been enforced with regard to small businesses – that the larger, corporate offenders continue to dump while DEM officials look the other way. Given the rampant corruption of the state government, and Save the Bay's corporate and legislative connections, such claims require further investigations.
3 For an extensive analysis of the media's treatment of environmental issues, see 'After Earth Day' (1992).
4 Both the *Socialist Review*'s special issue entitled 'Environment as politics: the shifting ground of activism' (1993) and Robert Bullard's anthology *Confronting Environmental Racism: Voices from the Grassroots* contain important and instructive critiques of environmentalism.
5 The implications of this 'bridge-like' position are analyzed in Moraga and Anzaldúa (1982).
6 Michael Taussig's comments about his ethnographic work might stage useful confrontations with the dangers of Daly and Griffin's pre-capitalist nostalgia. He cautions: 'Confronted with this modern mode of comprehension it is all too easy to slip into other forms of idealism, and also into an uncritical nostalgia for times past when human relations were not seen as object-relations beholden to marketing strategies.' His strategy for countering this would be instructive for ecofeminists: 'we adhere to a mode of interpretation that is unremittingly aware of its procedures and categories. . . . this self-awareness must be acutely sensitive to the social roots and historicity of the abstractions that we employ at any stage of the process' (1980: 7).
7 For a perceptive, if overly generous, discussion of Mary Daly's work, see Meaghan Morris's 'A-mazing Grace' in Morris (1988).
8 This points to another logical failure in ecofeminist arguments about social constructionism – social constructions are themselves man-made and consequently on a par with the technologies that ecofeminists would have women reject. Biehl has a very strong critique of the ambiguity with which the term 'social construction' is used by ecofeminists.
9 For examples of how the judicial system deploys such myths of the natural against women, see Colb (1992). I am grateful to Linda Baughman for drawing my attention to this essay.
10 There is an interesting tension in this section of *Rape of the Wild* between

Collard's text and notes made by Joyce Contrucci, who edited the book after Collard's death in 1986. Citing Katha Pollitt's writings in *The Nation* on motherhood, Contrucci's reservations about Collard's work surface in the form of notes advising the reader to keep important distinctions between the 'popular sense' of terms like 'surrogates' and 'surrogate' mothers and Collard's allegedly distinct (and distinguishable) use of these (1989: 107).

11 Again, one of the examples most frequently cited by ecofeminists involves the Chipko movement in India.

12 A central multinational tactic in global environmental discussions, particularly around regulations to decelerate ozone depletion, has been to emphasize the imaginary excesses of consumption in the third world, while down-playing the all too real excesses of the first world.

13 A visit to shopping malls in the United States will confirm this weird symbiosis. The past two years have witnessed the appearance of any number of stores devoted exclusively to selling nature. Stuffed animals representing endangered species, rain forest jigsaw puzzles, and 'whole earth' T-shirts are only a few of the commodities being sold by these chains.

14 To take one popular example, while 'Save the Rain Forest' may invoke important concerns about the fate of the forests, at the same time it structures an imaginary rain forest, populated only by various forms of flora and fauna, threatened from the outside by irresponsible 'natives' and their equally irresponsible governments. In addition to ignoring the extreme poverty in which the indigenous peoples struggle to survive, the primeval forest also eclipses the role that the United States (via the World Bank and the International Monetary Fund) has played in producing the crisis by irrevocably altering the economy of such countries. To 'Save the Rain Forest' without offering alternative economic possibilities would entail an enormous cost in human suffering and lives. Although the plight of the humans living in such areas has received more attention lately (Hecht and Cockburn, 1989; Donna Haraway, 1991b), it is also relevant that many of these texts focus on 'indigenous peoples' and 'subordinated knowledge' to the exclusion of the Marxist labor organizers and organizations that catalyzed these struggles.

15 For more detailed descriptions of the history of the maquiladora system, see Fuentes and Ehrenreich (1984) and Nash and Fernández-Kelly (1983).

16 Although Lorde does not contest Daly's claims in *Gyn/Ecology* on the basis of essentialism, she does assert that 'to imply, however, that all women suffer the same oppression simply because we are women is to lose sight of the many varied tools of patriarchy. It is to ignore how those tools are used by women without awareness against each other' (1981: 95).

References

Adams, Carol (1991) 'Ecofeminism and the eating of animals', *Hypatia* 6(1): 125–45.
'After Earth Day: a survey of environmental reporting' (1992) *Extra!* 5(3) April/May 1992.
Alpert, Jane (1973) 'Mother right: a new feminist theory', *Ms.* magazine, August: 52–94.
Barrett, Michèle (1980) *Women's Oppression Today: Problems in Marxist Feminist Analysis*, London: Verso.
—— (1988) *Women's Oppression Today: The Marxist/Feminist Encounter*, London: Verso.

Biehl, Janet (1991) *Rethinking Ecofeminist Politics*, Boston: South End Press.

Bourdieu, Pierre (1990) *In Other Words: Essays Towards a Reflexive Sociology*, Stanford: Stanford University Press.

Bullard, Robert D. (1993) editor, *Confronting Environmental Racism: Voices from the Grassroots*, Boston: South End Press.

Cameron, Anne (1989) 'First mother and the rainbow children', in Plant (1989: 54–66.

Carson, Rachel (1961) *Silent Spring*, Boston: Houghton Mifflin.

Chodorow, Nancy (1978) *The Reproduction of Mothering: Psychoanalysis and the Sociology of Gender*, Berkeley: University of California Press.

Clarke, John (1991) *New Times and Old Enemies: Essays on Cultural Studies and America*, London: Harper Collins Academic.

Coalition for Justice in the Maquiladoras (1992) *Stepan Chemical: The Poisoning of a Mexican Community*, Benedictine Resource Center, 530 Bandera Road, San Antonio, Texas.

Colb, Sherry F. (1992) 'Words that deny, devalue, and punish: judicial responses to fetus-envy?', *Boston University Law Review* 72(1) January: 101–40.

Collard, Andrée with Joyce Contrucci (1989) *Rape of the Wild: Man's Violence Against Animals and the Earth*, Bloomington: Indiana University Press.

Daly, Mary (1978) *Gyn/Ecology: The Metaethics of Radical Feminism*, Boston: Beacon Press.

—— (1984) *Pure Lust: Elemental Feminist Philosophy*, Boston: Beacon Press.

Davis, Mike (1992) 'The L.A. inferno', *Socialist Review* 22(1) January–March.

Diamond, Irene and Orenstein, Gloria (1990) editors, *Reweaving the World: The Emergence of Ecofeminism*, San Francisco: Sierra Club Books.

'Draft of environmental rules: "global partnership"' (1992) *The New York Times*, 5 April 1992: A10.

Echols, Alice (1989) *Daring to be Bad: Radical Feminism in America 1967-1975*, Minneapolis: University of Minnesota Press.

Ehrenreich, Barbara (1989) *Fear of Falling: The Inner Life of the Middle Class*, New York: Harper Perennial.

Faber, Daniel and O'Connor, James (1989) 'The struggle for nature: environmental crises and the crisis of environmentalism in the United States', *Capitalism, Nature, Socialism* 2 (Summer) 12–39.

Forbes, Dana (1992) 'Liberating the killing field', *MS.* magazine January/February 84–5.

Ford, T.J. (1990) 'Earth friendly ecotips', *Ms.* magazine, September/October 17.

Fuentes, Annette and Ehrenreich, Barbara (1984) *Women in the Global Factory*, Boston: South End Press.

Gedicks, Al (1993) *The New Resource Wars: Native and Environmental Struggles Against Multinational Corporations*, Boston: South End Press.

Gilligan, Carol (1982) *In a Different Voice: Psychological Theory and Women's Development*, Massachusetts: Harvard University Press.

Susan Griffin (1978) *Woman and Nature: The Roaring Within Her*, New York: Perennial Library.

—— (1989) 'Split Culture', in Plant (1989): 7–17.

Gore, Al (1992) *Earth in the Balance. Ecology and the Human Spirit*, New York: Penguin Books.

Hall, Stuart (1991) 'The local and global: globalization and ethnicity', *Culture, Globalization and the World–System: Contemporary Conditions for the Representation of Identity*, London: Macmillan: 19–39.

Hamilton, Cynthia (1990) 'Women, home, and community: the struggle in an urban environment', *Race, Poverty, and Environment Newsletter* 1(1) April: 10–13.

Haraway, Donna (1991a) 'Cyborgs at large: interview with Donna Haraway', in Penley and Ross (1991) editors, *Technoculture*, Minneapolis: University of Illinois Press: 1–20.

——— (1991b) 'The promises of monsters: a regenerative politics for inappropriate/d Others', in Grossberg, Nelson and Treichler (1991) editors, *Cultural Studies*, New York: Routledge: 295–337.

Harvey, David (1989) *The Condition of Postmodernity*, Cambridge, MA: Basil Blackwell Inc.

——— (1991) 'Flexibility: threat or opportunity?' *Socialist Review* 21 (1) January–March: 65–78.

Hecht, Susanna and Cockburn, Alexander (1989) *The Fate of the Forest*, New York: Verso.

——— (1992) 'Rhetoric and Reality in Rio', *The Nation*, 254 (24) 22 June: 848–54.

Jeffords, Susan (1991) 'Rape and the new world order', *Cultural Critique* Fall: 203–15.

Kauffman, L.A. (1991) 'New Age meets New Right: tofu politics in Berkeley', *The Nation* 253 (8), 16 September: 294–6.

King, Ynestra (1989) 'The ecology of feminism and the feminism of ecology', in Plant (1989): 18–28.

Kozol, Jonathan (1991) *Savage Inequalities: Children in America's Schools*, New York: Harper Perennial.

Lazarus, Neil (1991) 'Doubting the new world order: Marxism, realism, and the claims of postmodernist social theory', *differences* 3 (3) Fall: 94–138.

Lorde, Audre (1981) 'An open letter to Mary Daly', in Moraga, Cherríe and Anzaldúa, Gloria (1981): 94–7.

Marable, Manning (1993) 'A New American Socialism', *The Progressive*, February: 20–5.

Martínez, Elizabeth and Head, Louis (1992) 'Media white-out of environmental racism', *Extra!* July/August: 29–31.

Marx, Karl (1984) *Capital: A Critique of Political Economy* 1, trans. Samuel Moore and Edward Aveling, New York: International Publishers.

McGaughey, William Jr (1992) *A U.S.-Mexico-Canada Free Trade Agreement – Do We Just Say No?* New York: Thistlerose.

Meeker-Lowry, Susan (1992) 'Maquiladoras: a preview of free trade', *Zeta* magazine, 5 (10) October 25–30.

Merchant, Carolyn (1980) *The Death of Nature: Women, Ecology, and the Scientific Revolution*, New York: Harper & Row.

——— (1992) *Radical Ecology: The Search for a Livable World*, New York: Routledge.

Moraga, Cherríe and Anzaldúa Gloria (1981) editors, *This Bridge Called My Back: Writings by Radical Women of Color*, Watertown, CT: Persephone.

Morris, Meaghan (1988) *The Pirate's Fiancé: Feminism, Reading, Postmodernism*, London: Verso.

Nash, June and Fernández-Kelly, María Patricia (1983) editors, *Women, Men and the International Division of Labor*, Albany: State University of New York Press.

Orenstein, Gloria Feman (1990) *The Reflowering of the Goddess*, New York: Pergamon Press.

Ortner, Sherry B. (1974) 'Is female to male as nature is to culture?', in Michelle

Zimbalist Rosaldo and Louise Lamphere (1974) editors, *Woman, Culture, and Society*, Stanford: Stanford UP: 67–87.

Plant, Judith (1989) 'Toward a new world: an introduction', in *Healing the Wounds: The Promise of Ecofeminism*, Philadelphia: New Society Publishers.

Pollitt, Katha (1992) 'Marooned on Gilligan's Island: are women morally superior to men?' *The Nation* 255 (22) 28 December: 799–807.

Reagon, Bernice Johnson (1983) 'Coalition politics: turning the century', in Barbara Smith (1983) editor, *Home Girls: A Black Feminist Anthology*, New York: Kitchen Table Press, 356–68.

Ruddick, Sara (1989) *Maternal Thinking: Toward a Politics of Peace*, New York: Ballantine Books.

Russell, Dick (1989) 'Environmental racism: minority communities and their battle against toxics', *Amicus* 11 (2) Spring: 22–32.

Shiva, Vandana (1989) *Staying Alive: Women, Ecology and Development*, New Jersey: Zed Books.

Slicer, Deborah (1991) 'Your daughter or your dog?', *Hypatia* 6 (1) Spring: 108–24.

Spivak, Gayatri (1988) 'Can the subaltern speak?, in Nelson, Cary and Grossberg, Lawrence (1988) editors, *Marxism and the Interpretaton of Culture*, Urbana: University of Illinois Press: 271–316.

—— (1989) 'In a word. Interview', *differences* 1 (2), Summer: 124–56.

Taussig, Michael T. (1980) *The Devil and Commodity Fetishism in South America*, Chapel Hill: University of North Carolina Press.

Tokar, Brian (1990) 'Marketing the environment', *Zeta* magazine, February: 15–21.

—— (1992) 'After the Earth Summit', *Zeta* magazine, September 1992: 8–14.

Warren, Karen (1988) 'Towards an ecofeminist ethic', *Studies in the Humanities* December: 140–56.

—— (1991) 'Introduction', *Hypatia* 6 (1) Spring: 1–2.

West, Cornel (1991) 'Theory, Pragmatism, and Politics', in Jonathan Arac and Barbara Johnson (1991) editors, *Consequences of Theory*, Baltimore: Johns Hopkins UP: 22–38.

Williamson, Judith (1986) 'Woman is an island: femininity and colonization', in Modleski, Tania (1986) editor, *Studies in Entertainment*, Bloomington: Indiana UP: 99–118.

MICHAEL X. DELLI CARPINI

AND BRUCE A. WILLIAMS

'FICTIONAL' AND 'NON-FICTIONAL' TELEVISION CELEBRATES EARTH DAY: OR, POLITICS IS COMEDY PLUS PRETENSE

Introduction

While there is much new work in the field of communications that challenges such distinctions, many scholars who study the medium still assume a clear and natural separation between fictional and non-fictional television. Falling into the former category are most prime-time shows, specials, movies and other broadcasts serving, it is assumed, primarily as entertainment. Further, many scholars assume that such shows have little impact on the way people think about the 'real world', in general, and politics, in particular.[1] In the latter category are shows like the news, documentaries and other public-affairs programming. Such shows are assumed to deal with events or conditions in the 'real world'. With few exceptions, for example, political scientists examine only 'non-fiction' television when they search for the effect of the medium on political attitudes and beliefs. In this paper we critically examine the distinction between 'fiction' and non-fiction' television, arguing that it does not hold up under close scrutiny, Indeed, its unexamined persistence tends to blind scholars to the full political implications of television for democratic politics in the United States.

To make our argument, we proceed in two steps. First, we develop a notion of both politics and politically relevant television that does not depend on this distinction and that better captures the current contours of the medium. Second, we apply our theoretical arguments in a close examination of three seemingly different types of programs dealing with the same political issue: environmental pollution. Through this analysis we

demonstrate both the difficulty and the inappropriateness of maintaining the distinction between 'non-fiction' and 'fiction' television.

Fiction versus non-fiction television

Among most mainstream social scientists who study the mass media, mass politics is assumed to consist of two elements: opinions about the people, institutions, and policies of national politics; and voting in national campaigns. However, messages about campaigns, elections, institutions such as congress and the presidency, policies of the day, etc., are only part of the substance of political communication. Uncritical acceptance of this limited definition constrains the study of media and politics since the media's most important forms and profound effects are in the very areas which lie outside it. As we argue elsewhere, an adequate definition of politics must encompass three different, but related, levels.[2]

First is what we call the *institutions and processes of politics*. By these we mean the formal channels of politics and government – elections, the presidency, etc. Second is the *substance of politics*, or issues, policies, etc., that are on the political agenda or that are becoming part of that agenda (social security, AIDS, drug testing, criminal rights, etc.). Most work in political science addressing the impact of television investigates politics at only these two levels. Third, and most neglected by students of the media's political impact, is the *foundations of politics*, or the processes and concepts upon which the very idea of politics and government is based – authority, power, equality, freedom, justice, community, etc.

Our definition of politics raises questions ignored by scholars adopting a narrower definition. First, does the media affect attitudes about 'the foundations of politics'? Second, does the way in which the media affects attitudes and behaviors vary across levels of politics? Third, how does the media influence the relationship between fundamental political values and more proximate behaviors and attitudes? In our analysis of shows dealing with environmental pollution presented below, we find that the political values espoused by these shows are quite different at each of the levels we have defined.

Answering such questions requires a rethinking of what constitutes politically relevant television. The rest of this paper is devoted to a consideration of this issue.

The 'commonsensical' assumption of a clear distinction between 'fictional' and 'non-fictional' television derives from and is reinforced by several lines of reasoning that are seldom explicitly examined. First, the very distinction is assumed to be 'natural' as evidenced by its use in a wide variety of fields. So, for example, there is assumed to be a clear distinction between 'fiction' and 'non-fiction' writing. Novels, poetry and other works of 'imagination' fall into the first category. History and biography fall into the second. Likewise, it is assumed that television programming can be sorted into the same categories. However, this distinction is now being questioned in the very fields from which it is borrowed. In literature, for example,

certain genres like the historical novel challenge this distinction. In history and biography there is growing awareness that the use of certain narrative devices (borrowed from literature) shape the way we tell any 'story' and so inevitably involves the creation of a 'fiction'.

While this distinction is being questioned in many other fields, it nevertheless continues to be used in unselfconscious ways in the study of television's political impact. This is so not because the distinction is less problematic in the study of television (in fact, we argue that it is more difficult to sustain in classifying television programs), but because of the beliefs of both those who produce television and the social scientists who study it.

Programs categorized as 'non-fiction' are produced by journalists. The 'doctrine of objectivity,' widely accepted by American print and electronic journalists, and not coincidentally by most social scientists, reinforces the categorization by assuming that the purpose of such programs is to provide viewers with a neutral mirror on 'real world' events. Moreover, political scientists who study the media share with television journalists a definition of politics that is confined to the institutions and substance level. Thus, when political scientists look for politically relevant television they are drawn to this type of programming because it is explicitly labeled 'political'. From this perspective, it makes little sense to see the products of journalists as reflecting (or being indistinct from) the narrative conventions or devices borrowed from 'fictional' forms of writing or broadcasting. Yet, the unexamined, universally used terminology that news events are communicated as 'stories', once we call attention to this choice of words, seems to indicate much less distinction between 'fiction' and 'non-fiction' than journalists often assume.[3]

The distinction between 'fiction' and 'non-fiction' is also reinforced by the self-definition of social scientists as 'serious' scholars who ought not be concerned with the mundane and non-serious aspects of popular culture. Since television itself is commonly assumed to be part of 'low culture' (how many academics will even admit that they watch television?), social scientists are reluctant to confront its full political significance. Thus, it has been attractive to draw a boundary between the small portion of 'serious', 'non-fiction' programming, produced by other respectable professionals (i.e., journalists, campaign managers, etc.) that is worthy of serious study and the vast majority of television that is not relevant to the concerns of political scientists.

To the extent that this reasoning remains unexamined, it produces a 'common sense' understanding of television. That is, it seems logical or natural that 'non-fiction' television addresses public concerns and therefore has 'serious' political implications while 'fictional' television is simply a form of entertainment with few 'serious' and or political implications.

In our view, the very distinction between 'non-fiction' and 'fiction' is especially misleading when applied to television. Its unexamined maintenance leads to some fundamental misconceptions about the nature of the medium and its political significance. First, there is a growing tendency for

'entertainment' television to reflect real world issues and events (e.g., docudramas that portray actual events or series that deal with current political or social issues). The recent flap over Dan Quayle's attack on Murphy Brown and that character's response (or was it Candice Bergen's response, it's so hard to tell), is one recent example. Since these shows are consistently watched by large audiences it seems reasonable that they will influence the ways viewers understand such issues. We examine two examples of such shows in this paper: a docudrama on toxic waste pollution and *The Time-Warner Earth Day Special*.

Second, there is a more subtle tendency for 'non-fiction' television to use the form and substance of 'fiction' – staging events, using graphics and movie clips to dramatize issues, employing the narrative conventions of fiction story-telling, the celebrity status of newscasters, and so forth (see Fiske, 1987: ch.15). One reason 'non-fiction' programming borrows conventions from 'entertainment' programming is that the latter type of programming dominates. Thus most people's expectations about what will be on television and how it will be presented requires that public issues be dealt with in an 'entertaining' fashion. This has clear implications for the ways public issues can be raised on even 'non-fiction' programs. We examine below an example of a 'non-fictional' program that employs many of the devices of 'entertainment' television: an episode of the show *48 Hours*.

Third, television blurs the line between 'fiction' and 'non-fiction' by presenting fictional accounts of issues or events while they are still topical, and by tying these 'entertainment' broadcasts into the news itself, often using each to promote the viewership of the other.[4] In the past few months, for example, many entertainment shows had plots that revolved around the LA riots. With respect to the shows we examine below, ABC ran several stories about Earth Day on their nightly news broadcasts that explicitly referenced the prime time *Time-Warner Earth Day Special*.

And finally, because of the edited, scripted and contrived nature of its production (including 'live' television), in a very real sense *all* television is 'fictional' (see e.g., Seiter, 1987: esp. p.23). Yet, because it is a visual medium and there is a very strong conviction among viewers that 'seeing is believing', television has a great power to render invisible the conventions it uses to construct its treatment of public events. This power to naturalize its coverage makes it difficult to critically analyze the effect these conventions have on the portrayal of public issues.

These characteristics of television are fundamental to the ways in which it influences politics, and are missed because of the ways political television is normally defined. In short, much of what appears on television deals, at least tangentially, with the political (especially if we expand our definition of politics, as we did above). Thus, far from being natural or neutral, the distinction between types of television programs obscures television's impact. Along with theorists like Michel Foucault, we believe that distinctions accepted as natural or 'commonsensical' are not subject to critical scrutiny, and thus operate ideologically in the deepest, unexamined

manner. Such ideological significance can only be revealed by foregrounding these distinctions and subjecting them to critical scrutiny.[5]

Unexamined maintenance of the distinction privileges programs categorized as 'non-fiction' by implying that they can or should present politically neutral, objective pictures of the world. This view fails to consider that narrative devices drawn from other forms of 'entertainment' and popular culture are an inevitable component of any television show. For example, we show in our analysis of *48 Hours* that different segments draw upon the conventions of the Western, the family melodrama, and the police show to tell their stories. The limited number of 'genres' available to journalists shape the kinds of 'stories' that they can and cannot tell on the news. This is especially the case on commercial television where the expectations of viewers are heavily influenced by the devices used on 'entertainment' broadcasts. In our view, such devices have ideological significance, especially at the foundations level of politics (e.g., individualism, democracy, fairness, etc.).

Focusing attention on the 'fictional' devices inevitably employed on 'non-fiction' broadcasts, raises many other issues obscured by the unquestioned use of this distinction. For example, in what sense are network anchors actually journalists? Most do not write what they read. Their careers depend not on the skills traditionally valued by print journalists but rather upon the images they have established as celebrities.[6] As with all television celebrities, their jobs and salaries depend upon the ratings their shows achieve. We might see such people much less as neutral, professional journalists (their carefully cultivated self-definition), and much more as highly paid celebrities employed by large, private corporations that depend both upon governmental regulatory largess and selling time to advertisers interested in particular kinds of audiences. Seeing network personnel this way might affect how we analyze the ways news programs frame such terms as 'capitalism', 'socialism', 'freedom', 'equality', etc. For example, this sort of analysis might be especially revealing in analyzing the ways the networks have used such 'essentially contested concepts' in their coverage of 'The Collapse of Communism' in Eastern Europe (Connolly, 1983).

We would also suggest that prime-time 'entertainment' programming has become increasingly important as a place for the structuring of public discourse. First, all television deals with issues that have relevance for the foundations of politics. That is, it is a medium of communication, constantly watched by mass audiences, that always deals with issues like individualism, authority, community, participation, etc. Second, prime-time shows increasingly deal with the substance and institutions of politics by explicitly addressing the social and political issues of the day (both in docudramas and regularly scheduled series).

Simply listing the unasked questions raised by considering the political implications of 'entertainment' programming indicates the extent to which they have been ignored by social scientists. First, how often does (and has) prime-time programming address(ed) politically significant questions (at all three levels of politics)?[7] Second, what are the conventions, conscious and

unconscious, used by the actors, writers, producers and directors of such shows when they address political issues? How do they define their own role in shaping the public agenda? They clearly do not see themselves as journalists, but how do they see themselves? There are as yet no standards or doctrine (comparable to the doctrine of objectivity or fairness) for critiquing the ways in which such issues are portrayed. Just as authoritative sources define what is news, so too celebrities become 'sources' on entertainment programming by signalizing the importance of events or coverage. What are the effects on public debate of celebrities participating (both in and out of their established characters) in shows that deal with political issues? More generally, how do viewers receive and use the political messages of 'entertainment' programming as they form their own political beliefs and positions? Do they distinguish between news and entertainment programs as credible sources of information?

For example, consider the impact of the popular show *L.A. Law* on the practice of law in America and the way this impact challenges the distinction between 'fiction' and 'non-fiction'. According to two articles in *The New York Times* (Margolick, 1990; Weber, 1990), lawyers increasingly must consider the effect on juries of cases 'tried' on the show. Law school professors use episodes of the show as a teaching tool. Clients increasingly want lawyers who behave like those they see on the show, and dismiss those who do not. Clearly, a prime-time show is having an impact on the way viewers understand the law, the way lawyers practice the law, and the way students are taught the law. Is *L.A. Law* a 'fictional' or 'non-fictional' show? Does it have a political influence and importance that makes it a serious object of study? Even the very placement of these articles in the *Times* highlights the difficulty of categorizing such shows and their effects. While the articles were placed in the entertainment section of the newspaper, they could just as easily have appeared on the front page of the news section, or in the section of the paper that deals with legal developments. Clearly, there is nothing natural or inevitable about the placement of the story, nor is it clear how to categorize the story's subject. Answering such questions mean abandoning as 'common sense' the distinctions that guide social scientists when they examine the medium.

The representation of environmental issues

To explore the issues raised thus far we examine three very different types of shows all dealing with the same general issue: environmental pollution. Celebrating the twentieth anniversary of the first Earth Day in May 1990 pushed environmental issues on to the evening news and, as important to us, on to prime-time television as well. This resurgence of concern over the environment is interesting in and of itself. Environmental pollution is a difficult issue for the mass media, both print and electronic, to cover well.[8] It is an ongoing, slowly changing story that only rarely provides the dramatic events that render an issue newsworthy. It is difficult for journalists to cover the issue on a day-to-day basis and provide readers and viewers with the sort of in-depth information needed to appreciate the complex issues involved.

This is especially so on television, where compelling visuals are needed to push any ongoing story on to the news on any given day. Moreover, when dramatic events do occur (e.g., Exxon Valdez Oil Spill, Love Canal, etc.) they are covered for a brief period of time and in ways that often over-dramatize and simplify the issues involved. For these reasons, the extended attention to Earth Day and environmental issues was quite unusual. While it wasn't any specific change in the condition of the environment, but simply the twentieth anniversary of the first Earth Day that pushed the issue on to television, the opportunity is there to analyze the ways various types of programming (usually thought of as 'fictional' and 'non-fictional') deal with a serious and difficult public issue.[9]

Before beginning our analysis, it is important to emphasize how complicated, politically, economically and technically, the issue of environmental pollution is. In any specific area of environmental concern (hazardous wastes, global warming, air pollution, water pollution, etc.) there is great uncertainty and disagreement among scientific and technical experts over the level of pollution, whether the situation is improving or deteriorating, the overall threat posed by that pollution to the health of the overall ecosystem, and the adequacy and cost of proposed solutions. Appreciating the dilemmas of environmental protection requires some familiarity with this sort of technical complexity and uncertainty.[10]

Politically and economically, environmental pollution poses even more difficult issues. Since most forms of pollution in America are the by-products of private economic activity, dealing with them raises significant questions at all three levels of politics we defined above. At the substance level, specific public policies designed to protect the environment must address questions about the appropriate trade-offs between economic growth and the health and safety of citizens and the environment. At the institutions level, environmental protection raises questions about the role (both in terms of what it is and what it might be) of political institutions as regulators of the activities of private corporations. At the foundations level, environmental concerns address the overall meaning of and relationships among terms like capitalism, democracy, the public good, fairness and so forth. Thus, this issue is particularly appropriate for applying our definition of politics to various types of television programming.

DOCUMENTARY TELEVISION CELEBRATES EARTH DAY

The first program we examine is an episode of *48 Hours* entitled 'Not on My Planet'. This show provides us with an example of what would ordinarily be classified as 'non-fiction' programming: it is a regularly scheduled, prime-time, documentary program produced by the news division of CBS. As is often the case with documentary programming, *48 Hours* does poorly in the ratings and remains on the air as an example of CBS's commitment to public-affairs programming. This particular episode finished at no. 67 (out of 90 shows) for the week with a rating of 8.1 and a share of 14.[11]

A close analysis of the program – its structure, audio and visual

techniques, narrative conventions, etc. – challenges the 'common sense' distinction between 'fiction' and 'non-fiction' television. The show consists of seven brief (4–7 minute) stories dealing with different types of environmental problems: controversy over a landfill in Los Angeles, pesticide use in the San Joaquin Valley, suspected leaks from a petro-chemical factory in Texas, a group that organizes Hollywood stars to participate in environmental issues, concern over a hazardous waste-disposal facility in Alabama, efforts by the Los Angeles Police Department to arrest polluters, and the return of wildlife to the lands around the Rocky Mountain Arsenal. Thus, rather than providing an hour-long, in-depth treatment of a single issue, or a unified overview of environmental problems, the show is broken down into smaller separate stories.

However, while the stories address different environmental issues, they are all similarly structured. Each story has 'heros' – in all but one episode the hero is an 'average' citizen combating pollution in his/her own neighborhood. Six of the seven stories have villains – usually the spokesperson for either government or business. Each story, while posing a difficult problem with which the citizen-hero grapples, also offers a cause for hope or optimism, usually in the form of some solution that, while not yet perfected, looms on the horizon. Each story emphasizes the emotional and personal reaction of individuals to the problems they face, rather than attempting to address scientific, political or economic difficulties. Thus while the show might be categorized as 'non-fiction' because it purports to describe actual events, it frames and tells these stories within a single overarching narrative structure drawing heavily from other forms of television programming, especially 'fictional' dramas (but also other 'non-fictional' programs like *60 Minutes*). The stories use conventions drawn, for example, from other genres of television programming like the Western, the cop show, the family melodrama, and the celebrity-news *Entertainment Tonight* format.

The similarity in the narrative structure used to tell all seven stories takes precedence over any attempt to deal with the differences and complexities of the seven, in many ways quite distinct, issues. The strength of the narrative devices, the short-story format, the reliance on graphics and rapid cutting between shots all indicate the degree to which the conventions of television and television viewing (e.g., switching between shows in search of arresting images, the need to engage viewers on an emotional level with dramatic visuals and touching personal stories) tend to break down the distinction between 'fictional' and 'non-fictional' programming. While these narrative conventions are needed to make the specific stories entertaining and easily accessible to viewers, they are far from being politically neutral.

The show itself opens with a computer-animated logo and a series of rapid cuts among scenes, drawn from the various stories that will follow. Dan Rather, the 'host'(?), 'star'(?), 'anchorperson'(?) narrates opening and closing segments that define the overall narrative into which each of the following stories will be fit. Rather's segments are remarkable for the way

they implicitly establish the specific political discourse within which all the stories will operate:

> **Rather:** For most people Earth Day used to conjure up images of long-haired activists in tie-dyed shirts . . . no longer . . . Most Americans say the air they breath and water they drink is worse than ever . . . Americans say clean-up help isn't coming from government or business, so they're taking up the fight on their own.

This is a message rich with significance for understanding the way television deals with the foundations of politics. It signals that, while it used to be associated with 'radicals' outside the mainstream of American politics and hence not worth serious consideration, now environmental concerns are acceptable because 'average' Americans realize that their air and water is polluted. However, large institutions are not the solution, rather those same 'average' Americans operating as individuals and certainly not as radicals, will solve the problem on their own (as opposed to seeking to reform those large institutions). This opening also specifies the way in which the show will deal with scientific uncertainty: the ultimate criterion is not what experts say, but what Americans believe. Rather does not even raise the issue of whether the air and water are *actually* worse than ever (since one must first specify which water and what air we are talking about and even then there is much disagreement about how to answer this question); instead, if public opinion concludes that pollution is getting worse, then it is. This reinforces the emphasis on individual action and the wisdom of 'average' Americans as opposed to the confusing findings of experts located within those suspicious and ineffectual government institutions.

The way these foundational issues are defined provides the framework within which the specific stories, overtly dealing with the substance and institutions of politics, operate. At the level of the substance of politics, these stories deal with a diverse group of issues. Yet, there is never any on-camera discussion of what makes these stories similar or dissimilar. Instead, it is the narrative structure and its definition of the foundational issues involved, rather than any overt discussion that makes them seem so similar. We discuss two segments to emphasize the degree to which seemingly 'non-fiction' television employs narratives and formulas that owe much to the conventions of 'fictional' television and other forms of popular culture.

The segment on pesticide pollution in the San Joaquin valley, entitled 'Growing Concern', follows the overall narrative structure. Lasting eight minutes, it opens with the strongest possible emotional appeal: a group of parents discussing their dead children. These parents are convinced that pesticides used by nearby farmers caused the death of their children. Experts are not so sure. The story quickly focuses on the family of Kevin who died in 1986 at the age of eleven. While the show deals overtly with pesticides, it avoids considering the public policy implications of the issue by using the conventions of the family melodrama to focus on the private struggles of the family to deal with Kevin's death. Kevin's doctor, representing expert opinion, states that medical researchers, in fact, don't know what caused

Kevin's illness. However, cutting rapidly from the doctor, in a white coat acting unemotional and removed from the tragedy, to the family itself blunts the impact of expert information and reinforces the idea that it is the parents who truly 'know' what caused their child's death. While the strong emotional message of these scenes cuts off any serious debate over whether pesticides killed the children, it does create powerful, gripping television. In one scene Kevin's brother, while thumbing through photographs of Kevin, talks about what his brother's death means. He explains that the family launches balloons with messages for Kevin to read in heaven ('Hi Kevin. Everything is fine here. What's it like up in heaven?' reads one). The episode later closes with the actual balloon launching at Kevin's grave: Kevin's brother stands alone watching the balloons rise, presumably to heaven, while his crying parents hug each other. Indeed, as with much television, the entire episode engages our emotions more than it engages us in any sort of public debate over appropriate policies.[12] We do not believe that emotions can be, or should be, sharply separated from 'factual' understanding of public issues. Indeed, the sharp distinction between affective and cognitive understanding processing is one of those ideologically significant distinctions − like 'fiction' versus 'non-fiction' − assumed to be clear, but not adequately examined by mainstream social scientists. Nevertheless, it is interesting that much of the emotional tug of this episode flows from its borrowing from other television genres (e.g., family melodramas; medical shows, etc.); rather than any overt discussion.

All of this is pretty grim, but part of the formula is the need for some optimism. Here that is provided by a farmer (the individual as hero) who, after his son developed leukemia, turned to organic farming. The episode presents this as an individual, personal decision arising from his own tragedy. This hero is contrasted with a scene of other farmers sitting around in a restaurant drinking coffee (the hero farmer is never seen at rest, he is always out working on the land) who are reluctant to abandon pesticide usage. Unlike the hero farmer or the families of the dead children, who base their decisions on personal experience, these farmers coldly debate the economic costs and benefits of using pesticides. Nevertheless, one is left with the feeling that organic farming is the wave of the future.

The issue of government regulation − laws that would prevent the use of pesticides − or any sort of government or business action or responsibility is never raised. Instead, we are all implicated as individuals: it is American consumers' demand for good-looking produce that the farmers say keeps them spraying. Further, collective or coercive action that will solve the problem (by fighting for such laws, for instance) is never considered; instead, it is the hero farmer and the convictions of the grieving parent that hold out hope. Amazingly, this episode was followed by a commercial for Scott's Turf Builder Fertilizer.[13]

A second episode, 'Next Door Neighbor', also follows the narrative structure closely. It employs the conventions of the Western (especially *High Noon*) with a lone individual facing down the dangerous invaders of a small Texas town. The story chronicles the struggles of Diane Wilson, a heroic

fisherperson turned activist who is trying to monitor suspected leaks from a chemical plant near her home in Sea Drift, Texas. Lest we miss the Western flavor, the narrator calls Wilson 'an environmental Lone Ranger'. The six-minute story follows her as she tries to cope with the demands of family and job at the same time as she tries to arouse the community to the threat posed by the company. Here, the conflict necessary to drive the narrative is provided by a villain: a foreign-owned company with a long record of pollution and spills. The image of the company clearly plays upon anxieties about the vulnerability of the American economy and workers to foreign investment (the plant, 'Formosa Chemicals', is owned by a Taiwanese company). The issue of whether the factory actually is polluting is never addressed: it is enough that the hero – Diane Wilson – thinks they are. She is shown at a town meeting trying to arouse the citizens of the town but, as in *High Noon*, most of them are fearful for their jobs and the end result is that Wilson is left to carry on by herself.

Again, the story emphasizes the idea that the solution to these issues will not come from government or other institutions. In one scene an 'environ-mentalist' (Tonto?) helping Wilson take water samples is asked why the state or EPA isn't doing this (we never find out whether the samples reveal pollution from the plant). He responds, 'They don't have the resources or the political will. All across this state and country, you're going to find citizens out doing the job state and local agencies ought to be doing. That's just the reality of it.' Thus, while institutions are deeply flawed and not to be trusted, that is just how they are ('the reality of it'). Echoing the mythology of the Western, the solution lies not in institutional reform or political organizing, but in individual action.

After all seven episodes, Dan Rather returns to sum up with a rather remarkable closing statement:

Americans tell us pollution is hitting very close to home. Twenty per cent say they know someone personally whose health was damaged by pollution. Seven per cent say they know someone who has died [presumably from pollution]. But are Americans committed to doing something? Yes, say those who responded to our poll. Three out of four say the environment must be cleaned up, no matter what it costs. In fact, they'd even pay higher taxes to do the job. I'm Dan Rather.

This statement succinctly repeats the message of the narratives employed in the seven stories. First the use of public opinion, because it registers the views of average Americans, is the final arbiter of reality: the issue of whether people can really know whether the health problems or deaths of specific individuals actually resulted from pollution is ignored. Experts may disagree, but it is the common-sense perceptions of average Americans that really count. As with the specific episodes, despite the grim statistics the show ends on an upbeat note. There is hope because Americans are 'committed to doing something'; exactly what is never stated. However, that slight omission is unimportant because all that matters, within the confines of the discourse that the show establishes, is that Americans want something

to happen (clean up the environment 'no matter what the cost') for it to happen. This is a theme to which we shall return, since in all the shows we examined (through a variety of devices) television has come to celebrate itself as a place where a form of populist or direct democracy can take place. This vision of a perfected, direct democracy wherein citizens can rule for themselves without the corrupting influence of 'big' government at a distance from 'the people' is a deeply rooted yearning in American political thought: political scientist James Morone (1990) calls it the 'democratic wish'.

Our point in this analysis is that a supposedly serious 'non-fiction' show employs many of the devices of 'fictional' television and is no more serious, neutral, or accurate than 'entertainment' shows. The result of the infiltration of the conventions of 'entertainment' television into the province of 'non-fiction' programming is a show that operates at a variety of political levels, but ultimately treats a public issue in a way that mocks serious debate. The failure of the show to deal any more seriously with this issue than supposedly 'fictional' television is illustrated when we turn to a docudrama that deals with toxic-waste pollution.

TED TURNER TACKLES TOXICS

Incident at Dark River, a two-hour drama about toxic-waste pollution, was produced by and appeared on Turner Network Television several times in the months before Earth Day. While it would be categorized as a 'fictional' program, *Incident at Dark River* deals with many of the same public policy issues as *48 Hours* and in strikingly similar ways. At the center of the story is an heroic 'average' small-town American who is convinced, while experts are not, that his child has been struck down by industrial pollution. He is helped not by government or industry (both of which are revealed as corrupt and inept), but by a sidekick (here, an ecologically aware college student). As with *High Noon* and the 'Next Door Neighbor' episode on *48 Hours*, in the end the hero cannot count on his neighbors (frightened as they are for their jobs), but must act alone to deal with the threat to his community posed by an evil corporation. As with the 'Growing Concern' episode on *48 Hours*, a central dramatic element of the story, drawn from melodrama, is the struggle of his family to come to grips with a child's death. Despite these similarities, because of its two-hour length and its focus on a single type of pollution, *Incident at Dark River* in many ways provides a more sophisticated, in-depth and balanced story than does the 'non-fictional' *48 Hours*.

Incident stars (and was written by) Mike Farrell as Tim McFall, a maintenance worker at a college in a small town at the foot of the Rocky Mountains. McFall's daughter Kathleen is rushed to the hospital with a mysterious brain ailment after playing by the river that runs past her house. McFall gets no answers from rather surly and condescending doctors (the medical profession does not fare well on either *48 Hours* or *Incident*). Later, he finds his daughter's doll, reeking of chemicals, lying by the river near a pipe running out of a local chemical plant. Starbrite Chemicals, the villain of

the piece, is the largest company in the town and most townspeople, including those at the college, are dependent upon the company. We learn at the very outset that the company is illegally dumping untreated wastes into the river and that the company's chief executive, despite the pleas of concerned engineers, is unwilling to stop production long enough to remedy the situation (thus, as with the other shows, scientific uncertainty is never an issue – cause and effect relationships are always clear and unambiguous).

McFall has the doll analyzed by his friend, a professor at the college, and finds that it is contaminated. He goes with his friend to Starbrite and they meet the slick, public-relations director of the company. They receive a tour of the plant (on which the viewer learns more about the technology of waste treatment than he/she does on 48 Hours) and bland reassurances that the company is not to blame. Unconvinced, McFall uses the college library to do his own research into hazardous waste. There is a club of students concerned about the environment and he turns to them for help. He finds in the club, Dan Rather would be happy to note, a 'long-haired activist'. It turns out that McFall knows more about hazardous wastes than the students (since as 'long-haired activists', they admit to being more concerned with 'saving the whales and things like that' than the concerns of average, sensible Americans like McFall) and the show uses this as an excuse to have him educate them (us). In fact, here we get the same sort of 'factual' information as we do on 48 Hours:

> **McFall**: [Starbrite] uses heavy metals – lead, mercury, cadmium. You know about heavy metals? You dig that stuff out of the ground, sooner or later every bit of it – hazardous waste. The petrochemical industry in this country alone – 2½ million metric tons of toxic waste chemicals every year.

The students suggest that McFall go to the EPA for help and a female student volunteers to go with him. As you would expect, consistent with the conventions of the melodrama, she and McFall will have a brief flirtation. The rest of the show is a picaresque tale of McFall and his female companion finding out about the flaws and limitations of all the institutions to which they turn for help. They first find out how spineless academics are as allies (no surprises here) when the President of the college, pressured by Starbrite, warns McFall's friend to stop helping. The professor slinks away (once again, experts come off as an unreliable source of support or information). McFall and his companion find that the EPA, in the person of an obnoxious, officious and vaguely corrupt woman, will be no help:

> **Student**: So, the company says 'not guilty' and you say 'Oh thank you'.
> **EPA Official**: You don't understand the way the EPA works.
> **McFall**: I think I'm starting to.
> **EPA Official**: Basically, industry is supposed to be self-policing.

McFall: And your're here to help 'em out. Isn't that funny, I thought it was the public you were supposed to protect.

Soon thereafter, Kathleen dies and there is a touching scene at the graveside (quite similar to the balloon launching scenes in 'Growing Concern') between McFall and his son Pat who blames himself for his sister's death.

McFall and the student resume their quest by confronting the President of Starbrite. Here, unlike on any of the other shows, an element of the class basis of environmental politics is introduced.

President: If I thought there was a grain of truth in what you're saying, I'd get out of the business. I live in this community too. We share the same space on this planet.
McFall: My guess is that your family and friends share the same space in the swimming pool at the country club, not at the river.

McFall then turns to a local reporter who finds an employee of Starbrite who confesses that the company has, indeed, been dumping in the river. Here again, though, the actions of heroic and well-meaning individuals are foiled by corrupt institutions. The local newspaper, pressured by Starbrite, won't run the story. This prompts this critical and cynical outburst from the reporter to McFall:

Reporter: The guy who said the press is free only if you own one was wrong. It's still not, it's who pays the piper calls the tune and in this town that's Starbrite. All that First Amendment crapola they feed you, 'Congress will make no law . . .' Congress doesn't have to make a law. The fix is in man . . . Ever wonder what would happen if everybody figured out the way this country really works?

However, the reporter manages to get the story published in a nearby paper. The resultant publicity turns many of his friends against McFall, who is seen as trying to drive Starbrite out of town and cost them their jobs. McFall's wife, who has been critical of his efforts to uncover the truth about Kathleen's death, leaves him (thus setting up his flirtation with the college student).

Still nothing happens. The company denies responsibility and McFall is disillusioned. Here, the show confronts the problematic relationship between knowledge and action. In contrast, *48 Hours* avoided this thorny political problem by simply assuming that public opinion translates into policy solutions. The student lectures McFall that, if he wants anything to happen, he must do more:

Student: People need to be directed. You have to give them some direction. You can't just sort of let them know all this stuff is going on and expect them to straighten it out. It's like you're saying, 'Here's this problem, I've identified it, you go fix it'. It won't happen. It doesn't work that way.

McFall calls a town meeting and a scene results that is remarkably similar to the scenes of the town meeting called by Diane Wilson in 'Next Door

Neighbor' (both nostalgically evoke the New England Town Meeting). A debate occurs that, while brief and superficial, provides the show with a sort of balance sorely lacking in the other two shows we examined. Townspeople speaking at the meeting are used as a device to articulate the various perspectives that exist on pollution, risk, economic blackmail, and so forth (i.e., some claim Starbrite isn't dangerous, others say they need their jobs, others say that they owe it to their children to find out more, others argue that EPA will protect them, others that the government's risk standards are too lenient, etc.). Nevertheless, as with Diane Wilson's meeting, the town meeting in *Incident* ends inconclusively.

While political efforts in the real world may end inconclusively, the conventions of television drama (observed in both 'fictional' and 'non-fictional' television) require a more satisfying conclusion. One difference between *48 Hours* and *Incident* is that the former provides the 'happy ending' by assuming that public arousal will lead to a solution. The 'fictional' program gets to show the happy ending. Consistent with the conventions of the Western, the satisfying resolution comes through violence. Immediately following the town meeting a professor from Johns Hopkins (called by McFall's professor friend before he was scared off) appears at McFall's house and assures him that his daughter was indeed killed by pollution from Starbrite (thus, any lingering questions of causality are eliminated). McFall drives his pickup through the gate at Starbrite, takes out a sledge-hammer and tries to smash the valve that dumps waste into the river. He is restrained by employees, but his wife (who just happens to be there), in an act of reconciliation, picks up the hammer and finishes smashing the valve forcing the factory to close down and, presumably, remedy its disreputable practices.

THE SOLUTION IS IN THE STARS: THE TIME-WARNER EARTH DAY SPECIAL

While the two shows we just discussed represent infiltration of the conventions of 'fictional' programming into 'non-fictional' programming and vice versa, they are still recognizable as examples, albeit changed examples, of the documentary and the docudrama. However, one of the characteristics of television is that it constantly changes in ways that challenge the typologies we have for describing it. The final show we examine, the *Time-Warner Earth Day Special* demonstrates how the infiltration of conventions produces new sorts of shows that defy easy categorization. As Candice Bergen-Murphy Brown says on the show, 'I'm not quite sure what's happening here, it's difficult to describe.' We couldn't agree more.

The special was aired on ABC from 9:00 to 11:00 on Sunday night, the most popular evening, in prime time. The entire show was sponsored by Time-Warner and hence all commercials, with the exception of promos for other network shows, were for the communications giant. Unlike the other

shows we have examined, *The Earth Day Special* did quite well in the ratings: it was the 16th most watched show that week, the same week that our episode of *48 Hours* finished 67th, with a rating of 14.6 and a share of 24. This means that millions of television sets were tuned in for the consideration of an important issue high on the public agenda.

Walter Lippmann once defined news as the 'signalizing of important events'. By this definition, *The Earth Day Special* is a news program: it signalizes the importance of environmental issues. However, the signalizing works not through reporting on events or by consulting authoritative sources, but through the celebrity power of those who appear (act?) on the show. Thus, while it deals overtly with environmental issues and hence might be categorized as 'non-fiction', the show and its significance cannot be understood by anyone not immersed in the world of 'fictional' television and popular culture. The high ratings are evidence of how successful, especially when compared with news programming, celebrities from the world of entertainment are at signalizing events. Promotion of the show focused on the stars who would appear, indicating to those familiar with popular culture an important event indeed: they ranged from television stars (Bill Cosby, Rhea Perlman, Candice Bergen), to movie stars (Kevin Costner, Meryl Streep), to musicians (Quincy Jones, Barbra Streisand), to celebrity experts (Carl Sagan). Further indicating the importance of the show was the crossing of media (i.e., from film to television) and the networks (i.e., NBC and CBS stars appearing on an ABC show) by these personalities.

Before the credits appear, the show opens with Danny DeVito and Rhea Perlman sitting in a living room preparing to watch *The Earth Day Special*. Throughout the show, they reappear as the audience and signal to us the changing emotions we are supposed to experience at each stage of the show (sort of an environmental version of Kubler-Ross's stages of grief): denial of environmental problems; shock at recognition of the severity of the problems; hopelessness and depression; finally hope and optimism at what each of us can do as individuals to solve the problem. But how are we to take these two characters? On the show they are 'Vic' and 'Paula', rather than Rhea and Danny. Yet, there is no character development and we learn nothing about Vic and Paula. Instead, our understanding depends on us knowing that in 'real life' Perlman and DeVito are married. Thus, in a blurring of 'fiction' and 'non-fiction' that will be repeated again and again throughout the show, our understanding of these characters depends on our knowing their 'real-life' relationship (or what we assume to be their real-life relationship, itself a carefully crafted 'fiction') and the roles they have played on television and in the movies. If this discussion makes you slightly disoriented, hold on, it gets worse.

After our brief interlude with Vic and Paula, the actual show begins. We see computer graphics of the planet Earth over which are superimposed the lengthy list of the celebrities who will appear on the show. The list includes actors, musicians, Hollywood directors, cartoon characters (e.g., Bugs Bunny), puppets (e.g., The Muppets) and space aliens (e.g., E.T.).

The show takes place in a small town (as does *Incident at Dark River* and

virtually all the stories on *48 Hours*). Here again, the viewer immersed in popular culture knows that the townspeople are played by the casts of various daytime soap operas. The first celebrity to appear is Robin Williams, dressed in loud polyester clothing, who, in his well-established comic persona, preaches to the 'townspeople' about the virtues of mindless progress and the transition of humans from 'hunter-gatherers to shopper-borrowers'. Suddenly, the sky darkens, hi-tech lightening flashes and we find out that Mother Nature-Bette Midler is dying from the abuse caused by the excesses of progress. She descends from the sky, collapses and is rushed to the hospital where she is attended to by various actors who play doctors on television shows. Throughout the rest of the show, Candice Bergen-Murphy Brown stands outside the hospital and reports to us on Mother Nature-Bette Midler's condition (no, we are not making this up). The whole first segment, then, situated as it is in small-town America, serves as a nostalgic critique of progress and the Time-Warner commercials in this segment continue this theme: there is one for Henry Luce's founding of *Time Magazine*; one for the creation of Batman (D.C. Comics is owned by Time-Warner); and one for Woodstock (Warner Brothers Records).

After the commercials comes an extended segment designed to inform us of the 'facts' about the ills afflicting Mother Nature. Perhaps more than anywhere else on the show, this portion illustrates the futility of trying to distinguish between 'fiction' and 'non-fiction' television. As with 'non-fictional' television, experts are relied upon to provide us with information (however, such experts are only to be trusted when they present information that unambiguously agrees with the dominant perspective of the show). The first expert is Carl Sagan who explains the Green House Effect and Ozone Depletion to an audience of Soap Opera Cast-Townspeople. He gets one minute on the former and 35 seconds on the latter. We then switch to a short episode of the quiz show *Jeopardy* for more information about environmental issues. The next 'expert' to provide us with information is Harold Ramis in his character from the movie *Ghostbusters*, who tracks down Martin Short playing (in a character he has developed on *Saturday Night Live* that, in turn, is a take-off on *60 Minute* interviewee-victims) the sleazy, evasive spokesperson of a polluting firm. The next expert is Christopher Lloyd in his role as Dr Emmette Brown from the *Back to the Future* movies. The doctor arrives in his time-traveling automobile (replete with special effects by Steven Spielberg) and rushes to the hospital with news from the future. This news actually consists of a series of unconnected clips of current environmental degradation (hunting elephants, giant garbage dumps, polluted water, polluted air, etc.). What is the viewer to make of this? Does it matter that information is provided by 'fictional' characters as opposed to celebrity-experts like Carl Sagan? We fear that even posing such questions indicates how inadequate our categories are for capturing what is going on in this show.

At this point, the tone of the show changes from one of pessimism to optimism. The change is signaled in several ways. First, the type of commercials shift from nostalgia to celebrations of technological progress:

one is for sound movies, several others tout cable television. In short, technological progress, at least when managed by Time-Warner and not Robin Williams, has actually improved our lives.

Second, Carl Sagan returns to announce to the Soap Opera-Townspeople that there are solutions to environmental problems. Here, he sets the stage for the types of solutions that will be considered. As with the other shows we examined, whatever the problem, the only solutions are individual, not collective or political. Sagan says, 'Acid rain problems can be dealt with. Industrial pollution can be limited.' How, one might ask? 'Every one of us must do our part.' How will every one of us know what to? That's easy, the solutions will be provided by space aliens! Yes, lurking behind a garbage can is E.T. (the ultimate expert) who, saddened by environmental problems, produces a glowing book containing everything we can do (as individuals of course) to save the environment. He hands this over to the children of the town. This book is used throughout the rest of the show as a guide for solving environmental problems.

The rest of the show consists primarily of a series of celebrities (Jack Lemmon, Morgan Freeman, Michael Keaton, Meryl Streep, Kevin Costner, etc.) playing townspeople who talk about what they will do as individuals to save Mother Earth. We return to Paula and Vic, who discuss how they will begin to recycle their aluminum cans and put a plastic bottle in their toilet. The Cosby Family appears, in their television characters, discussing how they will do their part by not lifting pot lids while cooking, turning down the thermostat, and not keeping the refrigerator door open while searching for food. Emphasizing the importance of individualism, it is pointed out that all of this will save Bill-Cliff money.

Limiting discussion to individual solutions obviously restricts the range of options – basically all the advice boils down to turning down the thermostat, tuning up the car and other household appliances, and recycling, recycling and more recycling. Again blurring the line between 'fiction' and 'non-fiction', in addition to celebrities playing various characters, this segment also contains brief stories of 'real people' who run recycling programs in their communities and schools.

The closest this segment gets to an explicit consideration of government's role in environmental regulation is a vague injunction to 'check out Senators and Congressmen on the environment'.[14] The responsibilities of elected officials are addressed by a small child who says, 'I think that anyone who holds public office should care about the Earth'. No doubt this leaves quaking all those politicians who run for office on a platform of hating the Earth.

The show ends with a final blurring of the line between 'fiction' and 'non-fiction' programming. Feeling better, no doubt due to the commitment of humans to keep their cars tuned up, etc., Mother Earth-Bette Midler emerges from the hospital to address the Soap Opera Cast-Townspeople. She asks if it is OK to 'drop the mask for a moment' and address the audience as 'just Bette Midler'. Robin Williams also drops out of character. They face the camera and tell us:

Midler: I'm Bette Midler. I live on this planet. I share it with you. I belong to a movement that is a grass-roots movement, it's a movement to save our planet. This movement is not a hype and being part of it is not a trend. We sincerely believe that our earth is at risk. Since our earth is at risk, we the people of the planet are at risk as well. It's going to take a whole lot more, though, than just one television show and all our good intentions to save Mother Earth.

Williams: And I'm Robin Williams and these are Wayne Newton's clothes. And I'm here tonight to say we gave you the information, now it's up to you to get active. You can do it, it makes a difference. Go out there, recycle, you can do that. Vote with your hearts, vote with your hands, vote with your dollars, and vote with your votes. Don't wait for the politicians. Come on, they're going to read an opinion poll one day and say, 'Maybe now I'll do something.'

Midler: So what do we know? We know that the earth does not belong to us, we only inherit it for a very brief moment in time and then we pass it along to our children.

Williams: We're a kinder, gentler nation. Come on, let's act like one. We know that all things in nature are connected, that all things are interdependent.

Midler: We know that whatever happens to the earth will surely happen to us. We didn't weave this incredible tapestry of life, we are only part of it . . . And so, we're counting on you. Yeah, we're counting on you to get off your cans and recycle. Recycle! Reuse! Reduce! Replace!

Williams: And most of all rejoice! You have an incredible gift here. Don't blow it. Wise up.

As with the framing remarks of Dan Rather in *48 Hours*, there is much going on in this concluding segment. There are the confused politics: Can a political movement involve everyone on the planet? How can we join? Isn't there a difference between organizing for a collective, political purpose and simply acting, as the show advises us to, as individuals? Yet, given the underlying foundational politics of the show, the only solution is individual action. Hence, when all is said and done, the only advice the stars can offer is recycling (said in a variety of different ways – reusing, reducing, etc.)

More relevant to our discussion of the blurring of 'fiction' and 'non-fiction' is the question of how we are to understand this dropping of 'the mask'. Midler and Williams did not write what they read here any more than they have written their other lines (or any more than Dan Rather, for example, writes the lines he delivers[15]). They have dropped one mask (playing characters in the show), but they still appear to us as their celebrity selves and we cannot know the difference between this mask and the other 'selves' they might have (e.g., parents, husbands/wives, friends, etc.). The show creates the 'fiction' that we are now seeing the 'real' Robin and Bette, but can we ever really know celebrities in this sense? Are celebrities who earn millions of dollars a year just simply citizens of the planet like us? In short, as when Dan Rather tells us on the nightly news that he will see us tomorrow,

we are confronted here with the irreducibly 'fictional' quality of television (see Seiter, 1987).

The politics of television's treatment of environmental pollution

Just as these three shows all use similar conventions that blur the line between 'fiction' and 'non-fiction', so too they adopt a remarkably similar political perspective that further challenges our common-sense distinctions between various types of programming. Interestingly, the political slant shared by the shows changes as we move between the three levels of politics we defined above.

At the substance level of politics, all three shows adopt a liberal perspective in defining the issues posed by environmental politics. First, they all employ a catastrophic perspective on environmental problems and the risks posed by pollution. They assume that environmental pollution of all types is worse than ever, that each form of pollution poses a grave and immediate threat to humans and to nature, and that we must do something now. This may or may not be accurate, but it is certainly not the only perspective. As we have noted, there is much disagreement about the actual severity of the problems and the risks they pose. Yet, no serious attention is paid on any of these shows to scientific uncertainty, or the relative risks posed by various forms of pollution.

Second, none of the shows seriously address the trade-offs between regulation and economic activity. The notion that reducing pollution may require reduced economic growth is either not addressed, ridiculed as a ploy by unscrupulous businesspeople or the shows suggest that reducing pollution will be good for the economy. In short, when dealing with environmental regulation these shows present a comfortable liberal perspective that ignores or ridicules the questions raised by conservatives or more radical environmentalists.

At the institutions level of politics, all three shows are critical of the problem-solving capabilities of political and economic institutions. Government (in the form of politicians, the EPA, or state environmental agencies) is seen as corrupt, incompetent and completely inadequate to the task of dealing with the problems posed by environmental pollution. Thus, all three shows make it quite clear that we cannot count on government to help solve this problem. Nor can we count upon business to act responsibly. In all three shows, the business sector is represented by either evasive corporate spokespersons or shady and disreputable owners. In either case, they cannot be trusted to either obey the law or act responsibly.

While the politics of these shows at the institutions and substance levels supports the view that television has a liberal bias, or that it can be used for oppositional purposes, a very different perspective emerges when we move to the foundations level of politics. Here these shows all adopt a 'nostalgic individualism' that is extremely conservative and serves to blunt, in terms of political action, the more critical messages of these shows. First, all three shows are set in small-town America. *Incident at Dark River* is set in an

unnamed small town in Colorado. Most of *The Earth Day Special* takes place on a set designed to evoke nostalgia for small-town life. Four of the seven episodes on *48 Hours* are set in small towns (a fifth, although dealing with garbage in Los Angeles, is shot almost entirely in sparsely populated hills outside the city). While such settings are quite common on television, they have political significance for the way we understand environmental problems. By evoking an image of small-town life, where people know each other and can have a real impact as individuals, many of the problems of collective political action are slighted. The small-town setting allows all three shows to use the image of the New England Town Meeting as a forum for discussing public issues.

Indeed, television itself emerges in these shows as the place where this 'electronic town hall' can occur. This self-promotion of television as a substitute for the failed politics of existing political institutions is reinforced by the implicit assumption that television, through a variety of mechanisms, can more effectively represent citizens' opinions and interests than traditional political institutions or traditional forms of political action which are scorned, ignored, parodied, or need to be carefully monitored by television journalists.[16] In many ways, here at the foundations level, television plays on the deep-seated suspicion in American politics that any large institutions – be they public or private– are threats to democracy, and thus inherently corrupt. As we noted above, the American solution to this dilemma is 'the democratic wish' for a truly perfected citizenry that might rule on its own behalf without the corrupting interference of institutions that distort the relationship between the 'people' and political power (Morone, 1990). Because television's status as a large and powerful institution remains invisible in these shows, the medium seems to offer the possibility for such direct democracy. Certainly that is the implicit claim made in the use of infomercials by Ross Perot and national town meetings by President Clinton, where the illusion of an unmediated relationship between political leaders and the public is created.

We call such devices and the settings of the shows we discuss here illusions because they presuppose the existence of a self-conscious community and an active public sphere, things that do not exist for most Americans who live in urban or suburban settings. Further, the small-town setting diverts attention from the urban and suburban lifestyle of most Americans which may be an environmental problem in and of itself (i.e., the reliance on automobiles for transportation, pesticide usage on suburban lawns, the general emphasis on consumption). Ironically, it was this consumption-based life that was the target of many of the 'long-haired activists in tie-dyed shirts' who organized the first Earth Day.

Second, while institutions are portrayed as flawed and inadequate, the solution is never political organization aimed at institutional reform or change. Rather, individuals, acting on their own as individuals, are seen as the solution to the problem. Thus, in *Incident at Dark River* and several episodes of *48 Hours*, it is the heroic individual (straight out of the Western) who recognizes the problem and seeks to solve it by taking matters into

his/her own hands (see, e.g., Cawelti, 1970). When Diane Wilson or Tim McFall want to find out about pollution in their towns, they must act without government or expert help. Further, they do not appeal to government to change, rather, they see the inevitable flaws of 'big government' and 'big business' and work instead as two of the 'thousand points of light' we now rely upon to solve our social problems.

This emphasis on individualism as the only possible solution obviously limits the sorts of solutions that can be considered. Since cleaning up the environment has all the characteristics of a 'public good' and any solution is likely to involve a significant 'free rider' problem, individuals acting on their own are unlikely to ever solve the problem (Olson, 1965). Yet, the only solution offered on these shows that is designed to call forth any sort of action by viewers is recycling. Since consumption, in general, cannot be called into question, and we cannot count on political or economic institutions to regulate systematically the by-products of productive activity, the only solution is for individuals to consume, not less, but more wisely. Thus, on *The Earth Day Special*, after two hours of horror stories about the illness of Mother Earth, the only thing the stars can ask us to do is to recycle our cans and bottles, actions unlikely to significantly affect the destruction of the rain forests, the extinction of many plant and animal species, global warming, or the choking air pollution in many Third World cities (all problems briefly alluded to on the show). Indeed, it is interesting that where these shows deal with issues not easily solved by recycling, or other sorts of individual action (e.g., *Incident at Dark River*, or the Diane Wilson episode of *48 Hours*), they end without any real message or calls for action.[17]

Conclusion

We have argued that understanding the political impact of television requires both expanding our definition of politics and abandoning preconceived distinctions between 'fiction' and 'non-fiction' programming. Our analysis of programs dealing with environmental pollution indicates that this distinction is not helpful for categorizing shows in terms of their political relevance (especially when we expand our definition of politics). For us, television is best seen as a dynamic and changing medium (indeed these changes are often enormously entertaining and horrifying at the same time, as in *The Earth Day Special*) that routinely deals with politics in most types of programming.

However, while television deals with politics on a wide variety of shows, it does not deal with politics in a wide variety of ways.[18] While it may be possible to find specific instances of counter-hegemonic messages in television shows, it is important to not lose sight of the overall impact of the medium as an important mechanism for reinforcing the *status quo*. That is, taken as a whole,[19] the medium is firmly situated within and supportive of a consumer culture hostile to any but the most modest forms of oppositional political action.

Thus, all three shows we analyzed were liberal at the substance level of

politics and quite critical of government and business at the institutions level of politics. However, the overall impact of any critical messages are blunted at the foundations level where all three shows adopt a 'nostalgic individualism' which excludes any responses to environmental problems that might call into question consumer culture, the political status quo, or present economic-industrial strategies.

A final issue we raise involves the status of our 'reading' of these three shows. While we hope we have convinced the reader that the messages we discern are 'really' in these shows, we have not addressed the issue of whether audiences actually use such programs in constructing their understanding of environmental issues. To answer this question we have conducted a series of focus-group experiments that involve showing these programs to small groups and then comparing the discussions about environmental issues that result (we also run groups where no television is watched). While it is beyond the scope of this paper to report systematically our findings, one thing is clear: viewers use and rely upon 'fiction' programs in their discussions at least as much as they use 'non-fiction' programs (see Delli Carpini and Williams, forthcoming). It seems clear, then, that viewers do not share the assumption upon which most social scientific research into television's political impact is based. That is, viewers do not assume clear distinctions between politically relevant 'non-fiction' television and politically irrelevant 'fiction' television.

Notes

1 One of the major purposes of this paper is to show the degree to which 'common sense', and therefore unexamined, usage of certain key terms has limited our understanding of the impact of television on politics. We bracket many terms with quotation marks not to be irritating or inexact, but rather to draw the reader's attention to the problematic nature of their usage.

2 For a more complete discussion of these issues and our own perspective see Delli Carpini and Williams (1989).

3 For scholars who have made similar critiques of the privileged status accorded the news, see Edelman (1988), Fiske (1987: ch. 15), Postman (1984) and Tuchman (1987).

4 For example, a CBS docudrama on Oliver North was rushed on to the air so that its broadcast would coincide with the actual trial of Colonel North: the trial, the docudrama, and people's responses to both become subjects of stories on the nightly news.

5 For theorists who make similar sorts of arguments, see Connolly (1987) and Edelman (1988).

6 For an entertaining account of how these sets of values clash in high-profile anchor persons, see Joyce (1988).

7 For an interesting, but rare, systematic attempt to answer this question, see Lichter, Lichter and Rothman (1991).

8 On this, see Hertsgaard (1990).

9 On the idea that anniversaries constitute news events, see Romano (1986).

10 For a more detailed discussion of the issues raised in this paragraph and the next, see Williams and Matheny, forthcoming.

11 The rating indicates that 8.1 per cent of all television sets in the United States were tuned to the show. The share indicates that of all sets turned on at the time of the broadcast, 14 per cent were tuned to the show.

12 On the limitations of television as an effective medium for the treatment of serious public issues, see Postman (1984).

13 One measure of the political message and significance of programming is the willingness of advertisers, whose products might be adversely portrayed, to buy space on the show. In contrast to the furore over docudramas or prime-time shows that deal with issues like abortion (*Roe v. Wade*, episodes of *Cagney and Lacey*) or nuclear war (*The Day After*), the willingness to advertise a chemical product designed to keep your lawn green indicates that advertisers expect little connection between the show's content and viewers' actions. Similarly, the show carried several commercials for automobiles and other consumer products that have been implicated by many environmentalists, although certainly not by this show, as causes of environmental problems.

14 In a two-hour show, we could have actually been informed of the records of our Senators and Congressmen, or at least how to find out about such things.

15 On Dan Rather's role, or lack thereof, in writing his own copy, see Joyce (1988).

16 This point was brought to our attention by the insightful comments of Jody Berland.

17 It is especially interesting that this aversion to calling upon the coercive powers of the state to solve problems is not characteristic of television's treatment of all social problems. When the 'problem' is poor blacks using crack (and not wealthy whites buying and using expensive automobiles or polluting fertilizers, etc.), there is no reluctance to see the 'solution' as a declaration of war and the calling forth of the police powers of the state. See Campbell and Reeves (1990).

18 Elsewhere, we argue that the political perspectives presented on television are neither strictly determined, nor are they entirely free or open. Instead, borrowing from recent Marxist theories of the state, the political meanings of television are 'relatively autonomous'. Just as some Marxist theorists have highlighted the existence of deeply held value systems (e.g., democracy, participation) which limit the subordination of the state to the interests of capital, so too theorists of television's political impact must take into account the diversity of value systems which producers and viewers bring with them to the medium (e.g., a free and open press, public control of the airwaves, etc.). See Delli Carpini and Williams, 1990.

19 We do not use the phrase, 'taken as a whole', lightly. As we have argued, understanding the full impact of the medium on politics requires an examination of all types of programming.

References

Campbell, Richard and Reeves, Jimmie (1990) 'Representing the sinister: television news coverage of the "drug problem" during the Reagan years', paper presented at the International Communication Association Annual Meeting, Dublin.

Delli Carpini, Michael X. and Williams, Bruce A. (1989) 'Defining the public sphere: television and political discourse', paper presented at the American Political Science Association Annual Meeting, Atlanta.

—— (1990) 'The television audience: implications for political theory', paper presented at the International Communications Association Annual Meeting, Dublin.

—— (forthcoming) 'Methods, metaphors, and media messages: the uses of

television in conversations about the environment', in Crigler, Ann N. (forthcoming) editor, *Political Communication and Public Understanding*, Cambridge University Press.

Cawelti, John (1970) *The Six Gun Mystique*, Bowling Green: Bowling Green University Press.

Connolly, William (1983) *The Terms of Political Discourse*, Princeton, NJ: Princeton University Press,.

—— (1987) *Politics and Ambiguity*, Madison: University of Wisconsin Press.

Edelman, Murray (1988) *Constructing the Political Spectacle*, Chicago: University of Chicago Press.

Fiske, John (1987) *Television Culture*, New York: Methuen.

Hertsgaard, Mark (1990) 'Covering the world; ignoring the Earth', *Greenpeace* March/April.

Joyce, Ed (1988) *Prime Times Bad Times*, New York: Doubleday.

Lichter, S. Robert, Lichter, Linda S. and Rothman, Stanley (1991) *Watching America*, New York: Prentice Hall.

Margolick, David (1990) 'Ignorance of 'L.A. Law' is no excuse for lawyers', *New York Times* 6 May: E1.

Morone, James (1990) *The Democratic Wish: Popular Participation and the Limits of American Government*, New York: Basic Books.

Olson, Mancur (1965) *The Logic of Collective Action*, Cambridge: Harvard University Press.

Postman, Neil (1984) *Amusing Ourselves to Death*, New York: Penguin.

Romano, Carlin (1986) 'The grisly truth about bare facts', in Manoff, Robert and Schudson, Michael (1986) editors, *Reading the News*, New York: Pantheon Books.

Seiter, Ellen (1987) 'Semiotics and television', in Allen, Robert C. (1987) editor, *Channels of Discourse*, Chapel Hill: University of North Carolina Press.

Tuchman, Gaye (1987) 'Representation and the news narrative: the web of facticity', in Lazere, Donald (1987) editor, *American Media and Mass Culture*, Berkeley: University of California Press.

Weber, Bruce (1990) 'Laws of the land v. the laws of prime time', *New York Times* 6 May: E1.

Williams, Bruce A. and Matheny, Albert R. (forthcoming) *Democracy, Dialogue, and Social Regulation: Being Fair versus Being Right*, New York: Yale University Press.

ON READING 'THE WEATHER'

T he weather, like music, mediates between our physical and social bodies. Its rhythms and irregularities, and the rituals we construct around them, shape what it means to be part of the social, both within a particular time and space, and across to other times and places, as we imagine or remember them. For most of us, certain summer smells will always remind us of childhood adventures, and fresh autumnal winds will forever draw us out to buy new books and winter clothes. Each season promises its own different qualities of experience, and draws our pasts into a weathered future. Just as a special song will evoke a past experience, most of our images of place are intimately tied to mythic or remembered notions of its weather. As with music our sense of what is desirable in weather seems perfectly natural; our pleasures and antipathies in good and bad weather seem indeed to express our immersion in and sympathy for nature itself. But, again as with music, weather's mediation between our physical and social bodies is itself shaped by a host of technological, social and cultural forces. As these change, so too does our sense of what it means to live on the earth, in a specific place, and in the scientific-technical-environmentally fraught epoch of the present.

It is true that the culture of weather is significant for Canadians in particular ways. This is in part a result of our collective formation in the midst of its most alarming extremes, rendering a specific type of enlightened ambivalence the only sure token (if it is not geographically, ethnically, or seasonally consistent, at least it is not controversial) of collective identity. Everyday conversation does not typically draw this connection between weather and national identity, but the world of public representation and myth confirms it. Colonial representations within and about Canada have long been steeped in images of its weather that surround and account for mythic images of the 'Other' [Berland, 1993a]. Just as the Inuit and other northern inhabitants have been viewed as childlike by whites because of their adaptation to snow, so Canadians have been represented as childlike and backward in comparison to Americans, as Pierre Berton so elegantly documents in *Hollywood's Canada*. 'After viewing several score of [movies about Canada] and after reading the story lines of several hundred more,' (he writes), 'I came to a startling realization: There were no cities shown.' Hollywood's Canada was a 'land of measureless snows' (as promotion for a

Tom Mix picture put it), 'safe from the evils of civilization.' Its snowy images evoked an empty wasteland (which was often actually filmed in Washington or Arizona) to which Americans are forced to flee (involuntary exile, as it were) from the pursuit of American police. (1975: 44, 48) The 'North-west' was wild, snowy, sparsely inhabited by moral innocents (country doctors, Mounties), criminals, and half-breeds. For many years, both Americans and Canadians came to know the landscape and climate of the north from these movies. (Not so in the case of movies currently being shot *in* Canada, for which American directors cover the street names and disguise identifiable landmarks so that the mainly urban terrain will pass as American.) In each case, for southern Canadians viewing their vast and apparently undifferentiated North, and for Americans viewing an unknown Canada, images of a climate that departs from mid-continental moderation were used to signify a less civilized population.

In this context, an affirmative awareness of local climate becomes an awareness of identity and difference: among regions, countries, ethnicities, livelihoods. Thus cultural artifacts – whether paintings, films, photographs, or songs – now often symbolize regional experience through depictions of characteristic weather or seasonal times and spaces. Think of Randy Bachman and Neil Young singing Bachman's recent ode to growing up in Winnipeg, 'Prairie Town', with its nostalgic chorus: 'Portage and Main, 50 below'. In contrast, contemporary American mainstream film and television encourages us to dream of happiness in the Technicolor greens and blues of the southern or west coast of the United States. The more absorbed in these we become, the more the stark dramas of northern seasons can seem to us childish, overly precipitous, inconvenient, unjust, uncivilized.

The relevance of weather to Canadian identity is not, however, a purely cultural-representational issue. I wonder, for instance, whether the imaginary inhabiting of an idealized moderate and benign landscape will make us more or less able to respond intelligently to the challenges of global warming? When we fantasize about the coming of the greenhouse effect, does it look like the temperate landscape of the movies? Current changes in weather promise, according to some experts, to make a warmer and more fecund Canada the centre of empire in the next century, suggesting major challenges to the constitution of our political, temperamental and cultural life. We may have learned to dream in California, but we live in Canada, and this experience, here as anywhere, is inextricably tied to this landscape, this environment, these resources, and to our ideas about 'Nature' and weather as explanations for our national condition. What does it mean when these change?

To explore these and many other questions, an 'ethnometeorological'[1] study of our interactions with weather promises important insights about changing constructs of nature, culture and identity. For despite the apparent eternal continuity of the seasons, our sense of, knowledge about, and relationships with the weather are all indeed changing.

Big science

A recent book entitled *The End of Nature* (McKibben: 1990) offers a poignant eulogy for the ontological security that previously enveloped us in the name of Nature. 'When I say that we have ended nature,' McKibben writes, 'I don't mean, obviously, that natural processes have ceased – there is still sunshine and still wind, still growth, still decay. . . . But we have ended the thing that has, at least in modern times, defined nature for us – its separation from human society' (64). We have brought this about through both conscious and unconscious choices, he argues; through the indelible effects of human endeavours on the climate and the forests, and through the realization that we could exercise godlike powers on the world. The invention of nuclear weapons was one precipitating event in such ontological (and probably climatic) change, but perhaps equally important is the fact that 'We have become in rapid order a people whose conscious need for nature is superficial. The seasons don't matter to most of us anymore except as spectacles' (69). This is more than a superficial change, McKibben believes, because nature represented our bond with history, with immortality, with other creatures, and with the divine. 'In the place of the old nature rears up a new "nature" of our own devising', he claims; 'We are in charge now, like it or not' (96, 79).

This was written after the summer of 1988, which was characterized by extended drought in the US and much media attention to the prospect of a changing climate. For McKibben, whose book addresses this prospect, the loss of this Nature that no longer exists is tragic and irredeemable, not so much because of its seasonal reliability or its immediate tangible effects, both of which are ambivalent at best, but because of its *meaning*: its independence from human action and will. The old Nature assured humans of the existence of something huge, remote, and lawful, and it was intelligible, not in any literal sense, but in a semantic sense, in the ways that its signs could be interpreted, remembered and anticipated. One could read the sky, and other natural signs, and know not just what was coming, but also how complex was the order of the natural world, which, like a sacred text, spread before us to be deciphered and observed.

Because of its imperviousness to human contingency, weather in particular formed the cosmological frame within which men and women understood their own horizons and limitations. And because of the anticipated significance of climate change, weather in particular seems to represent the end of that cosmological separation. For McKibben, the fact that nature's phenomenological independence from us has been eradicated by pollution, technological progress and the general will to dominate nature is nothing short of catastrophic. If a truly final catastrophe can be avoided by recognizing that 'we are in charge now', such a rescripting of the cosmos carries a terrible price: the end of nature, the end of culture as we know it. Recognizing our agency in the conditions of nature might temporarily ameliorate some environmental damage, but it cannot avert what McKibben seees as permanent damage to the human condition.

This point of view is increasingly influential in contemporary popular nature writing and environmental thought. Arguably it defines the general zeitgeist of current public discourse on nature. It advances the notion that Nature as a concept is historical, and seeks to demonstrate that the ideals and practices of both humanism and technological utopianism have failed, for many reasons, all pointing to the loss of connection with and empathy for the natural world. This growing recognition of damaged interdependency also created the space for an alternative scientific understanding of the environment as a dynamic mutual creation – as *Gaia*. But this outlook has failed to gain ascendancy or even legitimacy in the institutional world of experimental science.[2]

To put all this in context, compare McKibben's prognosis to the somewhat earlier (and for its time equally typical) work of Louis Battan, a US Air Force trained meteorologist writing in the 1960s, when for political and technological reasons it was widely believed to be quite advantageous to intervene in nature. For this scientist, the apparently defunct harmonious climatic environment eulogized by McKibben could only be envisioned as the promised outcome of future technological prowess. In Battan's *Harvesting the Clouds*, hurricanes and tornadoes are 'the firing squads of the atmosphere' which 'deal out devastation on the scale of a bombing attack', causing millions of dollars' worth of damage to crops and buildings (Battan, 1969: 4–5). With the aid of science, however, American society is learning to protect itself from such devastation.

The militarization of meteorological language we see here did not originate with the American Air Force, but rather earlier, in meteorological research conducted in Europe during World War I. The discovery that moving air masses, described as 'continents', created warm and cold 'fronts' whose contact resulted in storms, laid the foundation for modern weather forecasting (Lockhart, 1988: 42–3). In the 1950s and 1960s, this metaphorized language entered the broader culture through the language of radio and television forecasts. Through this daily exposure, the new *objective* treatment of weather as dynamic but inanimate matter, based on proto-military systems-in-combat language, was 'naturalized' as the most accurate way to analyze the weather.

Here we see a stark instance of science constructing its 'other' as hostile, inanimate, vanquishable matter. Battan's writing on weather modification is also typical of its time in that it disguises the military orientation of the research through a rhetorical emphasis on domestic security. Battan's nature, like his chapter headings, is composed of storms, floods and droughts; it is dangerous, unpredictable and inconvenient, and can threaten the civilized man's 'way of life', for instance, in one memorable passage, the 'unalienable right' to shower every day, water the lawn, wash the car, fill the swimming pool, and ignore the leaky faucet (Battan, 1969: 8). Hurricanes all had women's names then; it is not surprising that troublesome nature sounds like a nagging wife. Fortunately for this civilized man's way of life, American science is advancing, as his subtitle ('Advances in Weather Modification') suggests, to the point where we will someday be protected

from nature's more unfortunate effects. From its crude origins in nineteenth-century hail cannons to modern chemical sophistication in cloud-seeding, US scientific weather-modification research has worked valiantly to eliminate the effects of natural disaster from the Western hemisphere.

At no time does Battan's book, published in 1969 (the year Americans landed on the moon), refer to military uses for these discoveries. In fact there were many cloud-seeding air sorties over South-East Asia conducted by the US military during the same period (in 1967 there were 591, and in 1968 there were 734 such sorties) (Seshagiri, 1977: 114). Controversies over US weather modification in Laos and Cambodia led to the publication, in India, of a detailed account of how floods, droughts and hurricanes had been subjected to strategic tampering in Indo-China (Seshagiri, 1977). Seshagiri reviews reports published by the Pentagon and President Nixon's Council on Environmental Quality, and a series of articles published in the *Washington Post* and the journal *Science*, which revealed that the US military used cloud-seeding, man-made flash floods, diverted cyclones, and artificial lightning (for causing forest fires) in Laos, Cambodia and North and South Vietnam, interfering with enemy movement and causing thousands of deaths in those countries. Seshagiri concludes that, 'The constant urge by super powers to fight direct wars but constrained by a world-wide antipathy will increasingly take the form of a suppressed desire which is gratified by covert actions unheralded, unobserved and undiscussed. The weather weapon is the most potent tool for fighting such a covert limited war' (118).

Note that Seshagiri's book, which calls for international monitoring and restriction of weather modification, was published in India, which is subject to almost catastrophic seasonal changes. This does not make the author sympathetic to the ideal of improved scientific intervention, however. 'Among future means of obtaining national objectives by force', states one (US) Department of Defense geophysicist cited by the author:

> one possibility hinges on man's ability to control and manipulate the environment of his planet. . . . I can envisage a world of nuclear stability resulting from parity in such weapons, rendered unstable by the development by one nation of an advanced technology capable of modifying the Earth's environment. (Seshagiri, 1977: 8)

The techniques described by these physicists were dependent on advanced knowledge about weather systems, requiring the same atmospheric surveillance and computer modelling which have brought us the daily television forecasts to which we are now accustomed (Berland, 1994). While the Indo-China controversy led to the creation of international law for controlling weather modification, 'Research [in the US] . . . is mostly carried out under a cloak of security — either for commercial or for security reasons,' Seshagiri warns. There are no comparable public records of weather modification in subsequent conflicts.

Both Battan's pre-NASA and McKibben's post-NASA (and post-hole-in-the-ozone) texts structure their representation of climate in relationship to

underlying concepts of technological progress and its radically transformative effects on nature and culture. Both authors portray weather in a manner that supports an argument about the social consequences of technological intervention. The opposition between them offers us a sense of the process through which weather has been discursively transformed; changed, as McKibben argues, in how it interacts with us and what it means to us. Such changes are not surprising, given the severity with which activities like cloud-seeding, nuclear testing, insect spraying and other forceful mid-century interventions challenged traditional ideas about nature – as witnessed by the publication of and response to Rachel Carson's *Silent Spring* in 1962. But rather than addressing themselves to the questions that might arise from this onslaught of scientific hubris, scientists engaged in scrutinizing the heavens have learned to avoid questions about the cosmological foundations of the natural order, or about their place in such an order. Instead they devote themselves to searching for the precise mathematical relationship between chaos and natural systems (which, as they themselves argue, has important implications for anticipating weather and recognizing climate change).

Apprehensions of a wilful monotheistic God and/or lawful and sublime nature at work in the whimsical morphology of the seasons are, of course, both cultural constructs, the more readily evident as such as they collapse before our eyes. The movement of the plants, the music of the spheres, the angry dispositions of stormy skies: all of these had entirely different meanings before Western culture placed human society at the centre of the universe. Changing weather was believed to carry messages, perhaps from some intending agent (one or more gods) and/or to make certain truths visible. One could discover nature's truths through empathy and ritual. 'Either there is a civil strife in heaven,' wrote Shakespeare in *Julius Caesar*, 'Or else the world, too saucy with the gods, increases them to send destruction.' Here Shakespeare traces an ontological shift with his usual acuity: these storms are messages from beyond human knowledge, but humans just might be able to find something of themselves there. This does not mean that we have been looking ever since. For modern science, as we have seen, sought to displace human empathy and belief from the core of knowledge about nature. Weather was thereby redefined as a purely physical, material, *autonomous* system of particles, currents and fronts, from which human beliefs and values were necessarily separated and dismissed as primitive myth and/or projection.

Early modern science contributed to a radical displacement of classic ideas about weather and nature, by placing the sun (rather than the earth) at the centre of planetary movement, and by advocating a neutral, technically mediated, observation and experiment-based science. Earlier empathetic beliefs about nature were further undermined by the scientization of weather research, which, by the late nineteenth century, had come under the sponsorship of military and naval administration. In the subsequent history of meteorology and public weather forecasting, we can trace the concrete transformation of weather knowledge by the instruments, practices and

paradigms of modern science. With improved observational and measurement technologies, weather knowledge was subsumed and transformed by categories of experimentation, measurement and observability, probability, and the simplification of truth which we know as science (Latour, 1990). In the new discipline, human empathy and engagement were related to a purely negative role. This discourse of objectivity made scientific research 'easier' (you could dismiss a theory without executing its advocate) while reinforcing the perception of nature as autonomous dynamic matter.

But this belief in weather as an autonomous system could hardly have outlasted the 1970s, by which time, probably without any suspicion that it might have been true, my fellow university students were blaming the CIA for excessive rainfall in agrarian zones of Canada. Mainly perceived as a material and ostensibly non-mythic force, weather had begun none the less to act once again as conduit for information about human activity. Similar speculations followed the oil fires in Kuwait, which were popularly held responsible for many subsequent episodes of bad weather. Because of the recent plethora of ecological disasters, and because of current controversies about the effects of global warming and ecological crisis, nature is now once again generally understood to be indelibly and perhaps fatally marked by human interventions. We remain joined to our ancestors by a sense of guilt and unease in the face of hurricanes and storms. Once again (or perhaps, still) we sense natural blight as a form of punishment for sins which we attempt to uncover through the specific archaeological tools of our own historic present. Because nature is now apprehended differently, as a natural and material rather than spiritual or mythic force, the explanatory paradigm for this human culpability is entirely different.

Weather and the nature/culture debate

There have been a number of recent commentaries, including McKibben's, which draw attention to the semantic chaos generated by the prospect of the greenhouse effect (a far scarier prospect than its name implies). But the greenhouse effect, a less intentional if more insidious product of big science, is only one of the broad transformations now mediating the weather. All of these transformations affect our bodies' physical and social experience, our temperament, our conduct and culture within this possibly changing climate. The change of weather that separates us from previous generations has occurred not just as a result of global warming but also in tandem with satellites, electromagnetic photography, computer model-building and photographic analysis, weathermen, television, computer graphics, syndicated weather services, city living, tourism, agribusiness and environmental politics. One result of this aggregation of techniques and technologies is that weather itself is now available to us as an abstraction. Part of the larger history of science, this change was initiated in the Renaissance, as we have seen, with scientists such as Galileo and Newton, who dismissed 'the empathized world of the medievals' in favour of 'a new abstracted system called Nature.' (Evernden, 1992: 55) That this also emerged as a significant

cultural change is evident if you look back at the classic fiction of the nineteenth century, which is full of thunderous storms and moody weather, but which rarely employs the concept of 'weather' itself. (See Urquhart, 1990, whose book revisits that literature: 'She wants to write a book about the wind, about the weather. She wants the words constancy and capriciousness to move in and out of the sentences the way a passing cloud changes the colour of the page. . . . She wants to predict time in relation to change and to have all her predications prove wrong. She wants recurrence . . .') The same kind of change is evident if you listen to popular songs up to and including the 1930s and 1940s, which are replete with evocative sunny days and stormy nights, but which rarely (with the well-known exception of 'Stormy Weather') refer to weather *per se*. All this (as I discuss at greater length elsewhere) has now changed. As weather (and the 'weather system') becomes an abstraction, subject to increasingly sophisticated statistical and philosophical inquiry, our everyday conceptualization and relationship to weather changes. Simultaneously the most tangible of experiences and the most abstract of concepts, weather has become at once more physical in its explanations, more conceptually, visually and geographically remote, more physically engaging (you can't go out the door without thinking about it anymore), and more ominous and burdensome in its meanings.

One important result of this semantic change, concerning which McKibben and Battan are in agreement, is that unaided human perception and memory – and therefore, local tradition, the wisdom of elders, and the everyday deduction of aural and visual signs, including the bodies of humans or animals – are no longer used to interpret or forecast the weather. The human eye cannot detect complex systems, we learn. Rather, these require the instruments and experimental resources of science (of which our weather is thus, in an important sense, a product).

Now there are two rather separate issues being raised here. One has to do with our reading of weather as an everyday cultural activity, and points to the ways that this activity, with its requisite skills, rituals, metaphors, communicative practices and institutions, has been radically transformed by science and the media in a relatively brief period. The second point we can extrapolate from this discussion, looking suspiciously like a postmodern 'normal science' reading of a text (in this case the weather), suggests that the weather can no longer be considered 'natural' (and/or theistic) but (like gender or other previously 'natural' concepts) must be understood as socially constructed artifact, wherein nature itself actually functions as a similacrum, to use Baudrillard's term, of itself. How ironic that we should hold up nature itself to this entropic mirror!

In fact this latter idea is quite appropriate to looking at television weather, compiled daily from satellite photos, computer graphics, FAX and teletype, regional and national maps, chromakey, and preprogrammed backdrops (Henson, 1990: 71–8). We have become accustomed to foretelling, or rather anticipating, the weather by looking at the television screen rather than at the sky (Berland, 1994). When we look at the weather, we now take the viewpoint of the angels – looking down at the earth, rather than up at the

sky. But there is no 'great chain of being', no divine order, no pantheistic order of cruel and kind elements either, in this imaging of weather. Our wisdom of the skies comes to us cloaked in paradigmatic agnosticism (overdubbed angels' choirs combined with satellite images of the earth hint at a new type of technocratic enchantment while assuring us of continued access to divine knowledge – that is, science), by virtue of NASA, a host of circling and geostationary satellites, and a continuous plethora of cybernetic and optical innovations. These new technologically mediated products tend to be stunningly beautiful – I myself am utterly captivated by colour photographs of the earth from satellite range – but completely silent, unlike trees, winds, insects and animals, whose sounds once taught our elders to know what was coming. Keeping in mind that a significant portion of useful information about forthcoming weather used to come from sound, not images (see Humphreys, 1942: 1–12, 250–71), our post-televisual reliance on highly mediated, distant images has surely contributed to the artificiality of the construct 'Nature' with which McKibben reproaches us.

However, this second argument is problematic, for it presupposes (as does McKibben, in fact) that nature existed at one time entirely independent of human activity and discourse, and at some fatal key moment became entirely contained within it, an inversion or simulation of itself within a bionic biosphere. It supposes, in other words, that nature was once a purely natural force, but because of (unnatural) Western science was subsumed or imploded by discourse. In this deplored state:

> Nature as given is that from which we start; change is inflicted from without. Hence, 'for us, nature is all that is not man-made; the natural state of anything is its state when not modified by man . . .'; From the beginning, there is this sense of fundamental distinction between human and nature, along with a strange ambiguity that permits us to regard nature as the domain of both norms and forms. (Evernden, 1992: 21)

The problem is that this normatively untouched nature would have to have preceded hunting, agriculture, ritual (like rain dances, for instance) and myth; indeed the presence of human society altogether. And clearly the new 'Nature' is hardly less wilful than the old one, judging from the continuing visitations of droughts, hurricanes, floods (currently revising the landscapes of Bangladesh and the American Midwest), earthquakes and miserable weather. Finally, and most important for this discussion, this moral opposition between nature and technoscape prevents a more useful comparative analysis of earlier and later social constructs of nature, and of the ways that such constructs are embedded in different types of agrarian, symbolic, technological and social orders.

In his history of Western constructs of nature, *Traces of the Rhodian Shore*, Clarence Glacken has shown that several recurrent questions about nature, divinity, humanity and order have occupied philosophers from ancient times. Glacken summarizes the three persistent questions as follows:

> Is the earth, which is obviously a fit environment for man and other organic life, a purposefully made creation? Have its climates, its relief, the

configuration of its continents influenced the moral and social nature of individuals, and have they had an influence in molding the character and nature of human culture? In his long tenure of the earth, in what manner has man changed it from its hypothetical pristine condition? (1967: vii)

Significantly, Glacken ends his history with the dawning of the industrial revolution in the early nineteenth century. There is more in common, he contends, between the ancients and the eighteenth century, in terms of how nature was thought about, and what kinds of questions were posed, than between the eighteenth century and the present. By looking at the ways in which twentieth-century culture and technology have transformed our relationships with the weather, it is not difficult to see why.

Memory, science, observation, knowledge

Before weather forecasting became an everyday ritual in the media, weather prediction was the subject of everyday readings of natural signs: the colour of the evening sky, the direction and force of the wind, the behaviour of animals and insects, the sound of trees, and the distance covered by ordinary sounds, all of which could be supplemented by the reading of barometers, which were widely available by the eighteenth century. This is the point, in other words, when the idea that nature was that which could be inscribed in instruments found its way into the rituals and knowledge skills of everyday life. This was still not yet the problematically dominant discourse on weather, however. Because of the perceived predictability of natural forces in any given region, weather lore was passed down through generations, encapsulated in rhymes, proverbs and mythic figures. The shortcoming of such signs was not inaccuracy; weather literature is replete with stories of pilots or scientists being shown up by local oral tradition, and CBC's *The Journal* (May, 1991) ran a story recently about a 14-year old girl who out-predicted Environment Canada two weeks running. The traditional observation of natural signs could produce short-term predications as reliable as modern meteorological forecasting, climatologists conceded in the same documentary. 'You can go with all your magic markers and your electronic equipment and your satellite photos and in the final analysis it's Mother Nature who's going to decide exactly what to do,' one TV forecaster remarked cheerfully. 'A ring around the sun or moon, brings snow or rain real soon,' mused Environment Canada's senior climatologist, is '70 per cent right – almost as good as Environment Canada'.

But predictions based on traditional knowledge could not extend across the same scale in time or space, past a day or two (an exception: halos around a moon promise rain within a 3-day period) or past the visible horizons of the observers. To extend the temporal range of weather prediction, and to respond to the growing curiosity of scientists and travellers, more rapid communication across space was a prerequisite. It was necessary to gather weather observations simultaneously in a number of places, a process that originated briefly in the seventeenth century but which was undertaken regularly only after 1780.[3] By 1820 systematic weather

observations were being organized across Europe and the US. The observation of weather in many places over a large area led to the realization that in Europe and North America, at any rate, storms generally travel from west to east, so that one could anticipate tomorrow's weather as today's weather 'a day's storm-travel to the west' (Humphreys, 1942: 340). Of course, such knowledge is useful only when it can travel more quickly than the storm itself; otherwise the weather would have come and gone before the local inhabitants could be warned of it. Thus the telegraph was a crucial innovation in the history of the weather, conveying daily weather information by 1849 and storm warnings as early as 1855. The telegraph, which 'freed communication from the constraints of geography' (Carey, 1989: 204), also freed weather knowledge from the constraints of local observation, thereby drawing larger units of time and space into the circumference of scientific forecast and planning. Weather is no longer a local fact; there is now a phenomenological split between how we experience it and how we see and think about it.

The most crucial changes in our interaction with weather, however, have transpired since the 1950s, when technical advances in meteorology were being articulated with military and aeronautical research, on one side, and commercial television, on the other. The first weather satellite went into space in 1960; by 1965, satellite imagery was being used for television weather reports, and by 1975, private companies were contracting out satellite photo services for television weather reports (Henson, 1990: 67–71). Most of what we now learn about forthcoming weather is gained from the application of statistical data (knowledge about the past) to 'pictures' of the weather derived from sophisticated satellite-and-computer-based visual observational technologies. These technologies have developed rapidly since the creation of NASA in 1958, by Eisenhower, to manage US aeronautical and space activities without direct military functions.

NASA was fraught with contradictory pressures: most powerfully, for national prestige (four months after becoming president, Kennedy committed NASA to placing a man on the moon and bringing him back by the end of the decade); secondly, for scientific research and development in space, portions of which had been taken over from the Pentagon, or came into conflict with programs maintained by the Pentagon; and last, for what was called 'applications', including weather satellites, the first of NASA's applications programs to be put into operation (Mack, 1990: 16–17). These satellites quickly became a central resource for the Weather Bureau, but the improvement in weather forecasting was 'less dramatic than many expected, not because of the quality or quantity of image data provided by weather satellites, but because of the lack of a model of the atmosphere exact enough to make reliable weather predictions even from plentiful data' (Mack, 1990: 215; cf. Berland, 1994).

The struggle to improve computer-based prediction models adequate to the weather's order/disorder continues to occupy scientists. For observational technologies remain far more developed than the power to interpret them. In the early years of NASA, there were conflicts between NASA and

the Weather Bureau concerning the relation between space research and its practical applications; these were resolved when the Department of Defense intervened on the Bureau's behalf, ensuring the Bureau continued access to NASA applications. (Mack, 1990: 22). Like the much-lauded 'man in space' project, weather forecasting as it has evolved can also be seen as a popular legitimating extension of the space program, complete with astronomic costs and mythic images.

In both Canada and the US, meteorology was undergoing a simultaneous process of institutionalization and privatization. In 1955 two government meteorologists went into business for themselves in Canada and made a lucrative living selling weather forecasts and cloud-seeding services to businessmen (Newman, 1956). Great benefits, usually of an economic order (suggested scientific writers and journalists) would accrue to those who took advantage of such up-to-date and practical knowledge. Therefore it was in the interest of businessmen, agricultural investors, transport executives and so forth, to invest in its production and dissemination. Canadian journalists were quick to speculate on the political implications of the new technology: 'The day approaches when a government may be thrown out of office because voters disliked its weather', one wrote (Newman, 1956: 35).

By this time, weather forecasting was becoming a common feature of television news. Introduced to American viewers in the late 1940s, mainly by men with military training, television weather exploded in the 1950s in a riot of jokes and gimmicks. 'Weathergirls' were a favourite feature of live television in the 1950s (Henson, 1990: 80–6); we might think of them as 'vanishing mediators', a term employed by Fredric Jameson to describe transitional figures who permit otherwise threatening change to occur, and who then disappear from the cultural landscape. Weathergirls accomplished the transition (or rather, joining) of meteorology, previously identified with military or scientific discourses, to the everyday world of commodifiable television entertainment. The introduction of weather satellites in 1960 coincided with the professionalization of television weather, which sought to establish itself as a proper disciplinary and scientific public service, causing the temporary disappearance of women forecasters. In recent years, as TV weathercasters have become subservient commentators giving visual voice-overs for pre-produced and pre-interpreted forecasts, women forecasters have reappeared on television. By this time, TV and radio forecasters (who, whatever their gender, again tend to be hired as on-air personalities rather than as meteorologists) had come to function much like what McLuhan called 'sex organs of the machine', a notion that conveyed his bleak vision of a nominal human presence in a human-created landscape of all-encompassing technological control.

The 1960s also saw the proliferation of commercial firms distributing syndicated weather data. Television could display weather occurring simultaneously across the continent, with colour radar, electronic lettering, and live satellite photos. After 1980, computer technology created a technical explosion of graphic services for television weather, provided not by the Weather Service but by commercial meteorologists seeking to profit

from computer graphic software (Henson, 1990). Today, weather forecasts offer us a ritualized celebration of the technological sophistication of satellite surveillance, space-based photography, and computerized image data analysis, all direct or indirect products of NASA research, with the added feature of computer graphics created specifically for television, whereby we become habitual clients of NASA, all narrated by weatherpeople who may or may not be meteorologists. With the important exception of hurricanes and tidal waves, however, the forecasts themselves are not significantly improved from the time when everyone knew that:

> Evening red and morning gray
> Help the traveller on his way;
> Evening gray and morning red
> Bring down rain upon his head. (Lee, 1976: 79–80)

In conclusion

We can begin to understand how every culture defines itself differently as a human community in relation to natural and invisible forces by exploring how it explains and interacts with the weather. As we have seen, intellectual and cultural changes transformed weather from an expression of God's moods and judgements to an autonomous force appropriate to the analytical instruments and research techniques of modern science. In turn, twentieth-century science – software research, mathematics, chaos theory, advanced observational systems, statistical analysis – has worked to displace meteorology from an analytic to a mathematical science. Paradoxically, then, big science has not only built upon, but also revealed to us the inadequacies of, modern science as an instrument for organizing our relationship with weather and with nature as a complex entity. As a consequence of this paradox, the postmodern discourse on weather has become a testing ground for the moral and cognitive limitations and responsibilities of science.

For one thing, no matter how sophisticated these instruments are, we cannot (in an everyday kind of way) foretell the weather with significantly greater accuracy than fifty years ago. Our culture accommodates this disjuncture in a number of ways: through qualifying statistics ('40 per cent chance of precipitation tomorrow'); irony and humour ('you don't need a weatherman . . .' and diverse comments on forecasters' fallability); and widespread common-sense commitments to non-scientific philosophical explanations for the intransigency or just/unjust logic of nature ('should've known it would rain – it was nice all last week.' Alternatively: 'you just can never tell with mother nature.')

More importantly, there are other truths about our relationship with nature that are obscured by our dominant scientific regimes. The attempt to eliminate human perceptions, needs and responsibilities from the world of science is now being fruitfully challenged by work in anthropology, philosophy and cultural criticism, and the history of science. Such work points to the diverse ways in which human politics, thought processes, instruments and technologies are all implicated in the creation of the entity

known as Nature. Supported by the wide daily dissemination of quasi-scientific scopic representations (like the weather channel), nature reveals itself to students of discourse and society as a product of current regimes of knowledge – as in fact it has always been. And yet, at the same time, nature continues to confound such regimes through its own complex intricacies and unexpected responses. Hence the proliferation of post-Frankenstein natural disaster movies and the widespread interest in chaos theory (which even makes a desultory appearance in *Jurassic Park*). If similar responses from the world of nature – like eroding ozone levels or global warming – remind us of the efficacy of human action, this does not mean that nature is, or can be, anthropomorphically, discursively, or in any other way, simply the product of human action or thought. Thus discourse theory and cultural studies also have their limits. Nature is an independent but not autonomous force, simultaneously affected by our actions and profoundly, sometimes irrevocably, shaping the possibilities and conditions of our lives.

If you converse with everyone about the weather, as I do, you quickly learn that just as something called 'nature' makes a special unsanctioned appearance beneath and between the cracks of modern science, so "residual" forms of knowledge and belief about the weather – whether of a classical, theistic or pantheistic nature – are thriving in the loquacious everyday world of popular culture. Here weather lingers in the figure of a difficult parent – sometimes punitive, sometimes kind, sometimes with clear purpose and sometimes without, but clearly in charge. This weather puts the forecasters to shame and unexpectedly spoils our plans without mercy. When we talk about it we often celebrate its dubious victory with a kind of collective self-deprecating vindictive irony. It is the weather, not science, who is finally in command. 'You can never tell with mother nature.'

It is unlikely that this intimate deference can – or should – survive the ecological and ontological changes now shaping the end of the century. These call for more respect, but less deference. For the weather has changed irrevocably in its meaning. It may still sometimes act in mysterious ways, but it is neither autonomous nor unresponsive to our interventions. Its images and actions really are telling us something about ourselves, and there clearly are important stakes in figuring out what that is. In other words it is not only our scientific and academic knowledge that we must scrutinize, but also our emotional and mythic bonds with the weather. If anything the weather is now (as a friend recently observed) more like a difficult child than a wilful parent – sometimes nasty, sometimes agreeable, always compelling our attention, always challenging our knowledge of it, and yet unnervingly responsive to our words and deeds. We are related to it, we do affect it, and to that extent we are responsible for its well-being. All we need now is a way to write that on to the maps, in all the diverse ways that such inscription occurs.

Notes

This article owes much to Cheryl Sourkes, Richard Ashby and other members of the Montreal science and culture reading group, for fruitful discussions.

1 The term is used by Lockhart (1988: ix) to describe 'The study of weather in relationship to human knowledge and belief.'
2 As James Lovelock, a scientist who contributed to the founding of Gaia, has written, such an approach failed to demonstrate immediate use value to the institutional sponsors of his research. After all, what is the use of demonstrating that there is (interconnected) life on earth, when they have asked you to investigate life on the moon? (Lovelock, 1987)
3 In Canada, the Hudsons Bay Company employed someone to keep weather records by 1792 (*The Journal*, documentary: 'The Weather', May 1991).

References

Battan, Louis J. (1969) *Harvesting the Clouds: Advances in Weather Modification*, New York: Anchor Books Doubleday & Co.

Berland, Jody (1993a) 'Weathering the north: climate, colonialism and the mediated body', in Blundell, Valda, Shepherd, John and Taylor, Ian (1993) editors, *Relocating Cultural Studies*, London: Routledge.

—— (1993b) 'Remote sensors: Canada and space', in Zinovitch, Jordan (1993) editor, *Semiotext(e) Canada*, New York: Semiotext(e).

—— (1994) 'Imaging weather: TV and the celestial panoptikon', in Boigon, Brian (1994) editor, *Culture Lab*, Princeton Architectural Press.

Berton, Pierre (1975) *Hollywood's Canada: The Americanization of our National Image*, Toronto: McClelland and Stewart.

Carey, James (1989) *Communication as Culture: Essays on Media and Society*, Boston: Unwin Hyman.

Evernden, Neil (1992) *The Social Creation of Nature*, Baltimore: The Johns Hopkins University Press.

Glacken, Clarence J. (1967) *Traces of the Rhodian Shore: Nature and Culture in Western Thought from Ancient Times to the End of the Eighteenth Century*, Berkeley: University of California Press.

Henson, Robert (1990) *Television Weathercasting: A History*, London: McFarland & Co.

Humphreys, W. J. (1942) *Ways of the Weather: A Cultural Survey of Meteorology*, Lancaster, PA: Jaques Cattell Press.

Latour, Bruno (1990) 'Postmodern? No, simply Amodern! Steps toward an anthropology of science', *Studies in the History and Philosophy of Science* 21(1): 145–71.

Lee, Albert (1976) *Weather Wisdom: Facts and Folklore of Weather Forecasting*, Chicago: Congdon & Weed.

Lockhart, Gary (1988) *The Weather Companion: An Album of Meteorological History, Science, Legend, and Folklore*, New York: John Wiley & Sons.

Lovelock, James (1987) 'Gaia: a model for planetary and cellular dynamics', in Thompson, William Irwin (1987) editor, *Gaia: A Way of Knowing. Political Implications of the New Biology*, Great Barrington, MA: Lindisfarne Press.

Mack, Pamela E. (1990) *Viewing the Earth: The Social Construction of the Landsat Satellite System*, Cambridge, Mass: MIT Press.

McKibben, Bill (1990) *The End of Nature*, New York: Anchor Books.
Newman, Peter K. (1956) 'They're selling packaged weather'. *Macleans* (Toronto), 7 January 1956: 8–9, 33–6.
Seshagiri, N. (1977) *The Weather Weapon*, New Delhi: National Book Trust.
Urquhart, Jane (1990) *Changing Heaven*, Toronto: McClelland and Stewart.

THIRD NATURE

Hell is truth seen too late.
(G.W.F. Hegel)

Hell's kitchen

When I arrived home from work this evening, I discovered that my biosphere had died. What a way to start the week! On looking back through the records, the reason was not hard to discover. A classic greenhouse-effect problem. Next time I'll wind down the fossil fuels a little more so my globe doesn't cook itself to death while I'm out.

Fortunately, the biosphere in question is only a simulated one. I have this program running on my home computer called SimEarth, which lets you model all kinds of biosphere conditions over a number of different time frames.[1] The one I think I'm getting a little obsessed with is a model of planet Earth from 1990 onwards. I set up this model every morning, selecting types and quantities of energy use and expenditure. I come home every evening and see if my earth is still running. Sometimes it is, sometimes it isn't.

There's something a little eerie about having a functioning biosphere in your home; something rather more disturbing about finding the thing has gone kaput while you were out. SimEarth lets you choose from a number of energy sources, including biomass, hydroelectric, solar, nuclear or fossil fuelled. It also lets you program a range of energy uses, including science, agriculture, medicine and the arts. Each of these has different effects. If you expend energy on agriculture, population increases rather more rapidly. If you devote more resources to science, technological change takes place rather more quickly. Some of these assumptions are of course crude, but not unreasonable. Naturally, a home biosphere has to be relatively simple compared to the heavy duty model.

The curious thing about it is how fiddling around with these crude variables gives you a feel for the global impact of fundamental choices about energy use. For example, I set it up one morning with settings which devoted a lot of resources to medicine and agriculture. When I got home from work I found that the population had shot through the roof. That one was predictable, I guess. What I hadn't counted on, though, was that increasing agriculture pumped out more greenhouse gasses. The temperature was ever so slowly rising, threatening to toast everything, unevenly but very crisply brown.

Like any patient confronted with a terminal diagnosis, I wanted a second opinion. So I switched from SimEarth to MicroPhone, my communications

software, and connected through my modem to the Pegasus Network.[2] Pegasus is part of a global alliance of computer-based networks and bulletin boards that includes PeaceNet and EcoNet. It's a curious fact that green politics has used very innovative and technically advanced communications solutions to the problem of organizing activism and information-sharing about global issues on a global scale. I'll come back to that later. My urgent problem was to ask why increasing the amount of food being grown had this lethal effect. After posting a few messages on the relevant bulletin boards and waiting for some e-mail to shuttle around the world, a knowledgeable adhocracy of 'organic' intellectuals had patiently answered my questions. The prognosis, I'm afraid to say, was not good.

It seems that methane is one of the gasses that causes global warming. A bit too much methane in the air and heat gets trapped in the atmosphere. It seems that by dialling up more agriculture, I was also increasing the amount of methane going into the atmosphere. This is because rice paddies are one of the sources of methane. It seems that deep in the muck at the bottom of rice paddies are little bacteria that produce methane as a by-product. Great! There I was, only this morning trying to see to it that all the people on my biosphere are well fed, healthy and get plenty to eat, and by dinner time I'm cooking the biosphere.

This was all a bit too much, but fortunately I was going out to dinner. Thai food – my favourite! I thought this would take my mind off my biosphere problems, but all that food on the table made me loose my appetite. That big silver dish with all that rice in it just made me think of over-cooked biosphere. The beef red curry, delicious though it was, only made things worse. It seems that one of the other sources of methane in the world is, of all things, cow farts.

Yes, cow farts. It had never occurred to me that there was the slightest global significance in the fact that cows fart. The thing is, they fart methane. Well, not the cows exactly, but the bacteria in their stomachs that break down all that grass. Those bacteria, like their little friends in the rice paddies, make methane. It makes sense, given that in China they actually use pig farts as a source of power. They collect methane and bottle it and use it for cooking – probably a nice pork and black bean sauce – with lots of rice.[3]

So when I programmed my little biosphere with great health care and lots of food production, I was also selecting a higher rate of methane output. It just goes to show how you have to think about all of the consequences of anything you do. Good health care is a great idea, everybody should have that, but without some sensible and humane form of population control it means more people, and more people means more land under cultivation, and that means more methane, and that is a bit of a problem.

So the next time I set up SimEarth I set it up a bit differently. Rather than concentrate on expanding food production in the short term, why not put more resources into science and technology instead? In fact, why not go for maximum productivity? Damn the torpedoes, full speed ahead! This was a bit of a gamble, I thought to myself as I drove off to work. What if science didn't come up with the answers in time? What if burning up fossil fuels at a

rate of knots didn't kick progress along fast enough? What the hell is progress anyway? SimEarth was starting to become a bit like a daytime soap opera where I would just catch the last episode of the series after driving home from work, and this one was a real cliff-hanger.

The last of the series, in fact. By the time I got home, SimEarth had reverted to what it calls in its droll humour – 'geological time'. There was nothing left alive, so my planet was just ticking over, waiting eons for life to mysteriously happen again. Hmmm. Lets see: pollution up, oxygen levels down, carbon dioxide up, temperatures sky high. It seems the techno-gamble didn't quite work out. It seems that cranking up the whole global economy to the max, pumping out and burning up every source of energy as fast as possible certainly did increase the pace of technological change, but in this scenario, it increased the rate of global climate change even faster.

The problem wasn't the methane this time. By keeping population and food production growing a bit more slowly it seems I had kept my little green earth from spinning out into that scenario. The problem this time was the carbon dioxide. There it was on the graph – shooting up at a devilishly sharp tack, taking temperatures up with it. The problem seems to be the fossil fuels – burning up all that oil and coal. This produces carbon dioxide, among other things, and when you increase the amount of carbon dioxide in the atmosphere, you turn the toaster on again. Like methane, it traps the heat from sunlight. The really sad part was that all the way home in the car I had been really eager to see if my little gamble had paid off. Little did I realize that it was doing exactly that – driving – that was part of the problem. So many of our industries, so much of our transport burns up fossil fuels. I had always thought that if the economy in the real world cranked along at maximum efficiency, then technology would also bobble along at a rate sufficient to deal with the little problems that might occur along the way. Well, maybe. What SimEarth was saying to me was that like most people, I had always taken this on faith. What happens if the little problems aren't just accidental by-products – a little oil spill there, a toxic-waste disaster there – what if the industrial race itself was mucking up the global conditions of its own success? A disturbing thought indeed.

All right, so maybe I'd be third time lucky. Lets ease up on the population expansion and the use of fossil fuels and see what happens. I know, let's go nuclear! Maybe this is the way to have the best of both worlds, so to speak. Lots of energy to keep industry and technology cooking, but without turning on the greenhouse pop-up toaster. Well, this time there was good news and bad news. The good news was, my biosphere didn't cook this time. I had well and truly solved the greenhouse problem – permanently. Rather than overheat it, I accidentally shoved it into the deep freeze. Its called nuclear winter – and it results from letting off a few too many thermonuclear devices. The dust cloud from that keeps the sunlight out altogether. So how did this happen? Well, I gave my little SimEarthlings not only a great source of power, but a dangerous weapon. It was not as if I had taken away the sources of potential *conflict*, however. It seems they just started blasting away at each other. Its hard to tell where it started, although the radioactive

patches seem to last through a few eons-worth of the subsequent 'geological' phase. You can see little nuke signs, carved on the brown stump of a formerly green planet, like vandal-carved graffiti on trees that announces to nobody in particular: 'we were here'.

Still, its not hard to imagine it starting. On the news that day there were fresh reports from Iraq about how UN investigators had found facilities dedicated to developing such weapons, and another report on how the break up of the Soviet Union was going to leave bits of the former Union's nuclear arsenal in several different states. The little skull and crossbone icons carved on to the SimEarth map of the world are a scenario that is still possible. Perhaps we are deluding ourselves in thinking it is now less likely. One thing about SimEarth is that it is resolutely historicist. It proposes world historical trends, which human agency can wrestle with but which do impose a certain kind of necessity on what is possible. It seems you start with a perfectly good Earth and either zap it in a toaster or nuke it in a microwave.

The philosophy of storms

There are other SimEarth stories. When I posted a draft of the little parable you have just read on Pegasus and in some internet newsgroups, people wrote back from all over the world with all kinds of amazing experiences with it. A Canadian had blown the lid off the biosphere but raised a strain of intelligent robots. A woman in San Francisco had kept it going for months, populated with a million sentient cetaceans, all using nanotechnology to run their watery utopia. But these were the extreme versions of a narrative teleology that the simulation proves relentlessly for you over and over: there are limits to growth.

Its not much of a game, SimEarth. You never get to win. The best you can do is keep the ball in the air as long as you can. One is stuck for a tone in which to describe such a thing. Describing the end of the world as we know it with an ironic matter-of-factness, as I have just done, is not much of a solution, but at least it keeps the shrill and apocalyptic rhetoric at bay without lapsing into the calming bromides dispensed by the pro-development lobby. Even if it does smack of the smugness of *The Hitchhiker's Guide to the Galaxy* (Adams, 1986) where the Earth is demolished in the first chapter to make way for a new hyperspace bypass.

Searching for a less flip image, watching your planet go into its terminal dunk, when there is nothing left that can reverse the cumulative transformation of nature set in train, one can't help feeling like Walter Benjamin's angel of history:

> Where we perceive as a chain of events, he sees one single catastrophe which keeps piling wreckage upon wreckage and piling it in front of his feet This storm irresistibly propels him into the future to which his back is turned, while the pile of debris grows skyward. This storm is what we call progress. (1989: 257–8)

Or perhaps one feels more like Heiner Müller's 'luckless angel':

The past surges behind him, pouring rubble on wings and shoulders thundering like buried drums, while in front of him the future collects, crushes his eyes, exploding his eyeballs like a star wrenching the word into a resounding gag, strangling him with its breath. (1990: 99)

This suits the experience – and the times – rather better, I think. The droll experience of being flung forward into nothingness by the terminal transformation of nature; an experience of hell seen too late. One appreciates now in a new way that this luckless angel, whether flung forwards or backwards, is a masculine 'he'. Either way, SimEarth looks like the image 'he' would see, the mounting catastrophe in the rear-view mirror which propels history into oblivion. Only it's interactive! You can play with catastrophe to get the ending to turn out just right, before it erases your subject-position as angel/voyeur.

SimEarth prompts a surprising theoretical conclusion. After being abandoned by Sartre and abolished by the poststructuralists, historicisms are back with a vengeance, and where least expected: *the historicization of nature.*[4] There is indeed an end and ends to world history, but not what Hegel (1991), Marx (1976), Koyeve (1986), or Fukuyama (1992) expected. In the rest of this essay I want to rethink the possibilities of historicism in the light of my SimEarth experience, and the reintroduction of a narrative curve into time and a totality of effects into space.[5] Both historicism and totality are untimely concepts in the land of theory, but perhaps have a role to play in the terminal gardens where SimEarth plays upon the monitor for ineffectual angels. As Andrew Ross (1991) notes, 'we have little that can properly be called a green cultural criticism.' Perhaps this is because criticism has retreated a little too far from the problems of historical fate and social totality. Perhaps we need to recover Benjamin's sense of an angel of history, a position outside the contingent catastrophes of development, from which we can imagine and theorize the abstracted dialectic of 'progress' as a whole. Which may sound a bit like Jameson's project but, we shall see, isn't.

Mapping third nature

SimEarth is, in a sense, an animated map, a map with the added dimension of a cartography of its possible histories – which perhaps accounts in part for my fascination with it. When I was a kid growing in suburban Australia, in a little weatherboard house perched between the railway line and the Pacific highway, I loved to look at the atlas and draw maps with coloured pencils. First I would draw the contours of nature. In green and blue and brown I projected an image of the ocean, the land and the mountains. This was a jaggy mass of impassable terrains, each unique and torturous.

Then I filled those contours with dots of various sizes, all enclosed with jagged lines which divided the landmass up into a patchwork of spaces. Unknowingly, I drew the geography of places, of our second nature.[6] The dots marked out cities and towns of various sizes, the borders marked out the territories these towns were able to bring under their control in the

modern period. The railways and the newspapers between them defined spaces that were integrated economically, politically and culturally. Regionalism gave way to nationalism. This tendency breaks down the separation of places and aggregates them into bigger, more abstract units. Thus the natural barriers and contours of the land were overcome with a second nature of productive flows.

Next, I took out a big red magic marker and started to join up all of the dots. Big fat lines between the big towns, smaller ones between the regional centres. From the telegraph to telecommunications, a new geography has been overlayed on top of nature and second nature. The development of third nature overlaps with the development of second nature – hence the difficulties of periodizing the modern and postmodern. The salient point for me is the development of the telegraph. What is distinctive about the telegraph is that it begins a regime of communication where information can travel faster than people or things.[7] The telegraph, telephone, television, telecommunications – telesthesia, perception at a distance. When information can move faster and more freely than people or things, its relation to those other movements and to space itself changes. No longer a space of places, we move on to a space of flows (Castells, 1985).

If there is a qualitative change in the social relations of culture which deserves the name of postmodern, perhaps this is it. Or perhaps we could call this state of affairs 'third nature'. Second nature, which appears to us as the geography of cities and roads and harbours and wool stores is progressively overlayed with a third nature of information flows, creating an information landscape which almost entirely covers the old territories.

While this process has been going on since the telegraph, it reaches critical mass in the late 1970s. The 'postmodern' is an aesthetic catalogue of its symptoms. 'Cyberspace' is a literary description of its subjective effects. Both postmodernism in theory and cyberspace in literature are explorations of the landscape of third nature, but neither offer a concept of it.

We can see now, very clearly, what the terminal state of third nature would be. Deleuze and Guattari ask provocatively and more than once: perhaps we have not become abstract enough?

> One can never go far enough in the direction of deterritorialisation: you haven't seen anything yet – an irreversible process. And when we consider what there is of a profoundly artificial nature . . . we cry out, 'More perversion! More artifice!' – to a point where the earth becomes so artificial that the movement of deterritorialisation creates of necessity and by itself a new earth. (Deleuze and Guattari, 1983: 321)

What would it mean to become more abstract, ever more abstracted from the boundedness of territory and subjectivity? One can imagine a delirious future: beyond cyberspace. Not the future of Marx's communism: from each according to their abilities, to each according to their needs. Rather the future of the rhizome made concrete: where every trajectory is potentially connected to every other trajectory, and where all trajectories are equal and

equally rootless. Where, truly, we no longer have roots; we have aerials. Where we no longer have origins; we have terminals.

On the very first page of Jameson's *Postmodernism* he says that:

Postmodernism is what you have when the modernisation process is complete and nature is gone for good. It is a more fully human world than the older one, but one in which 'culture' has become a veritable 'second nature'. (1991: 1)

Where Jameson sees culture as capitalism's second nature 'perfected', I see a more differentiated process. On the one hand, the 'overdevelopment' of second nature, in all its forms, in the West, and its slow but violent rise in other parts of the globe that manage to struggle free from underdevelopment. On the other, the overcoming of the limit of second nature in a new terrain, a terrain organized with vectoral rather than social relations, freeing itself from the necessity of spatial contiguity.

These new vectoral relations, more abstracted still than the second nature they emerge from and overcome, are not necessarily synonymous with 'culture'. Culture in a sense lies in between. Jameson draws attention to Heidegger's idea that the 'work of art emerges within the gap between Earth and World, or what I would prefer to translate as the meaningless materiality of the body and nature and the meaning endowment of history and of the social.' (1991: 7) A work like Warhol's *Diamond Dust Shoes* lies precisely between second and third nature: it mediates between the experience in everyday life of the historical and social as lived experience in a physical environment; and an experience lived through telesthesia, an experience of an other world of media vectors. It is precisely in the shop window that these two natures cross paths, as Warhol knew. But what he did not live to see was something like SimEarth, an artefact which no longer lies in the space between third nature and second nature. It no longer maps a relation between terrains, it simulates, in the strong sense of the term, a scenario for the totality of the natures, organized as an abstract field of data. Experience is banished to the other side, the side of the angels. It is a postmodern artefact without compromise, being, in the end, posthuman.

Hence the postmodern is both something more and less than the expanded realm of commodified culture: it is the systematic creation of a network of vectoral relations which have not only a cultural but also a political and, as we shall see, a scientific dimension. Indeed, the constellation our luckless angel seems headed for includes new forms of science like artificial life, new forms of politics like the environmental movement besides the Starship Enterprise – and SimEarth.

Under concrete and glass

> Under concrete and glass
> Sydney's disappearing fast
> They'll take it all for profit and for plunder

And although we'd like to stay
They keep driving us away
And to the western suburbs we must wander. (Mick Fowler)

It is the experience of increasing *abstraction* from nature that reaffirms it as an absolute limit. For example, ever since I first heard about 'global warming' caused by a 'greenhouse effect' I have, like many people, had difficulty imagining it. I've been involved in local campaigns to save particular tracts of bushland or rain forest. I'm a life member of the National Trust and the Australian Conservation Foundation. Yet these kinds of organization and activism were no help to me on this one. They dealt with tangible things; particular things. Thinking the connection between saving this bit of bush down the road and the quality of life in one's local environment takes no great leap of imagination. Its the sheer obviousness of the issue that drives the politics of local activism.

The local dimension of green politics begins where one can experience the transformation of nature into second nature. Two rhetorics are commonly brought to bear on this struggle. One is local and contingent, based on notions of loss, gain and inconvenience for the local participants. The green bans movement in Sydney had a strong element of this to it. When residents of a wealthy suburb approached the Builders' Labourers' Federation for support in retaining the Kelly's bush foreshore as a 'natural' preserve, the union responded by black banning work on the site by its members, thus bringing all work to a halt (Roddewig, 1978).

This decision had not been an easy one for the Communist-led union, given that it viewed its interests as having little in common with the upper-class matrons who led the local groups determined to save the bush. Critics of the decision within the union pointed out that saving Kelly's bush did little more than save the real-estate values of a few harbourside homes. The union leadership's counter-argument was to generalize the idea of the value of the bushland from the local residents to the population of Sydney. Harbourside parkland is a 'resource' that has 'value' for all Sydneysiders, and hence the union could claim to be acting on behalf of the local where the local is defined at a level big enough to carry the moral and political freight necessary to win the day. The late Mick Fowler's folk song sums up the struggle – as essentially one over the quality and control of second nature, but one which exposed in the process, through a certain political and cultural praxis, a relation to nature as standing reserve.

This is an instance, one of many, which occurs on the frontier between nature and what Hegel and Lukacs called 'second nature', which is what becomes of the transformation of nature by human agency, once it becomes 'naturalized' in its turn as the terrain of everyday life. Ironically, such conflicts are often won by putting a higher value on nature than on its transformation. 'Nature' might thus be saved, but only at the price of including it in a system of human valuation, as a 'standing reserve' of instrumental value rather than as an autonomous terrain in its own right

(Heidegger, 1977a). Even more ironically, what may be saved is rather the sign of nature than nature itself. A bit of harbourside scrub, playground for feral cats and dogs, is hardly nature. It is already in effect a kind of second nature, a terrain transformed by traces of social activity.

There is also a global rhetoric that is more and more frequently mobilized in campaigns to save the local. In the history of the campaigns to save Tasmanian wilderness, from Lake Pedder to the Gordon and Franklin rivers, such a rhetoric developed, whereby nature becomes what Heidegger termed a standing reserve which has value for the planet itself, not just 'all Australians' or 'all Tasmanians'. This development of a notion of widening spheres of interest in the preservation of something resembling a natural terrain has its price: the very success in saving Tasmanian wilderness now leads to increasing problems of 'wilderness resource management' caused by burgeoning numbers of tourists (Mercer, 1991). Once again, the nature saved is quickly transformed into a kind of second nature, managed economically as a standing reserve, and managed culturally as a new kind of humanized landscape (Wilson, 1992). This at least is how things might be read in the Australian context, which alongside Canada is probably one of the few rich societies in which massive resource-development projects occuring in wilderness areas are a central part of contemporary economic reality and historical and cultural experience.

This expansion outwards of a cultural problematic in which the confrontation of nature with second nature can only be resolved by revaluing nature *within* second nature has more recently collided with a scientific problematic headed in the opposite direction. As Andrew Ross (1991: 196) notes, there is something rather strange about a TV weather forecaster appearing at a political rally in his capacity as a specific intellectual trained in meteorology. Ross's cultural and political contextual-ization of the problem notwithstanding, computer simulation models put to work on the available data on temperatures and theoretical models from physics concerning the interaction of certain gasses propose a global problem of atmospheric warming. Here one is obliged to work backwards from a global doctrine of scientific provenance to the local. Optimistic readings of the Gaia hypothesis not withstanding, what one has to come to terms with here is evidence derived from a 'third nature' which points to the catastrophe logic of second nature's transformation of the terrain upon which it is grounded (Lovelock, 1988).

Out of a terrain of information-gathering and processing, a world is extrapolated, a vastly more sophisticated SimEarth, which becomes the medium through which the entire process of the transformation of nature into second nature can finally be raised to a level at which it can be thought of as a totality of *effects*, if not as a totality of process. For what is missing from the sophisticated simulations of global climate modelling is an understanding of the socio-technical processes which create it in any other terms than their physical inputs and outputs. Hence what is lacking is precisely an understanding of interests which might link the global scenario back to the local and the domain of experience.

The science of third nature (and the third nature of science)

It need hardly be said that in framing these issues thus, I want to sidestep the historically rich problem of the relationship of culture to nature (Williams, 1980). Attempts to excavate the relation between these terms these days often perceive the degree to which they are 'socially constructed' but nevertheless either hypostasize them as metaphysical absolutes which secondarily take on historically variable forms, or ignore the ontological problem altogether with a rather too thorough nominalism.[8]

In contrast, I want to concentrate on a view of second nature as something perpetually constructed and reconstructed, not just as a concept but as an actual social terrain, out of the transformation of nature by socialized labour. In the collective struggle to wrest freedom from necessity, organized human labour creates a more hospitable terrain of second nature, a terrain which nevertheless becomes a new necessity, a new sphere of alienated experience. The cultural response to that alienation splits two ways: towards a revaluation of a 'lost' nature, and towards a yearning for a further transformation of the terrain of second nature into a transparent, indeed 'natural' form. The former impulse has in turn a tendency to split now into a social conservatism and a conservationist ethic. The forward-looking impulse also splits into a technological and a mystical vision.

Alongside both a return to nature and a perfecting of second nature, a third cultural response has emerged, where the unresolved contradictions of nature and second nature are displaced on to third nature. A terrain which is neither natural nor architectural, third nature appears here as a network of information which covers and surmounts both prior terrains. Whether in the form of a 'mirror world' simulation, an intensified 'virtual reality' of experience, a 'cyberspace' of interactivity, the limits of second nature are supposedly solvable by wresting a new domain of freedom from necessity on yet another terrain.[9]

Lyotard's (1984) so-called 'crisis of the metanarratives' in this light is a crisis of both the leftist vision of the perfectibility of second nature by a transformation of its laws of development from capitalist to socialist, and the rightist vision of the perfectibility of second nature through the progressive extension of capital as a free and developmental form of second nature itself. Metanarrative did not go away, it was displaced nostalgically back to nature or forwards to what Ross calls the 'silicon positivism' of a utopic third nature.

Of these developments, I think the displacement of hope on to an emergent terrain of third nature is the key one, for it is also the terrain upon which new metaphors and methods for rethinking the problematic inter-action of nature and second nature are forged. Now nature itself is rethought in terms of the tools of third nature. The use of simulation models to create scenarios of global warming are a striking example, and the most obvious one where third nature comes to have social and political effects. But there are others: for example, the field of research known as artificial life leads to a rethinking of the hydraulic and mechanical metaphors by which life has been

understood, in terms now of metaphors derived from digital information technologies. As David Bolter (1986) has argued, technologies have epistemological consequences. As Mark Seltzer (1992) and Anson Rabinbach (1990) show, the mechanical and hydraulic technologies which typify the techniques of second nature had extraordinary cultural and social effects.

It is not just the cultural deployment of science and its authority that is affected, historically, by the process of building a second nature and a third nature. Science itself dwells within the horizon of these landscapes. Take for example, Bruno Latour and Steve Woolgar's (1986) famous study of the Salk Institute. In the terms I am proposing, it is principally a study of a branch of science organized within the horizon of second nature. As Latour's 'fieldwork' shows, animals enter into the laboratory and are processed by a variety of complex machines by skilled workers. The results are ordered and classified as information, and the information is written up in papers, posted off by the secretary at an average of one every ten days. Here we have the kind of science which, as Heidegger (1977a: 21–3) noted, not only produces as an effect technologies, but is itself an effect of technologies.

A series of processes transforms matter from one state to another, yielding a series of documented results. Once the results are achieved, these physical processes are discarded, and the results become part of an economy of statements, in which the researcher struggles to prove the reliability of a theory and establish it as a fact which will stand without qualification. Thus a standing reserve of animals and machines serves to reveal within nature certain properties which may or may not be a resource for developing new drugs or treatments, for example. Hence the immediate goal of making the animal tissues reveal a fact is connected to a wider goal of improving the functioning of second nature, through improvements in health, in this example.

In the Salk Institute example, nature, in the form of the laboratory animals, are a managed resource, a standing reserve. The aim of the processes the lab subjects them to is the extraction of information useful for managing the quality of another standing reserve, the human population. But what connects this immediate project to the wider one is a passage through an increasingly dense and self-reflexive third nature. The papers published by the Institute contribute to a vast intensive matrix of vectors that are the scientific database, which in turn plugs into an equally vast and growing extensive network of scientific communication.

In order to manage the burgeoning field of facts and conjectures, a third nature grows across the landscape, a terrain where information is interrelatable independently from the second nature where it is produced or resides. Electronic databases, computer-mediated communication, ever faster, cheaper and more complex forms of computational power – all these things developing together constitute the contribution of the scientific establishment to the growth of third nature. As with most other developments of third nature, in business and the military, it arose out of the complexity of the information needed to manage second nature as it

solidifies into an ever more complex environment, built out of and over nature itself.

But it does more than that. It creates a whole terrain of experience and experiment in itself. Forms of science develop which do not just use third nature as a tool, but as a metaphor, or as an experimental terrain in its own right. Hence it should come as no surprise that digital technology should become a vehicle for rethinking the problematic of nature itself in the field of 'artificial life', as Stephen Levy (1992) documents. The artificial-life paradigm developed primarily out of the experiments in computer programming. In the last decade or so, scientists have had access to cheap 386 and 486 computers, and the training to write and run programs on them. In the absence of funding for fieldwork or complex machines, young scientists took to modelling. Or in other words, they developed a science appropriate for the third nature of the computer. Artificial-life experiments treat the computer itself as environment, and attempt to simulate things like the process of natural selection within that environment.

Similarly, the field of chaos theory received impetus from third nature, from attempts to simulate, among other things, the weather.[10] Chaos theory emerges out of the limit of computer modelling as applied to complex dynamic systems. It is a theoretical proposition meant to fill the lacuna which emerges now that there is a third nature in which information can be assembled and processed along complex vectors. We cannot look to science for a way beyond the 'crisis of the metanarratives'. In the first place, such narratives never went away, they were simply displaced from a moribund second nature back to an imagined nature or a projected third nature. In the second place, science is totally caught up in both these narrative currents, either as a predictive discourse on the 'fate' of nature or as a prime mover in the development of third nature itself, in collaboration with military needs and objectives (DeLanda, 1991).

Nature after third nature

How are we to think of nature from within the emergent horizon of third nature? I want to offer three propositions about this. All three revolve around critique of a certain repertoire of ideas about 'nature', which as a convenient (if loaded) shorthand I will call the 'mother nature complex'. The mother nature complex presents nature in terms of the need for a return to origins, to an originary state of being. But we no longer have origins, we have terminals. Far from being an inert and persistent other nature has been radically historicized. As Bill McKibben says:

> We have changed the atmosphere, and thus we are changing the weather. By changing the weather, we make every spot on earth man-made and artificial. We have deprived nature of its independence, and that is fatal to its meaning. (1990: 54)

Mother nature is dead. Given that, as McKibben notes elsewhere (66), we now use the term nature as most of our ancestors used the word god, this is

not an insignificant claim. It hinges, in the quote above, on a certain theory held within the scientific community, and presented in simplified form in SimEarth. Namely, the theory of global warming. But this is no mere neutral product of science. Nor is it merely a debate susceptible to political interest and cultural overdetermination, as Andrew Ross correctly notes. It was only a science within the horizon of third nature which could produce such a proposition. Theories of the greenhouse effect have been around for a long time, but several things were required to test them.

In the first place, a network of accurate measuring stations around the globe. Thus, 220 years after Captain Cook's first scientific voyage to the Pacific, the imperial conquest of the antipodes and the development of a global terrain of second nature provides the conditions for creating a more or less global matrix of scientific data about the planet (Wark, 1993).[11] Secondly, the communication of such results on a constant and uniform basis. Global communications networks, the bedrock of third nature, provide the vector for this. Thirdly, the intensive vector of computational power to simulate processes extrapolated from this data. Lastly an 'invisible college' of experts able to share results while widely separated in space, and conduct debates within the scientific community on an ongoing basis and global scale. In the sciences, electronic mail and electronic publishing using the Internet are already the leading forms of such interaction. In sum, whatever conclusions the scientific community can draw about the future of nature are heavily dependent on the development of third nature as the terrain on which the interaction of second nature with the biosphere can be measured and projected.

Given this context then, how might a 'green cultural criticism' proceed?

I

It is only by becoming more abstract, more estranged from nature that I can make the cultural leap to thinking its fragile totality. This is of course the opposite of conventional wisdom on the subject, which suggests that by an act of will we can return to a 'harmony' with 'mother nature'. The significance of the parable of SimEarth for me is that the program is a highly abstract interactive parable in itself which presents at a human scale a very abstract narrative idea. Moreover, it was only by recourse to global information relations that I was able to convince myself of the rightness of its story. Pegasus and CNN, as we shall see, are themselves a landscape of images which can be interpreted via a parable like that of SimEarth.

We can, as Heidegger (1977b) so presciently predicted, appropriate the world to ourselves as 'picture'. In fact, we can now do better than that, we can appropriate the world as interactive simulation. Indeed, the world now *only* appears to us as a simulation *programmed* for us as 'ours', as an interactive product of our simulating activity. Yet far from presenting an image of the world as if it were there *for us*, to be conquered, it appears now *against us*, as nature no longer inert, dependable and predictable. This may well be a crucial dividing line between the modern and the postmodern:

nature no longer appears piecemeal, as isolated and catalogued instances, framed by the technologies of modern science. It now appears as totality, in simulations based on global data sets. Where the modern development process saw parts of nature as a standing reserve for certain ends, cut out of the terrain as a whole and classified as a resource for the construction of a new terrain, now the ensemble of terrains as a totality appears as standing reserve in relation to the project of maintenance as a whole. The isolated achievements of conquest and transformation appear within the totality as random acts with unpredictable consequences. Through abstraction the concrete re-emerges – as a process out of our hands.

This is not to say that this awareness is an automatic outcome of technologies of perception itself. That would be to lapse into the naive hopes of the technofuturists, Indeed, we have every reason to believe that this is, as Bill McKibben (1993) says, an age of 'missing information'. Nevertheless, there is an alternative to McKibben's somewhat romantic evocation of the presence of the very nature he sees as a lost horizon in the struggle to create a third nature which does indeed have an instrumentally verifiable relation and regulatory function in relation to the dynamic interaction of nature with second nature. But here, most problematically, appears an ontology of nature, or rather of nature's relation to the socio-technical terrains which 'socially construct' our relation to it.

II

The second proposition restates the first, but in terms of the culture of academic institutions. Poststructuralism would seem at first sight to be a loose body of theoretical practices which have nothing to do with any concept of 'nature' and the practice of green politics. The reason for this is that in critiquing classical Marxism, and faulting it for its concepts of historical necessity, trajectory and totality, poststructuralism has unwittingly exacerbated the underlying notion of mother nature. At its most optimistic, poststructuralism celebrates a creativity without restraint, indeed a positively transgressive will to difference. But these are times when the global limits to growth appear as a grotesque version of the Marxian totality made concrete. These are times when necessity reappears, not as a compulsion to extract surplus from nature and thus freedom from necessity, but as a compulsion to prevent the extracted surplus from overcoming and destroying its very conditions of existence.

As such, postructuralism appears in part as quite out of step with the times, as a modernist throwback rather than a timely advance.[12] Where it was absorbed, as routine academic practice, as a global theory of difference, what we now need are different theories of the global. Where the particular, the historically and cultural contingent has been raised to the level of a general principle in a lot of cultural studies, now perhaps what is required is historically and culturally contingent approaches to the general.[13] By framing the problem of totality in such a highly nominalist form, the aim is to circumvent the 'bad totality' which much work in cultural criticism has

been reacting to for the last two decades or so. Having prescribed the limits to the concept of totality, perhaps it is time to relearn its uses.

III

This leads me to my third proposition, which in a sense expresses the first again but in terms of political culture: the green movement is a thoroughly postmodern movement. It may even be the classic form of postmodern political culture. This is a claim which also appears counter-intuitive. It is a claim which green activists and theorists have vigorously denied whenever I have voiced it (Wark, 1991; Christoff, 1991; Wark, 1992c; Flew, 1992; Frankel, 1992a and b). Far from being, in the first instance, a politics of a return to 'mother nature', green politics belongs primarily on the terrain of 'third nature'. The paradox of the shift 'from red to green' politics is an attenuation, rather than a strengthening, of the connection between the political as a domain and nature as a terrain (Bahro, 1984). The global limit to the particular and contingent projects of modern development only appear at a more abstract level, where the space of the Earth becomes mapped and modelled by abstract sciences, relying on abstract vectors of perception (Wark, 1990). The problem, and this would require another essay to elucidate, lies in the articulation of new vectors of perception to new, more abstracted collectivities created out of the vectors of communication which constitute third nature.

SimEarth is a kind of rebus for these problems: a simulation of a simulation of a regime of truth organized out of the logistics of perception, the vectors of communication and the techniques of calculation of third nature. It was only by linking, in my everyday life, this most abstract puzzle to the totality that these ideas occurred to me in the first place. While green politics appears to be a shortcut out of postmodern abstraction and complexity and back to nature, it is nothing of the sort. It is quite the opposite. It is a symptom of being flung backwards out of second nature, by the congealing together of a new terrain if perception and communication, which in our times becomes ever more conscious of itself as third nature. Green politics, postmodernism and the new information paradigm sciences are the symptoms of its emergence – an ecology where viruses spread along the vectors of communication linking computers, rather than human or animal bodies. An ecology abstract enough to uncover the ends of the transformation of nature into second nature, and announce its meta-narrative consequences.

Notes

1 SimEarth is manufactured by the Maxis company and distributed by Broder-bund. The basic algorithm used in SimEarth is also employed in the SimCity, A-Train, SimAnt and SimLife simulations also produced by Maxis.
2 The Pegasus node can be contacted from the Internet by telneting to peg.pega-sus.oz.au. Pegasus Communications Pty Ltd can be contacted at P.O. Box 284 Broadway, QLD 4006, Australia.

3 One would not want to give the impression, however, that contemporary Chinese agriculture and rural culture is environmentally sound, no matter how much rural China may appeal as a romantic, pastoral ecological image. William Hinton (1991) argues that the introduction of market incentives has increased productivity but permanently damaged the rural ecosystem.

4 A good critique of historicism from a postcolonial perspective is Young (1990). This book nevertheless lacks an environmental dimension, which is exactly the level at which the world-historical totality presents itself on the theoretical and practical agenda.

5 What I am looking for here is an historicism which is at the same time spatial, which is indeed a history of the production of successive regimes of spatiality of ever-increasing abstraction – the production of 'natures'. As Jody Berland (1992: 39) has pointed out, with the exception of Canadian communications theory derived from Harold Innes, cultural criticism suffers from an 'historicism of the theoretical imagination'. See Harold Innes (1992).

6 This idea of a second nature as a 'socially constructed' but 'naturalized' terrain of experience is an old one. One can find it in Pascal and in Hegel. In the *Philosophy of Right* Hegel identifies second nature with the 'system of right', an accumulated product of the activity of mind acting upon itself, in the world:

> The basis of right is, in general, mind; its precise place and point of origin is the will. The will is free, so that freedom is both the substance of right and its goal, while the system of right is the realm of freedom made actual, the world of mind brought forth out of itself like a second nature. (1967: 20)

Georg Lukacs brought this conception of second nature down to earth, and back into a more critical understanding of history as the process which produces second nature out of the liquidation of the terrain of feudalism, which was more an adaption to, than a transformation of, nature itself.

> Capitalism destroyed both the spatio-temporal boundaries between different lands and territories and also the legal partitions between the estates. In its universe there is a formal equality for all men; the economic relations which directly determined the metabolic exchange between men and nature progressively disappear. Man becomes, in the true sense, a social being. Society becomes the reality for man. Thus the recognition that society is reality becomes possible only under capitalism, in bourgeois society. But the class which carried out this revolution did so without consciousness of its own function; the social forces it unleashed, the very forces that carried it to supremacy seemed to be opposed to it like a second nature, but a more soulless, impenetrable nature than feudalism ever was. (1983: 19)

7 On the significance of the telegraph, see Carey (1989).

8 A useful critique is Evernden (1992). Evernden draws a distinction between socially constructed conceptual frameworks of Nature, and nature itself, which has an independent material existence. The problem, however, is the process by which nature is transformed by social labour, out of which arises Nature, or the cultural and social construct, which is in turn part of the process of further transformation.

9 Three recent texts which evidence this trend are Gelernter (1992); Rheingold (1991) and Benedikt (1991).

10 Both Gleick (1987) and Levy (1992) are interesting as examples of an approach to science writing which appeals to a computer-literate 'new middle class'. Levy also writes a column for *Mac World* magazine.

11 On the significance of Cook's and other voyages to the Pacific for the development of second nature and its science of nature, see Smith (1989).
12 More specifically, I have in mind here Deleuze and Guattari (1983), and the 'weak theory' advocated Gianni Vattimo (1988). I should add that both are theoretical approaches to which in other respects I am quite drawn.
13 For an 'antipodean' version of the historical totality, see Wark (1992a and b).

References

Adams, Douglas (1986) *The Hitchhiker's Guide to the Galaxy: A Trilogy in Four Parts*, London: Pan Books.
Bahro, Rudolf (1984) *From Red to Green*, London: Verso.
Benedikt, Michael (1991) editor, *Cyberspace: First Steps*, Cambridge: MIT Press.
Benjamin, Walter (1989) 'Theses on the philosophy of history', in *Illuminations*, New York: Schocken.
Berland, Jody (1992) 'Angels dancing: cultural technologies and the production of space', in Grossberg, *et al.* (1992) editors, *Cultural Studies*, New York: Routledge.
Bolter, J. David (1986) *Turning's Man: Western Culture in the Computer Age*, Harmondsworth: Penguin.
Carey, James (1989) *Communication as Culture*, Boston: Unwin Hyman.
Castells, Manuel (1985) editor, *High Technology, Space and Society*, London: Sage.
Christoff, Peter (1991) 'Thoroughly modern Greens', *Australian Left Review* 135: 46–7.
DeLanda, Manuel (1991) *War in the Age of Intelligent Machines*, New York: Zone Books.
Deleuze, Gilles and Guattari, Felix (1983) *Anti-Oedipus*, London: Athlone Press.
Evernden, Neil (1992) *The Social Creation of Nature*, Baltimore: Johns Hopkins University Press.
Flew, Terry (1992) 'Alienating and elitist', *Australian Left Review* 143: 46–7.
Frankel, Boris (1992a) 'Social movements and the political crisis in Australia', *Arena Magazine* 2: 11–14.
—— (1992b) *From the Prophets, Deserts Come*, Melbourne: Arena Publications.
Fukuyama, Frances (1992) *The End of History and the Last Man*, London: Hamish Hamilton.
Gelernter, David (1992) *Mirror Worlds*, New York: Oxford University Press.
Gleick, James (1987) *Chaos*, London: Cardinal.
Hegel, W. G. F. (1967) *Philosophy of Right*, Oxford: Oxford University Press.
—— (1991) *The Philosophy of History*, Buffalo: Prometheus Books.
Heidegger, Martin (1977a) 'The question concerning technology', in *The Question Concerning Technology and Other Essays*, New York: Harper Torchbooks.
—— (1977b) 'The age of the world picture', in *The Question Concerning Technology and Other Essays*, New York: Harper Torchbooks.
Hinton, William (1991) *The Privatisation of China: The Great Reversal*, London: Earthscan Publications.
Innes, Harold (1992) *The Bias of Communication*, Toronto: University of Toronto Press.
Jameson, Fredric (1991) *Postmodernism or, The Cultural Logic of Late Capitalism*, London: Verso.
Kojeve, Alexandre (1986) *Introduction to the Reading of Hegel*, Ithaca: Cornell University Press.

Latour, Bruno and Woolgar, Steve (1986) *Laboratory Life: The Construction of Scientific Facts*, Princeton: Princeton University Press.

Levy, Stephen (1992) *Artificial Life*, London: Jonathan Cape.

Lovelock, James (1988) *The Ages of Gaia*, New York: Norton.

Lukacs, Georg (1983) *History and Class Consciousness*, London: Merlin.

Lyotard, Jean-Françoise (1984) *The Postmodern Condition: A Report on Knowledge*, Minneapolis: University of Minnesota Press.

Marx, Karl and Engels, F. (1976) *The German Ideology*, Moscow: Progress Publishers.

McKibben, Bill (1990) *The End of Nature*, Harmondsworth: Penguin.

—— (1993) *The Age of Missing Information*, New York: Penguin.

Mercer, David (1991) *A Question of Balance*, Sydney: Federation Press.

Muller, Heiner (1990) 'The luckless angel', in *Germania*, New York: Semiotext(e).

Rabinbach, Anson (1990) *The Human Motor*, Berkeley: University of California Press.

Rheingold, Howard (1991) *Virtual Reality*, London: Secker & Warburg.

Roddewig, Richard J. (1978) *Green Bans: The Birth of Australian Environmental Politics*, Sydney: Hale & Iremonger.

Ross, Andrew (1991) *Strange Weather: Culture, Science and Technology in the Age of Limits*, London: Verso.

Seltzer, Mark (1992) *Bodies and Machines*, New York: Routledge.

Smith, Bernard (1989) *European Vision and the South Pacific*, Melbourne: Oxford University Press.

Vattimo, Gianni (1988) 'Bottles, nets, revolution and the tasks of philosophy', *Cultural Studies* 2.

Wark, McKenzie (1990) 'The logistics of perception', *Meanjin* 49.

—— (1991) 'Greens in the post', *Australian Left Review* 133: 36–9.

—— (1992a) 'Speaking trajectories: Meaghan Morris, antipodean theory and Australian cultural studies', *Cultural Studies* 6: 433–48.

—— (1992b) 'Autonomy and antipodality in the global village', in A. Cavallaro, *et al.* (1992) editors, *Cultural Diversity in the Global Village: The Third International Symposium of Electronic Art*, Adelaide: Australian Network for Art and Technology: 99–104.

—— (1992c) 'Saturation point', *Australian Left Review* 136: 46–7.

—— (1992d) 'The Green old days', *Australian Left Review* 141: 46–8.

—— (1993) 'Suck on this planet of noise'. In D. Bennett (1993) ed. *Cultural Studies: Pluralism and Theory*. Melbourne: Melbourne University Literary and Cultural Studies, Vol. 2.

Williams, Raymond (1980) 'Ideas of nature', in *Problems in Materialism and Culture*, London: Verso.

Wilson, Alexander (1992) *The Culture of Nature: North American Landscapes from Disney to the Exxon Valdez*, Cambridge: Blackwells.

Young, Robert (1990) *White Mythologies: Writing, History and the West*, London: Routledge.

ANNE BALSAMO

DEMOCRATIC TECHNOLOGIES
AND THE TECHNOLOGY OF
DEMOCRACY

■ John Street, *Politics and Technology* (New York: Guilford Press, 1992) 212pp., $35.00 Hbk, $14.95 Pbk.

J ohn Street negotiates a multi-layered landscape formed by the basic question: What role does technology play in the shape of contemporary political arrangements? In his opening section called 'A few technicalities', he articulates the question that guides the rest of the book and in so doing demonstrates that such considerations are anything but 'mere technicalities'. In asking 'how are politics and technology linked', he sets an ambitious agenda for himself. Even in narrowing his focus to the link between technology and forms and reforms of *democratic* politics, he establishes a broad topic of investigation that requires discussion of basic debates concerning the definition of technology, and the role of 'the state' in technological development. And, for the most part, he delivers a thorough meditation on the current structural configuration of the politics of technology.

Street's analytical project requires a working definition of technology which for him includes more than the notion that technology is a 'piece of hardware employed or fashioned to serve a particular purpose' (7). He extends the definition to include a distinctly human quality: 'what determines its [a tool or machine's] status as technology is the deliberate and conscious use of it by human agents' (8). This sets the foundation for his argument that any analysis of technology must account for the degree of human control it makes possible or the limits on control it establishes.

Following this line of explication, he asserts that technology also 'refers to the way in which the parts are organized, through the application of knowledge, to realize their particular purpose' (8). Technology in this sense also includes the notion of 'technological know-how'. But this still isn't an adequate definition for his purposes; it must also include, he explains, the 'set of decisions about how that technology ought to work' (9). Thus Street puts in front of his reader an expanded definition of technology that includes not only the artefacts which are commonsensically understood as technology, but equally important, the human knowledge about how to use and deploy such artefacts.

Armed with this expanded theory of technology, Street returns to his guiding question: How should technology be assessed in a democratic society? After he re-presents the basic theories of the relationship between technology and political change, Street argues for a hybrid model of technological change that asserts the central importance of a 'feedback loop' between changes in political conditions and changes in technological arrangements. To illustrate, Street draws the following diagram:

Changes in political conditions ⟷ Developments in science and technology

New political demands/needs ⟷ New technical possibilities

In describing this model, Street argues that there is no rigid link between political structures and technological forms: technical innovations certainly do influence political possibilities, for example in war technologies, but 'politics plays a role both in terms of the values and judgements at play, and also in the institutional structures and political interests that transmit and organize these ideas' (42). Political influence is, in turn, influenced by technological developments – developments that at times may look like they have an autonomous momentum in that they appear to be separate from any clear form of social determination. To demonstrate how the appearance of 'autonomous momentum' is actually a consequence of other political factors, Street turns his attention to two important lines of force that he implicitly argues set technological change in motion: (1) the role of the state in the determination of technological research; and (2) the politics of science. Where the chapter on 'The State and Technology' is one of the strongest chapters in Street's book, and offers useful information about the dimensions of state regulation of technological development and application, the chapter on the 'Politics of Science' is the weakest in terms of its discussion of political consequences of the postmodern crisis of scientific rationality.

It is by now one of the most obvious features of contemporary US culture that the state and technology are inextricably linked not only in that the state's infrastructure is fully saturated by technology, but also in that the state is principally responsible for promoting technological development through its roles as customer, regulator, or underwriter of the production of scientific knowledge and technological research. As a regulator, the state is responsible for monitoring the building and operation of technology; the

main responsibility of the state as regulator is to safeguard citizens from technological dangers. This often takes the form of establishing and policing compliance with safety regulations, fairness policies, and required levels of technological service. In this capacity, the state takes on the responsibility to establish an apparatus of control that embodies broad democratic principles of representation and the promotion of collective 'social' good.

We know also that the state influences the development of technology when it directly purchases or invests in new technologies. Through its role as either customer or underwriter, the state offers various political agents the opportunity to mount campaigns against or in favor of specific technological programs. This focuses critical attention on the ways in which technological policy is formulated, debated, contested and implemented. This requires an investigation into several related processes, including how technological decision-making is divided among government agencies, how experts are identified, and how advisory committees function. As Street implies, it may be difficult to track down this material because one of the tendencies of government 'advisory committees' in relying upon experts and deputy advisers is to close off discussion about technological policy and public good from the scrutiny of public debate.

Street's discussion of the relationship between democratic political structures and strategies of technological control raises several questions that must be addressed in any cultural analysis of technology: what specific form does state regulation take? how is a state's purchase of or investment in technology negotiated? how is technological policy established? what form, if any, does public participation in technological decision-making take? But direct state intervention, as regulator or investor, is only one line of force determining the shape of technological development. An equally powerful, and no less politically potent line of force is the role that science plays in the determination of technological research and development.

Street's chapter on the 'Politics of Science' is not as fully developed as earlier sections. His point in this chapter is to discuss 'whether science changes according to the political pressures brought to bear upon it or at work within it, and whether the truth it offers is partial and selective in ways that matter politically' (71). He anchors his discussion of the politics of science within a Kuhnian version of the interaction between the social and scientific worlds to support his claim that science is socially, and therefore politically, influenced. But he fails to discuss the work of science sociologists such as Donna Haraway, Bruno Latour, Michel Serres, and Steve Woolgar; work that would have directed his attention not only to the way that scientific *knowledge* reflects political values and interests, but more importantly to the way that the relationships between *scientists*, funding *institutions*, and economic *reward systems* are complexly structured and serve to establish yet another political dimension to the production of 'science'. This is not a politics inflicted by some reified notion of 'the state', but a much more complex notion of politics as the exercise of power on behalf of one class of people to the disadvantage of another. Rhetorically, this would have made his treatment of 'women in science' as a 'case study'

more politically responsible. As it is, his case study of 'women in science' is explicated entirely through Brian Easlea's study of the masculine identity of atomic-bomb scientists. In that he fails (for the most part) to consult the critical feminist scholarship on science and technology that has emerged in the past decade, his 'case study' is rather anemic where it could have been much more robust. So that instead of being able to describe the many different ways in which politics play a role in the production and deployment of scientific research, he evades the multi-perspectival feminist analysis of the enterprise of science. If he had followed Haraway's assertion that all technologies are reproductive technologies, he would have had the opportunity to illustrate several additional dimensions of the politics of science question; dimensions addressed by various feminist projects including such topics as: (1) the assessment of the political and ideological effects of scientific discourse within educational materials; (2) the role that women play in the development of technologies; (3) the reproduction of the masculinization of science and technology; (4) the global distribution of scientific and manufacturing labor; (5) the institutionalization of scientific findings; (6) the policy debates about insurance reimbursements and employer liability laws. Although he will briefly return to consider the feminist critique of technology in his closing chapter, he devotes very little space in the course of his argument to discussing in any depth the various feminist analyses of politics of science or of technology.

His discussion of the role of the state in the determination of technological research and development, and of the political nature of scientific knowledge outlined a conceptual account of the way that technology is determined by broader cultural forces. He then moves to a more specific description of two current arrangements of democracy and technology. Here he offers two extended case studies; in the first he outlines the treatment of technology within the various Green political movements and in the second he discusses the debate about electronic democracy and forms of information technologies. His point is to illuminate the different ways in which technology is implicated in debates about forms of government, notions of social and public good and formulations of social problems.

In his discussion of Green political movements, he asserts, in a section called 'Different Shades of Green', that: 'in analyzing the Green argument, we have to be aware that there is no single Green movement, and there is, therefore, no single "Green" analysis of technology' (139). For his purposes, he focuses on the 'Deep Green' movement represented in the work by Jonathan Porritt, to illuminate how such a perspective sets democracy against technology, where technology is understood to be the root of all evil, and democratic, decentralized forms of citizen participation hold the key to controlling technology. In an informative discussion of the major critiques of the Green position, Street articulates the central faultline in the Green argument: how, exactly, will local changes in community practices transform global political and economic structures? In response to the slogan, 'Think globally, act locally' Street reminds readers that such a decentralized community-based program relies on a centralized, global perspective. He

suggests that the Green movement has not been able to specify the mechanism whereby local political programs can change global technological arrangements. This, for him, is a significant analytical shortcoming.

Street considers in turn those who assert a very different relationship between technology and democracy that is in direct opposition to the Green position. In contrast to the Green movements, those who assert 'the technical fix' argue that technology can actually solve the problems that it has in fact created. In reviewing this approach to the issue of technology and politics, Street discusses the arguments for a new form of democracy based on information technologies. In this case of the technical fix, proponents assert that electronic democracy has become the necessary form of democratic politics in the 'information age'. As he did with the Green perspectives, Street first outlines the argument in favor of the use of information technologies in the service of democratic politics and then delineates its flawed logic. The key criticism relies on the notion of information access. Where advocates of electronic democracy argue that computer communication networks disperse great quantities of information to concerned citizens so that they can spend less time tracking down the information they need to make informed decisions, critics charge that the quantity of information does not guarantee quality of information. Furthermore, determining the relevance of information – the core of the democratic process – involves practices of social communication, not simple database access. In short, Street's critique of the 'technical fix' argument questions the model of democracy facilitated by the new information technologies, and the unintended consequences of the deployment of such technologies.

By now it should be clear that Street is working toward an understanding that technology should not be either *demonized* as the source of all our social problems (Green movement), nor *celebrated* as the key to solving all our social problems (Electronic democracy). In his last chapter he outlines a third approach that draws on the strength of both the Green movement that evaluates how technology reflects political values and excludes others, and the technical fix approach that recognizes how democratic structures are already influenced by technological arrangements:

> Although they differ in their weaknesses and their strengths, the two arguments share a common flaw. Both create a false dichotomy between politics and technology. The Greens want to recreate a pure politics in which 'human' values can survive and flourish. For this to occur technology must first be reduced to a subservient position. The technical fix school, on the other hand, want to eliminate the 'irrationalities' of politics through the deployment of technological progress. While the two groups have drawn opposite conclusions, their arguments rest upon a common assumption: that politics and technology can be separated. But such a separation is impossible to make. (178)

His third approach, which he labels the 'cultural approach', integrates the 'political argument and the technological assessment' to assert that, fundamentally, technology is a social process. Both technology and nature

are social constructions that serve as both consequence and determining force of further social interactions. To explicate what is involved in a cultural approach, Street offers a third case study of the 'freedom of speech and mass communications'. He points out that mass-communication technologies have become the cultural context for discussions of Western democracy. Consequently, freedom of speech is no longer a self-evident and easily guaranteed democratic right. He asks: 'What exactly is meant by "freedom of speech" in a world in which the means of communication are owned by media conglomerates and in which access to these means is very restricted?' (185)

In his subsequent discussion of this question, Street returns to his expanded definition of technology to argue that any answer to this question must include a thorough analysis of 'the design of the technology and its potential applications; the organization of the technology – who has access and control; and finally, the content which it carries – political education' (187). Thus he concludes that a cultural perspective must account for: (1) the production of technical expertise as a cultural form of authoritative knowledge; (2) the various institutional forms of technological regulation; and (3) the available methods of technological assessment. Above and beyond these concerns though, Street also argues that a cultural analysis must also be prepared to articulate alternative means of 'organizing such things' (194). This, of course, is the hardest part of any cultural analysis of the politics of technology: how to rearticulate technological arrangements according to different, progressive political objectives.

To this end, Street's book is a valuable guide for cultural critics; one that will enable them to construct analyses of the organization of technologies, knowledges, and policies such that we can begin to plan strategies of rearticulation. In a more educational sense, this book would be very useful in any undergraduate course that addresses the relationship between science, technology and culture in that it describes the social and institutional organization of science and technology in Western postmodernity in accessible terms. And, more importantly, it redefines the issue of politics as a central aspect of technological research and development. In illuminating the political nature of technological arrangements, Street offers cultural studies a map of the terrain upon which Western democracy will be reinvented in the twenty-first century.

ROSS GIBSON

'THE CULTURE OF NATURE'

■ Alexander Wilson, *The Culture of Nature: North American Land-scape from Disney to Exxon Valdez* (Cambridge MA: Blackwell, 1992) 335pp., $21.95 Pbk.

T here is a robust shape to this book. In overview it isn't especially seamless, smooth or 'well made'. It is not a sleek monograph shaped to fit a tidy, singular world-view. The bumpiness of the book is probably due in part to the conditions of its research and writing. Alexander Wilson makes a living variously – at horticulture, journalism and landscape design – and many chapters must have been instigated under one or another of his professional guises. For example, there are essays about recreational road-travel (file this under 'Leisure Studies' and 'Geography'), about the layouts and rhythms of nature parks, zoos and nuclear power plants ('Landscape Architecture', 'Local Politics'), about nature movies ('Genre Studies') and about the production-consumption cycles that generate life and death in several North American habitats ('Agit-prop Journalism', 'Ecological Theory', 'Horticulture').

I'm not about to condemn this variegation. The apparent raggedness of the book does not betray any woolliness of thinking. On close inspection and deployment, the book is not ragged. It is vigorous. It has an ecological scrappiness deriving from Wilson's years of wandering, reading, thinking, comparing and writing across the vastly scrappy and changeable North American continent. And like a robust and busy ecology, the book manages to work and thrive because of its hybrid, interdisciplinary vigour. As it investigates, it replicates environmental shapes; the maintenance of a classical, 'architectural' rectitude is not part of the project. A smoother, more 'resolved' book on the North American landscape would not help with the messy task Wilson sets himself and his readers: to refigure the operations of power, efficiency, profit, satisfaction, hunger and resolution that people take to and from the country. It's a programme entailing aesthetics, biology, politics, history and a whole lot more. Therefore the book is vigorous and prolific, not sleek.

Moreover, it is usually persuasive and often very pretty. Wilson attempts to keep the object alive as he analyzes it, even when there are graceless

accretions spoiling it. Take for example his rendition of the border country not far from his Toronto home-base:

> In the sinuous lake and river country of the Great Lakes-St Lawrence watershed, the land is relatively flat and yet densely vegetated. There are no sweeping vistas, so the aesthetics of this landscape in its more or less wild state is built on experiencing nature in its details. The activities that make sense here are intimate, even private, like canoeing or mushrooming. Yet the geography allows for great numbers of people to have this experience of the immanent frontier all at the same time. When you add the automobile and the express highway to this equation you end up with a well populated region of the continent colonizing large portions of the remaining bush with millions of second homes, each with its private road and intimate view. (31)

Wilson's cultural studies have many moments of such grace, when the play of rhythm, connotation and nuance in language is worked deftly to provoke and persuade. The prose style is a result of an ecological attention to patterning, dynamics and harmonics. This is cultural studies which tries to take its shape from a dynamic encounter with its object; it abjures the more customary 'grid' approach which jams an object through a set of routines to see what snags on predetermined burrs of inconsistency, culpability or bad faith. The latter approach can ossify through too much respect for the *status* of prescribed method. Wilson tends to be nimble rather than intransigent. He usually allows himself to be *moved* by his thinking. Even when condemnation is his animus, he evokes the wonder of the monstrosity so that a reader can sense the compulsion that must be brought to the task of restoration. Take for example this passage that winds up sounding like a mad-scientist rendition of Woody Guthrie's 'This Land is Your Land':

> Dams and power plants are the appurtenances of modern industry, geographical evidence of human work and the transformation of nature. These and other technologies fully occupy the industrial and post-industrial landscape of North America, from the petroleum-based farms of Saskatchewan to the militarised deserts of the American West to the relentless electric grid of the Tennessee River watershed. (257)

You have to be impressed by the grandeur of what's gone wrong. And you have to get as smart and as adaptable as devolution before you can scheme up ways to restore a place.

Restoration is the practice the book sets out to comprehend and enact, and in the process Wilson takes time to expose carefully and forcefully the errors of certain smug intransigencies within the conservation movement:

> Restoring landscape is not about *preserving* lands – 'saving what's left,' as it's often put. Restoration recognizes that once lands have been 'disturbed' – worked on, lived on, meddled with, developed – they require human intervention and care. (17)

Such a practice, simple as it sounds, actually requires structural change to the status of being Western, so that one can begin to engage with the material

realm in such a way that 'ethical' notions like responsibility and custodianship, as well as more spiritual ideas like communal sentience, can all become second nature. Accordingly, assumptions about the work we do to the environment need to be called to account. Wilson clinches this idea in a bold run of sentences:

> But in the late twentieth century, technology is not merely a collection of tools and machines or a representation of power. It is also a sensorium, a field of perception. If the land is wired, so are we. (258)

The Culture of Nature thus proposes a self-management regime which is also a technique for learning to speculate and operate in globally systemic terms. This entails avoiding as much as possible the centralization of power in metropoli, acknowledging the constant mutability of a dynamic ecology and preparing oneself and one's community to adapt mentalities, moralities and politics. For this reason there is a purposeful regionalism built into Wilson's argumentation. Many of the tracts of land and systems of custodianship that are read as exemplars in the book are in out-of-the-way stretches of North America, several of them in Canadian provinces. Wilson resists the requirements of incumbent power here: the book's main US market has to work with exemplification from outside its customary purview. The book remaps (or rewires) significance across a widespread, 'alternative' North America, a jittery circuit-board of localities that are mostly unfamiliar yet interrelated and mutually biotic.

In the long run, the book accepts a set of writerly challenges which are also political tests. For example: how to talk in universalizing terms of 'us' and as 'we' in an era when the self-serving ploys of liberal humanism have become obvious at the same time as theories of speaking-positions have validly complicated the idea of talking for others? How to remind ourselves that we are talking about our water, our air, our lives at the same time as we must acknowledge that our survival actually depends also on empowering (and getting out of the way of) factions of otherness and difference so that *they* (who in so many respects must be known as not *us*) can restore and manage their local systems of specialized knowledge and custodianship? For the most part, through delicacy of writing and thinking (symbiotic actions in an ecological sense), Wilson shows some ways to proceed into this ideological scrub.

In overview, such semantic fitness is one of Wilson's great strengths. Is it only the aesthete in me that applauds the attention to verbal play and style in the book? As I read and take notes, and get a little excited occasionally, I believe the aesthete can be a politician, and I think also that we need to become as adept as possible with the suggestive intricacies of nuance in our critical writing. Only through such work and play can we hope to win the constituency which will enact the necessary changes to the ways we think about all our organizations in all our hay-wired lands.

▪ ARTICLES ▪

IAN HUNTER

HISTORY LESSONS FOR 'ENGLISH'

■ John Dixon, *A Schooling in 'English': Critical Episodes in the Struggle to Shape Literary and Cultural Studies* (Milton Keynes: Open University Press, 1991).

Introduction

John Dixon is a deservedly prominent teacher of English teachers. His *Growth Through English* was perhaps the single most important manifesto-cum-manual for what has been known since the sixties as the 'personal growth' model of English. Still, it is one thing to practise a discipline and quite another to subject it to scholarly investigation. Apologists are rarely good historians or sociologists of their own disciplines. They are usually too convinced of the disciplines's moral necessity – and too busy telling the story of its (pending) moral triumph – to allow the facts to assume less comforting patterns. John Dixon's *A Schooling in 'English': Critical Episodes in the Struggle to Shape Literary and Cultural Studies* is no exception to this rule.

Foucault and his collaborators have described the tasks of a 'history of the present' in terms of the need to make things that are familiar to us strange, and to make things that 'go without saying' much harder to say. Although chronologically speaking Dixon's book is a history of the present, its aims are the reverse of these. This book takes what is arguably a very unexpected cultural transformation – the redeployment of a formerly esoteric regimen of aesthetic cultivation as a disciplinary practice in mass education systems – and makes it seem inevitable. By the time Dixon is finished, English and cultural studies are so deeply identified with the moral universals of humanism – personal experience, enjoyment, democracy, popular resistance, community, life – that their history is robbed of all contingency and, indeed, all historicity. The only question that we are left with is why it took so long for their triumph to occur, or what last obstacles must be finally overcome.

I should confess immediately though that, as the author of a rival history of English, I am more an engaged interrogator than a detached spectator of Dixon's work.[1] The reader will of course wish to keep this in mind during all that follows. All the more reason, then, to begin with a fairly full summary of the book's argument.

The story of English

In Dixon's view English is born all at once – albeit in an infant form requiring further development – as a practice of literary reading in the late nineteenth century. We can note that, given this origin, the pedagogical role of English in the school system is not something essential to it. This is something that happens to English as it is institutionalized, a process that has both costs and benefits. Dixon's developmental history is organized into three stages. The first deals with what Dixon takes to be the origins of the discipline, in the University Extension movement of the period 1867–92.

Origins are always difficult to arrange, particularly when – as is often the case – their role is to represent the emergence of a timeless essence into history. For Dixon the essence of English lies in a particular type of literary reading: an intimate and reciprocal relation between the literary text and its reader that holds the keys to both 'language' and 'subjectivity'. The birth of English in the late nineteenth century therefore has two conditions. On the one hand, there was the fact of (aesthetic) literature and the fact that, apparently, everyone wanted to read it: 'It was an era when original thinking – and the discussion of it – found a home outside archaic educational structures. As a result, it aimed to attract, not a cloistered and male elite, but a national circle of readers' (28). In Dixon's view, the teaching of English literature began to emerge outside the institutional environments in which it had been ignored or stifled because people simply enjoyed the experience of it: 'Central to that rescue was the actual enjoyment of reading' (30). In other words, English was born because it already existed, in the untutored capacity for and enjoyment of aesthetic experience.

On the other hand, English was born because the time was ripe. The desire for social, political and educational reform had apparently penetrated all social strata and departments of existence, assembling the bits of society into a single mood or disposition that promised the recovery of a lost humanity:

> Feelings and hopes like these were alive in every town and city: among skilled workers, now with the vote; members of the co-operative movement; women, but especially middle-class women, struggling to gain recognition as equals in work; the rebellious and non-conformists among a growing class of professionals; a small but active minority of reformists in the ancient universities. (13)

These groups are unified by their desire to liberate themselves from structures and institutions defined, by Dixon, in terms of the functions of constraint and repression. So, given the native desire to find themselves through the spontaneous enjoyment of literature, it was inevitable that such

groups would pursue their emancipation by seeking to read literature outside its repressive institutional location in the universities. Dixon thus regards the University Extension movement – in which freelance university lecturers taught short courses to self-selecting groups in various provincial towns and cities – as the creation of self-realizing democratic groups and communities:

> A Democratic University of peripatetic teachers and active self-organising students: this is what was proposed, in effect. The decades 1870–89 were to prove its testing ground – and its most triumphant moment . . . Is there still something to be learned from this model? (16–17)

Still, without disagreeing with Dixon's positive evaluation of these developments, there is evidence in his own account that they may have been dependent on agencies less warm and spontaneous than self-organizing democratic community groups. The Northern Council for the Promotion of Higher Education for Women, for example, consisted not only of highly cultivated feminists and literary intellectuals but also high-level bureaucrats, university officials and one of Her Majesty's Inspectors of Schools (15). We also learn that perhaps the single largest group attending the Extension courses consisted of elementary school teachers (32). Was the emergence of this new audience testimony to the universality of the enjoyment of literature and the desire for democratic social reform? Or did its literary capacities and interests owe more to the designs of an educational bureaucracy which, as a part of its strategy of mass education had, about twenty years earlier, set out to produce a stratum of literate teachers from the lower classes? Already, outside the reach of Dixon's focus on spontaneous communitarianism, we catch a glimpse of larger forces and a longer history lying behind the emergence of English.

We will return to these issues below. For the moment we need to observe that Dixon regards the 'innovating experiences of the Extension courses' (29) as the midwife for the birth of a new kind of criticism. Dealing with an audience untrained in Classical rhetoric or historical philology, but possessed of a strong moral interest in reading, the lecturers taught a form of reading that differed significantly from the rhetorical and philological modes (29–32, 39–42). Specifically, this was a practice of reading not oriented to objectifiable knowledge of the text or its composition, being focused instead on achieving a highly 'inward' relation to the text. According to Dixon: 'It was the beginning of a new disciplinary tradition for reading' (41).

Now this tying of a practice of reading to a specific pedagogical milieu is highly suggestive. It is an historical lead, however, that Dixon finds impossible to follow up, because he has already identified this practice of reading with the spontaneous experience of literature. The Extension course is thereby reduced to the transparent expression of this experience; and in this guise it sweeps away the rhetorical and philological disciplines, which appear as little more than repressive constraints on the desire for aesthetic experience. For Dixon, the pedagogy of the Extension courses has no such

constraining or structuring effects because it is simply the form in which self-organizing groups 'combine' to commune in the experience of literature. The difference between aesthetic reading and philological description thus loses its historical character and becomes instead a pseudo-philosophical distinction between immediate experience and its abstract analysis. We thus begin to glimpse a certain kind of absolutism buried in the ostensibly open and tolerant story of the discipline. The signs of this intellectual absolutism can be seen in Dixon's endorsement of A.C. Bradley's tautological view that only the aesthetic reading gives access to 'the poem as a poem':

> What [Bradley] sees himself fighting, as a teacher, then, is the 'tendency to substitute other studies for the poem as a poem'. By all means, carry out the 'more prosaic task – that of learning to understand the mere words'. But the activity that follows must be imaginative. Without that – he implies – there can be no enjoyment. (40)

Here we identify a figure of thought that is central to Dixon's discourse: the figure of 'the breakthrough to experience'. The Extension pedagogy lacks all historical specificity because it is the place at which history – the repressive domain of archaic and constraining institutions – is broken through to reach the timeless truth of aesthetic experience. History cannot be rendered transparent to aesthetic experience instantly, however, and there are problems not solved in the initial breakthrough. In particular, Extension lecturers like Bradley, for all their virtuosity in demonstrating the truth of the aesthetic experience, lacked the means to reflect on it and thereby to transform it into a full intellectual discipline. According to Dixon, what was missing from the 'new disciplinary tradition of reading', was a 'psychology' adequate to the experience, a theory of signs to handle its linguistic mediation, and an account of the relationship between literature and society that would show how the experience was structured by historical forces (46–7, 69–76).

The task of developing a mode of reflection true to absolute aesthetic experience is left to I.A. Richards and his collaborators at Cambridge, whose story makes up the second phase of Dixon's developmental account. Because the general form of phase two so closely replicates that of the first stage we can be briefer here. Once again the history is handled in terms of a fortuitous and convenient conjunction between the ripeness of the time and the genius of individuals in search of experience. The time was ripe for the birth of criticism in 1919 because the young men returning to Cambridge from the war were filled with a loathing for all the official lies and propaganda that had killed their comrades. Apparently they couldn't wait to take this animus out on . . . philology (80–5). Cleansed of philology's rules and schemas by a bracing bloodbath, Richards and his collaborators were free to follow their spontaneous interest in analyzing aesthetic experience wherever it led them. Fortunately for Dixon it led them straight to the unfinished business left over from criticism's initial step into history – the

problem of integrating the unmediated experience of literature with an analysis of its conditions of possibility:

> On the one hand [Richards and his cohort] projected a reciprocal demand for theory, for a new analytical clarity in thinking about reading and criticism. On the other, they made the act of reading texts and passages an object of discussion, detailed analysis and (joint) study. (86)

In short, it was time for another breakthrough, which had two results. First, Richards discovered what Dixon regards as a still unsurpassed theoretical foundation for criticism. He did this by incorporating literature in a more general theory of signs, where (according to Dixon) Richards analyzed meaning in terms of how speakers and interpreters use language in particular contexts (91–102). The focus on how language-users interpret signs 'in use' is held to represent a theoretical breakthrough in relation to philological analysis because it allows texts to be approached not as objective artefacts but as co-operatively produced objects of experience.

Second, Richards invented a new way of teaching criticism, one that was adequate to the communal experience of literature. Thus appeared the famous 'practical criticism' seminar which, says Dixon, emerged partly from a theoretical interest in educational psychology but more from the inherently collaborative and democratic character of literary experience:

> The notion that teachers *as a group* are learning – *expect* to learn from each other, in experiments – *show* they learn from the discussion sparked by a student's exploratory response – creates a special kind of intellectual climate. It makes space for students to think and speak more freely, without a sense that a final, authoritative judgement is always waiting round the corner. (105, original emphases)

So, practical criticism integrates aesthetic experience and its theoretical analysis by enacting the co-operative construction of meaning in a fully democratic and self-organizing reflexive practice. Needless to say, approached in this manner the practical criticism seminar – like the precursor Extension course – loses all constraining effects and becomes the transparent expression of the aesthetic experience and its reflexive theorization. Still, even Dixon has to deal with the fact that the practical criticism seminar is also a highly normative and disciplinary milieu, with student responses routinely being read as symptoms of various kinds of moral, psychological and aesthetic failure – sentimentality, inhibition, moralism, and other 'stock responses'. By no means inherently embarrassing, this exercise of pedagogical power must be so for Dixon, as it threatens to undermine his image of the seminar as a spontaneous self-organizing collective – an image which he moves to shore up by treating the corrective discipline as itself a purely voluntary process:

> Most of the students were young (18–20); many, ardent readers of poetry no doubt – otherwise why attend? No one was compelled to go. The revelation that pretty well all of them were prone to misinterpret, and

demonstrably so, must have been shocking, challenging and stimulating. (107)

Still, the damage has been done. We have caught a glimpse of the seminar's highly structured and constraining (perhaps positively so) disciplinary relations. We begin to suspect that pedagogical relations are far more deeply involved in the 'experience' of literature than the account of this true believer can allow. We will deepen this suspicion below.

For the moment we can note that, as with the first, Dixon regards this second breakthrough as incomplete. Richards' momentous achievement in Dixon's eyes was to have located literature in a conception of language that identified it as the condition of experience. Assuming that language is the mediator of experience in all human activities, then a theory of language opens the door to a general analysis of all social speech acts or 'ideologies'. Through this door lies the future form of English, Cultural Studies (111–17). If Richards and his band did not step over this threshold, says Dixon, that is because they lacked an adequate account of history and the relation between literature and society. Such an account was extant – in the work of the Russian theorists Volosinov and Bakhtin – but its impact on anglophone intellectuals would have to wait for the final stage of the discipline's maturation.

So one more breakthrough to experience is required. It happened apparently during the 1960s and 1970s, when Dixon and his colleagues were active as teacher educators and as the 'organic intellectuals' of the organized profession of English teaching – not that the organization of the profession is something that falls within the scope of Dixon's history. His eyes are fixed on higher goals: on the final historical and theoretical breakthrough that will (almost) complete the self-realization of the discipline.

Once again this occurs through the obliging conjunction of a ripe time and a (collective) genius in search of true experience. This time it is not Victorian reformism or post-bellum radicalism that sweeps through society – unifying its fragments into a single global mood, making it ripe for intellectual picking, or the pickings of intellectuals. This role falls instead to the radical student movement. According to Dixon, it was the 1960s student movement which, in reacting to class inequalities at home and US imperialism abroad, pointed the way towards liberation for all of society's repressed groups – women, the working class, blacks (147–9, 172–3). It was in this context that a variety of groups began to agitate to change the school system in general (to achieve educational equality through comprehensive schooling) and the English curriculum in particular. This time, says Dixon, it was not bathing in blood but participating in teach-ins that allowed for the breakthrough. Such activities, in association with 'a renewed searching for 'democratic' traditions in the British left' (151), allowed a broad coalition of groups – feminists, students, the Birmingham Centre for Contemporary Cultural Studies, the trans-Atlantic teachers of English – to pursue radical theorizations of experience and to wage war on imperialism, inequality and . . . philology.

Still – despite broad agreement on the need to democratize education, acknowledge working-class experience, and develop an historically informed analysis of all cultural media (print and TV, high and low) – Dixon's story here is not one of co-operative progress towards a common solution. On the one hand this goal was defeated by the constraining hand of the existing institutional structures, which failed to deliver a metropolitan interdisciplinary centre capable of providing a truly collaborative milieu (179–84). But on the other, this constraint only exacerbated a tendency towards schematizing and theorizing that was already present in some of the oppositional groups. Dixon seems to have the Birmingham centre in mind – still not forgiven for its flirtation with structuralism and semiotics:

> Theorising in the field of Literature, Culture and History was a job beyond the existing institutions. The work was going to be piecemeal, not systematic; partial syntheses seemed bound to be quickly overtaken (by global intellectual movements). And in the drive towards theoretical answers, the questions and experience of ordinary people stood to be marginalised. (184)

Dixon's story of the Cultural Studies movement is thus one of failed promise. Hence it falls to the trans-Atlantic teachers of English and their organic intellectuals to pursue the goals handed down from the Extension movement and the heady days of post-war Cambridge – to complete the discipline by achieving the reconciliation of aesthetic experience and theoretical reflection in a self-organizing and reflexive pedagogy. According to Dixon the synthetic concept that had been biding this historical moment – waiting for a time that never quite arrived – is the notion of 'dialogue':

> Dialogue, studied in context, challenges all previous theories of discourse, I would claim. And, crucially, it exposes the fallacies of literary and cultural studies that supposedly restrict their analytical enquiries to the 'text' – thus, whether consciously or not, privileging a specific reading, that of the theorist.
>
> Similarly, without a dialogic theory, the 'text' itself is not placed as a response, in its turn, to what others have said or written . . . Equally, any given reader and reading is to some degree abstracted from the personal and social context in which meaning and significance were constructed. When this happens, the work of both production and reception is uprooted from its formative shaping in society and history. (185–6)

Given the theoretical, political and moral work that this concept must perform in completing all the unfinished business of Dixon's history, it is hardly surprising that it struggles to hold together several levels of analysis. First, at the 'deepest' level, the notion of dialogue allows Dixon – drawing on Russian dialogical linguistics and American ethnomethodology – to transform Richards' theory of meaning into a big-picture account of the mutual formation of language and the subject of experience. Fortunately, the details of this somewhat baroque account need not concern us. We need only observe the relations of mutual constitution that it establishes between

language and subjectivity. On one side of the equation this theory proposes that the subject is confronted by indeterminate signs. Before these signs can mean anything a context must be invented for them which the subject does, says Dixon, borrowing a concept from the Russians, through a process of 'inner speech' (136–41). Here inner speech is the linguistic equivalent of the Kantian synthetic ordering of consciousness that makes (linguistic) experience possible.

On the other side of the equation, however, lies a 'too-determinate' subjectivity, one removed from the truth of experience by fixed preconceptions, and these too are the product of (inculcated and stereotypical) 'inner speech' (202). Here it is consciousness that must be renovated by the experience of the sign or text, rather than the other way around. 'Inner speech' thus has the conceptual disadvantage of lying on both sides of the equation in Dixon's account: it is both the linguistic ordering of consciousness that makes the experience of textual meaning possible, and the socially inculcated structuring of consciousness that textual meaning must penetrate and reorganize to free us from 'stock responses'. It is the play between these two positions – between the text that we create in responding to it, and the text that creates us by challenging our responses – that Dixon calls the dialogical theory of meaning.

There is not much to be gained in dwelling on the circular or, in Dixon's view, 'paradoxical' character of this theory as it is not really an attempt to describe languages or their uses. The role of the dialogical theory is really to establish a moral vantage point from which its theorist can integrate all the departments of life from the perspective of the expressive subject. Hence, at the second level of this synthesizing account, Dixon uses this notion of dialogue to complete the theorization of criticism, this time drawing on reader-response theory (194–9). Again, the details need not detain us, except to note the explicitly circular or 'paradoxical' character of the 'dialogue' in which the reader's interpretation constructs a text that simultaneously constructs the reader's interpretation. It is significant that, at this level, teaching and the teacher appear to play no part in the process, with text and reader being posited in a mutually self-formative and self-corrective relation. So, Dixon cites Louise Rosenblatt's comment that 'the reader's creation of a poem out of the text must be an active self-ordering and *self-corrective* process' (196, Dixon's emphasis).

When teaching does reappear, at the next level of the widening circle of dialogue, it has been purged of all signs of disciplinary training and moral governance. After all, if the aesthetic reading is just an extension of the child's self-formative interaction with language, then the English classroom is not the condition of learning to read aesthetically, merely the place where this native capacity can be exercised. In this power-free expressive milieu, the teaching relation can only mimic the relation between reader and text, with teacher and student appearing as equal, mutually-formative dialogical 'partners':

To restore active thinking, teacher and students had to set up the tasks and '*each write for the other*' in new roles. Work in progress – thinking on the

wing – might be just as well worth responding to as a finished product. Student writers . . . had to write as equals for their peers, as guides and advisers for less experienced readers, and as imaginative and intellectual explorers with teachers as mature (but not infallible) guides. (165)

This pedagogical milieu, for which Dixon was a leading technician and advocate during the 1960s and 1970s, in fact lies at the heart of his account. The possibility that this milieu might itself be a carefully crafted disciplinary institution is never entertained. Yet, as Dixon says of Richards' classes, it is a pedagogy that routinely positions its students for 'the revelation that pretty well all of them were prone to misinterpret'.

The final and least restrained of all the levels is one where the model of dialogue expands to incorporate 'history' and the relation between literature and society. Given the assumption that all departments of existence – law, broadcasting, international relations, sexuality, social consumption – are underpinned by a single nexus of 'language and subjectivity', and given that the English classroom is the transparent expression of this nexus, it can claim to be the privileged site where the whole of 'society' is opened to moral inspection:

So, literary and cultural studies had recurrently to bring into the open the conditions of existence for all these practices, and to analyse their organising forces in a given historical era – including the present, the moment when student and teacher are themselves producing texts and readings. (208)

Under the moral pressure of this last dialogical exchange – where society is 'read' as if it were a series of literary texts, and the reading of literature is a device for assembling aesthetic impressions of 'social problems' – the English lesson undergoes a truly grandiloquent intellectual inflation. It begins to see itself as a general moral diagnostic and therapeutic for all social and personal problems 'in a given historical era'. Let us begin our critical discussion of Dixon's book in earnest by commenting that before English can take on the exalted role of the Subject of History it must first understand its own history as a subject; once it has it will no longer dream of that role.

Back to school

This is a highly polemical book, although the polemics are disguised somewhat by superficial signs of tolerance and openness. It is a response to the revisionist histories of Baldick (1983), Doyle (1989) and Eagleton (1983). Dixon attempts to rescue an earlier progressive image of English from these analyses of it as an ideological cover for various kinds of social exploitation. His main criticism of these revisionist works is that in attempting to read off a history of English from its general ideological function they are 'too abstract', missing in particular the co-operative 'networks' and groups which, as we have seen, play the central role in Dixon's story (1–8). Still, without dismissing Dixon's criticism of these other accounts, there is a clear sense in which his focus on self-organizing groups is

just as far removed from the contingencies of history as is their focus on the discipline's 'social mission'.

Reconsider, in this regard, the role of such groups in Dixon's account of the way in which the Extension movement gave birth to 'a new disciplinary tradition of reading'. Dixon may well be right in suggesting that the impetus for this movement did not come from the universities. This does not mean though that it came from outside established institutions altogether – from the spontaneous 'enjoyment of literature' apparently characteristic of women, trade unionists, elementary-school teachers and other oppositional groups. Dixon's humanism prevents him from asking *how* such groups acquired the capacity for advanced literacy, the interest in reading, and indeed the motivation, discipline and organizational abilities required to run a 'voluntary' self-improvement network.

Individuals sometimes gain such capacities through autodidactic labour, but for whole social strata to acquire them an immense work of institution-building and social discipline is required. Before Dixon's apostles of culture could take up their positions in front of literate, interested and self-disciplined lower-class audiences, a few other things had to be done: a popular school system had to be built; a complex machinery of administration and inspection had to be put in place; suitable pedagogies had to be improvised; teacher-training institutions had to be established, and much more. This set of developments, which began in earnest in the 1830s, was not spun off by self-organizing oppositional groups acting out of a love of literature. It was the achievement of large-scale governmental organization and bureaucratic expertise. In this regard, the words of the emerging school system's most creative bureaucrat – spoken, it transpires, in 1866 – turn out to be far more faithful to the historical moment than Dixon's:

> It is no small matter that the training colleges and day schools which exist have established throughout the country an idea of the organisation and form of a system of public education, which has made itself permanently a part of public opinion throughout influential classes. But the ministers of state and leaders of political opinion were in advance of the great body of the people when this system was built up. It did not spring from the people, it originated with the Government. Nor, though influential classes have accepted it, are the people yet trained to receive from the hands of the State this system, and to support it by their own voluntary contributions. (Kay-Shuttleworth, 1980: 85)

No doubt there will be many ready to attack Kay-Shuttleworth for his paternalism, but his remarks were in fact entirely appropriate to the historical circumstances. Before dismissing them we need to note that their target was the middle-class doctrine of *laissez-faire* which, like certain anti-statist ideologies of our time, was opposed to state schooling in the name of freedom. In any case, the lesson should be clear: before 'self-organizing' groups could appear, a large amount of governmental organization had to have taken place.

We should note though that 'government' in this context is not equivalent

to the notion of the state as a unified and sovereign political will. Instead, following Foucault's (1991) discussion, we use it to refer to an ensemble of political technologies – systems of economic management, public health, social welfare, education, discipline. From about the eighteenth century, these technologies began to support a variety of programmes aimed at knowing and managing particular governmental domains, in the name of an optimal development of the state and its population. The emergence of state schooling in England is governmental in this sense. It is central to Foucault's discussion, however, that government does not invent the instruments through which it takes place, as pure expressions of a sovereign political will. Instead, it borrows and adapts such instruments from a variety of sources – from the economic management of estates, the military disciplining of armies, and the pastoral guidance of lay populations. In doing so it also borrows and adapts the objectives or 'wills' of these domains. This leads to an important insight into the emergence of popular education in states like England and Prussia. In these states government took over and adapted the institutions of Protestant pastoral guidance, developing school systems that pursued the social training of the population through the systematic inculcation of individual conscientiousness.[2]

We are still learning about the role of religious disciplines of inwardness and self-regulation in the development of state schooling. Laqueur's (1976) study of the 1780s Sunday school – the key precursor institution – provides an important lead. Protestantism it will be recalled was a 'religion of the book', and moral reading – at first of the Bible but then of secular moral stories – was an important means of relating to the self and (through techniques of supervision and interrogation) of opening this relation to the pastor or the teacher. I have discussed elsewhere (Hunter, 1988) how this use of reading as a technique of inwardness and moral supervision was adapted to the emerging state-school system. At the centre of an emerging literary pedagogy lay a special relation to the teacher (as a sympathetic guide and unintrusive exemplar) and to the text (as the means by which the students' personal responses were intensified and supervised).

In other words, I am suggesting that a major condition for the emergence of the literary reading as an intense personal experience – and indeed for the existence of readers with the literate and ethical abilities required to undergo this experience – was the deployment of moral reading in the emerging school system as a technique of spiritual discipline and social management. So, far from signifying an absolute or unconditional experience, beyond the reach of 'constraining institutions', the widespread 'personal' reading of literature can be traced to its pedagogical transmission as a technique of individual inwardness and collective discipline. This pedagogy, with its gentle teacher and its unremitting surveillance – with its 'experienced' text about which one is always mistaken – is a key condition of the English classroom, right up to and including Dixon's utopian vision of students writing 'as imaginative and intellectual explorers with teachers as mature (but not infallible) guides'.

In short, English did not spring into history when the personal reading of

literature at last found the right pedagogical milieu; that is, one whose democratic and communal character allowed such reading unconstrained expression. Neither did its critical moments coincide with democratic struggles, epochal wars or popular radicalisms. To the contrary, English started to take historical shape when a governmental pedagogy began to deploy the personal reading as a disciplinary technique; and its temporality is marked by the less spectacular rhythms of bureaucratic planning and teacherly improvisation. English was not born as an institutional expression of the experience of literature; it emerged as a pedagogical institution that gave students the capacity to relate to literature as an 'experience'. Given Dixon's own position as teacher educator, it is hard to say what is more disturbing in his detour around the pedagogical reality of 'English': his failure to look squarely at its actual history; or his refusal to face up to the remorseless exercise of moral discipline involved in this (as in every) system of training.

Criticism versus philology

So English was (and remains) a product of the merging of governmental and pastoral discipline that took place during the eighteenth and nineteenth centuries. But it also had other components. Perhaps the most important of these was a discipline of reading that can be called 'aesthetic' and that existed in a complex historical relation with the moral inwardness of Protestant devotional reading.

Like explicitly religious reading, aesthetic reading conceives of the engagement with the text as an immediate experience capable of transforming the reader. It differs, however, in the way that it organizes this engagement and of course in the kinds of text used. Dixon begins by specifying the aesthetic mode in a negative manner, by contrasting what he calls 'criticism' with moral philosophy and of course the *bête noir*, philology. Unlike these latter disciplines which, according to Dixon, abstract from the experience of the text, encasing it in rigid concepts or dessicated rules and procedures, criticism attempts to recreate or evoke the experience at a short remove. Once again it is the self-organizing Extension lecturers who are credited with the initial realization of this criticism, with Bradley being drawn on to make the contrast with the rival 'abstract' discourses. Dixon cites Bradley to the effect that such discourses separate the ideas from the language of literature, but to the artist 'the substance and the form are one thing':

> A fundamental point is being made, it seems to me, about drama and theory as contrasting poles of discourse. Discussion of poetic drama as an 'experience', Bradley is asserting, must find forms of language that retain – rather than eradicate – its characteristics as a kind of dynamic 'vision'. Only in that way will the actual 'struggle', with its complexity of 'elements', be grappled with adequately. Abstract discourse, by comparison, must lose touch with the substance of drama and thus its value. Products of this kind are inadequate to the experience. (45)

Two initial points should be made. In the first place, it is clear that Bradley and Dixon are talking about the Romantic or aesthetic notion of the 'unity of form and content'. But why then credit its discovery to English intellectuals in the 1880s rather than German intellectuals a century earlier? That is the historical point. The theoretical point concerns just what department of reality this notion actually belongs to.

For Bradley and Dixon the notion of form-content unity is justified by the nature of aesthetic experience itself, which requires a particular 'closeness' to the actual language of the text. It is clear, however, in the initial German formulations of the doctrine, that we are dealing with a reality of quite another kind. In Schiller's account, for example, it is clear that form-content unity is not a feature of aesthetic discourse or experience as such. It is something that has to be *achieved by the reader*, and its absence is typically a sign of a special kind of ethical failure:

> But it is by no means always a proof of formlessness in the work of art itself if it makes its effect solely through its contents; this may just as often be evidence of a lack of form in him who judges it. If he is either too tensed or too relaxed, if he is used to judging exclusively with the intellect or exclusively with the senses, he will . . . attend only to the parts, and in the presence of the most beauteous form respond only to the matter . . . The interest he takes in it is quite simply either a moral or a material interest; but what precisely it ought to be, namely aesthetic, that it certainly is not. (Schiller, 1967: 157)

Here, I would suggest, the notion of form-content unity finds its home not in the text but in a special discipline inside which the text is put to a specific use. Above all, the unity of form and content has the character of a *test*; it is something to which one must be subjected and which one can (must) fail. The object of this discipline and testing is to achieve a certain stylization of the self – to differentiate oneself from those who are too tensed (didactic moralizers) and too relaxed (literalists and thrill-seekers). The aesthetic experience is therefore not the starting point of the literary reading but the difficult goal of a strenuous practice of self-problematization and self-cultivation. Criticism's 'closeness to the text' is the result of a difficult balancing act in which the critic is supposed to use the text to heighten certain aesthetic emotional states while simultaneously modifying this passion through reflective analysis of textual structure. The pay-off from this discipline is that the aesthete supposedly avoids mortgaging his personality to particular points of view and thereby gains access to the totality of experience.

For most of the eighteenth and nineteenth centuries the aesthetic reading remained the voluntary *Lebensführung* or spiritual lifestyle of a tiny minority of aesthetic virtuosi and ethical athletes. Ordinary tensed-up Protestants of course continued to read for moral content, and didactic works of moral direction and practical devotion – conduct books, exemplary biographies, providence literature – dwarfed the sales of aesthetic literature.[3] When, at the beginning of the twentieth century, the aesthetic

reading began to be incorporated into the upper reaches of the education system – at first in the training of teachers and then in the emerging English classroom itself – it was of course as a special way of testing and disciplining the self. In other words, in treating the aesthetic experience as the absolute foundation of criticism – instead of as a moral and psychological state induced by a strenuous 'work of the self on the self' – Dixon universalizes what is in fact a historically contingent 'practice of the self'. This is what makes his treatment of philology so bereft of historical understanding and intellectual toleration.

For Dixon the rhetorical and philological approaches to language and literature that prevailed in the grammar schools and universities are symptomatic of ethical as well as intellectual failure. In his eyes these approaches are not disciplines with their own objectives; they are 'products . . . inadequate to the [aesthetic] experience' which, we have seen, is an ethical test. Only this explains his willingness to dismiss philology as a bankrupt tradition, quoting with apparent approval Churton Collins's claim (made in 1891) that through philology the great masterpieces of English Literature 'have been resolved into exercises in grammar, syntax and etymology. Its history has been resolved into a barren catalogue of names, works, and dates' (30).

Now one doesn't have to defend all the activities that went under the name of philology to say that Dixon's dismissal of it is both rash and inaccurate. After all, the time at which Collins was writing was also the time at which the Philological Society had just completed its staggering collective labour on the single most important linguistic and literary work of the century. I am referring of course to the *Oxford English Dictionary* – a work of undisputed typological elegance and historical erudition; the daily source of numberless consultations and clarifications; William Empson's secret weapon; and a towering monument to scholarly discipline, care and patience. But the nineteenth century also saw important philological work on Anglo-Saxon, medieval English, Indo-European languages and language standardization.

Two observations are warranted. First, in his characterization of nine-teenth-century philology as a barren and 'catechitical' exercise, Dixon draws on none of the available studies of the discipline. Neither are any listed in his bibliography.[4] But this absence would fit with our suggestion that Dixon is not actually attempting to provide an historical description of the relations between criticism and philology, and is in fact simply using philology as a moral foil for a triumphalist history of English.

Second, and more importantly, in treating the relation between criticism and philology as if it were the relation between true aesthetic experience and its false (abstract) analysis, Dixon convicts philology of 'failing' to reach a goal that it does not and cannot try to achieve. For, we can recall, the aesthetic experience is the end result of a specialized spiritual discipline, while the philological description of texts is the product of quite other intellectual disciplines – of historical reconstruction, typological analysis, script decoding, and so on. The difference involved is roughly that between *engaging* in the composition or performance of a text in a specific ritual or

social context, and *describing* this context and its compositional and performantial activities as cultural practices or rites. It is a mistake to see either activity as a failed version of the other.

Consider in this regard a representative piece of modern philological analysis: Albert Lord's *The Singer of Tales*. Here Lord (1960) develops a detailed description of the methods of oral composition used by illiterate bards in modern Yugoslavia. He does so in part to shed light on the structure of Homeric verse. For a philologist like Lord the actual use of the oral epics by their singers and audiences – as means of staging and sanctifying the ethnos, at tavernas, weddings and religious festivals – belongs to a particular department or way of life. The attempt to provide an 'objective' description of this use – through a philological analysis of the training of singers in oral composition and performance, and of the structure and social role of the epic songs – belongs to another department. The latter is indeed an attempt to reflect on the former cultural milieu, not however with a view to inducing or recreating the affective or religious states undergone by those participating in this milieu.

This necessary compartmentalization of different domains of intellectual and moral life is one that Dixon neither achieves nor comprehends. For Dixon, like his Romantic forebears, the philological description of literary milieus and artefacts is (or should be) an attempt to transmit or recreate the emotional and intellectual states resulting from a particular use or reading of literature. Dixon comments that in criticism: 'Prevailing imagery . . . is not so much inspected or listed as gathered and evoked' (54). Because philology does not in fact do this – it is not an evocative or incantatory discipline – it is held to have 'failed', and joins the ranks of the vanquished trailing behind criticism's march towards its historical rendezvous with experience, enjoyment and truth. But the philological description of literature can no more 'fail' to recreate the states of its aesthetic users than Lord's description of the oral epic can 'fail' to induce the states undergone by the communities for whom it is a cultural rite.

Dixon's difficulty of course is that he (like most other educated citizens of 'European' societies) belongs to a largish community for whom the aesthetic reading is indeed a cultural rite, as well as to a much smaller caste (of scholars) whose discipline and duty is to achieve a detached analysis of such rites. In treating the aesthetic reading as an unsurpassable 'experience' that philology attempts and fails to capture, Dixon is failing to achieve this discipline and failing to respect the ethical boundary between practising a rite and describing it.

This is not a problem if one's role is that of a priest or technician of the cultural practice in question and, indeed, for most of his career this has been Dixon's role. He is a distinguished teacher of aesthetic reading and a justly honoured composer of its manuals of instruction. It is a problem though if the priest-technician of the rite also wishes to be its historian, and in failing to differentiate these two disciplines and roles simply reproduces the rite dressed up as 'history'. Unfortunately, Dixon doesn't avoid this set of difficulties.

We can recall that Lord does not demean those communities that participate in the rites of the oral epic by treating them as 'failed philologists'. (Although this is what 'Kantian' linguistics does when it imagines its own descriptive rules to be 'unconscious' structures in the minds of language users.) For Dixon, however, philologists are precisely 'failed aesthetic readers'; and in treating them in this way he not only demeans philologists, he also undermines their important ethical function: to step outside the circle of aesthetic cultivation long enough to provide a description of it. The methods of disengagement and disciplined analysis necessary to take this step are an important means of avoiding intellectual fanaticism.

Deflationary strategies

This may well be the first time that philology has been defended in the pages of this journal. No doubt it will strike many readers as absurd to wish to rescue philology from its aesthetic mugging. After all, English may have had its faults but at least it attempted to break through philology's narrow positivism, and to pose theoretically and politically important questions about the relations between language and subjectivity and literature and society. But in my view the faults of English lie precisely in these attempts. Conversely, I have suggested that philology's 'positivism' – that is, its attempt to delimit its domain and object of knowledge to a specific set of descriptive disciplines and procedures – may be an important ethical and intellectual resource. It teaches us the lesson that respecting the intellectual limits of disciplines can be an important ethical duty; that not all departments of existence are open to inspection from a single vantage; that 'experience' is not the foundation of knowledge but a specialized state induced by non-cognitive disciplines; and that it is not enough to say 'history' or 'society' or 'subjectivity' to form the object of a valid knowledge.

Needless to say, these comments do not form part of a strategy to 'bring back philology'. It is unlikely that philology will ever be anything more than a small scientific discipline and, more to the point, philology can't be brought back because it never went away. No, what the comparison between criticism and philology permits, is to chart the limits of the aesthetic domain. It allows us to see that criticism is not the vehicle of an experience that philology fails to grasp and is instead a discipline for inducing an experience that is peculiar to criticism. The emergence of practical criticism at Cambridge in the 1920s was not therefore the result of a breakthrough to an experience to which philology had proved 'inadequate'.

Far from being an epochal innovation invented by warrior Dons, practical criticism was the by-product of larger and less personal forces. The first and most important of these we have already looked at: the development of a state-wide education system in which the conduct and capacities of children were governed through the discipline of moral reading. The Protestant inwardness of this discipline, and its use as a means of engaging the interests

and shaping the conscience of large masses of working-class children, meant that the emerging literature lesson had little in common with the rhetorical and philological traditions of the grammar schools. This was the setting that first saw the deployment of texts – stripped of all linguistic impediments and scholarly apparatus – as a means of eliciting and correcting students' 'personal' responses. It is not to wars and geniuses that we owe this use of literature but to state-trained school teachers and the exigencies of the system in which they worked. Hence, twenty years before Richards began his experiments, we find a teacher educator writing in the American *Journal of Education* that:

> The great danger in literature teaching is its tendency, in the hands of insufficiently qualified teachers, to degenerate into linguistics. . . . the text alone should be in the hands of the class; all help must come direct from the lips of the teacher. (Zimmern, 1900: 558)

Second, this use of texts was inflected through the incorporation of the aesthetic reading as a pedagogical discipline. We have already observed that the aesthetically unified text was above all a test of the reader's ability to achieve a particular stylization of the self: a device that required both the heightening of aesthetic feeling and the exegesis of textual detail. The contribution of Richards and his colleagues was to improvise techniques for the pedagogical administration of this formerly voluntary and esoteric discipline. That is why 'sentimentalism' (too much feeling) and 'inhibition' (too little), 'formalism' (too much attention to textual detail) and 'literalism' (too little), are the key 'misreadings' of practical criticism. These are not cognitive problems in the relation to the text; they are ethical problems in the relation to a self that is, by turns, 'too tensed' and 'too relaxed'. In other words, Cambridge English (but also American New Criticism) improvised the pedagogical means of administering the aesthetic reading as an ethical test or ordeal – one in which exhaustive textual commentary was in fact a sedulous emotional self-exegesis and a demonstration of the practitioner's ethical distinction. In this manner another spiritual discipline was grafted on to the upper reaches of state schooling. It soon began to play a key role in forming the ethical and political comportment of the teaching profession.

The third factor that played a role in the formation of the discipline – at least in the way criticism came to be practised – was that set of disciplines known as the human sciences: linguistics, psychology, sociology. Partly for reasons of space and partly for reasons of relevance I will not say much about this question here. A few clarifying comments will suffice. In particular we can observe that these quasi-scientific disciplines were not the 'foundations' of English. English, we have seen, emerged as a specialized pedagogy from the contingencies of 'government', not as a science from the speculations of theory. Moreover, in purporting to use these disciplines to achieve a theoretical formalization of English, it seems highly likely that literary theory from Richards to Jameson has done little more than add a 'theory' inflection to the administration of the aesthetic test. After all, the notion that aesthetic experience is the product of 'unconscious' (linguistic, social,

psychological) structures is beside the point if in fact this experience has the character of ethical telos inside a governmentally administered spiritual discipline. Its own complicity in and dependence on this circumstance would help to explain why literary theory has nothing interesting to say about the pedagogical milieu that forms and maintains the aesthetic experience. Can something similar be said about the exposés of English that have emerged from the field of Cultural Studies? Is it possible that, in discussing English as the ideological instrument of various unconscious social, historical and linguistic structures, the work of Baldick, Doyle and Eagleton may have been improvising on the discipline rather than explaining it? Let us leave that speculation for another time.

We are now better placed to understand what happened at the parting of the ways between criticism and philology. Only in stories told by insiders to celebrate the triumph of criticism will this event appear as a recovery of true aesthetic experience from the false abstraction of philology. In reality, this moment witnessed the brief and ill-understood institutional overlapping of two different activities: a practice of self-testing and self-cultivation, and a discipline of linguistic description and historical reconstruction. In the event, it was not its transparency to aesthetic experience that was responsible for the subsequent exponential development of English but a far more mundane factor: its utility as a means of providing 'spiritual grooming' on a mass scale to students and their teachers.

Not that this genealogy is a reason for looking down on English. To the contrary, wonder and admiration would be more appropriate responses to a system that managed to take what had once been the esoteric practice of a spiritual élite and redeploy it as a civic discipline for working-class children and their teachers. To take this unexpected and extraordinary development for granted is to rob ourselves of the capacity to grasp one of the 'contingencies that make us what we are'. It is also to obscure the truly formidable success and strength of the profession and ethos of English teaching.

English cannot be criticized for being an apparatus of social discipline and spiritual training. To the contrary, this should be the source of a degree of historical pride. Its difficulties lie elsewhere, in its incapacity to reflect on this reality and in its delusion that it is something grander – both problems arising from the *kind* of spiritual exercises employed in English. We have seen that the exercises of the aesthetic reading work to induce the belief that there is indeed a 'highest' form of experience – a privileged vantage from where, through the dialectic of 'language' and 'subjectivity', the analyst can catch experience as it forms and hence see into all the departments of existence. Not only is this disposition responsible for Dixon's 'history' of English as the perpetual breakthrough to experience, it also informs the limitless moral and intellectual claims that he makes for the discipline.

It will be recalled that, at the final expansion of dialogical theory, Dixon envisages a point at which a whole range of social practices will be opened to judgement in the critical reading: 'So literary and cultural studies had recurrently to bring into the open the conditions of existence for all these

practices, and to analyse their organising forces in a given historical era – including the present, the moment when student and teacher are themselves producing texts and readings' (208). This aspiration to religious transparency wildly over-reaches the real but mundane virtues of teaching children the arts of literary reading and writing. Its results, as exemplified in the following passage, can only be described as unfortunate:

> For example, how could my own reading of the Frost poem not be lightened, in July 1990, by the winter revolutions in Europe – only to be darkened again by trigger-happy reactions to the invasion of Kuwait? It is this living context, I could say, with its deeper interests, which shapes both the reading and the dialogical evaluation – unless, of course, that is stifled and repressed in the classroom or the professor's study. (197)

Why, one feels like saying, should we be interested in what John Dixon 'the person' thinks about the Gulf War or the nationalist reconfiguration of Eastern Europe, unless he happens to be a person trained in the histories of these regions, in international relations, or in the principles of statecraft? Moreover, what is it that makes the profession he represents presume that it possesses the range of intellectual and moral qualifications necessary to teach about such matters competently in a civic setting? It is enough to say that Dixon is not interested in wars or state reconstruction as military, political, economic or social realities. He is interested only in his own aesthetic reactions to such events. He is concerned only with the manner in which these events – once they have been tagged with the crudest of moral judgements – 'lighten' or 'darken' the emotional state achieved through the reading of poetry.

One could comment here on a culpable degree of self-absorption. Even less fairly, one might observe how quickly the 'winter revolutions' that served to induce Dixon's aesthetic high turned into fratricidal anarchy, and how important is the duty to abjure prophecy. But it is the intellectual and moral grandiloquence of an entire profession and mode of intellectual conduct that we are dealing with here. At the very least Dixon's example gives us cause to question whether the discussion of social, political and civic issues should be left in the hands of 'English' teachers. There is no professional reason why English teachers should be competent in this range of issues, any more, for example, than maths teachers should. We can only look forward to the day when the teaching of politics and civics through poetry lessons will seem as odd as the teaching of history through algebra lessons.

Notes

1 See Hunter (1988) to which, I note for the record, Dixon does not refer.
2 For further discussion see Hunter (1988), Laqueur (1976) and Melton (1988).
3 For further discussion see Ward (1974).
4 In particular there is no mention of the standard studies by Aarsleff (1967, 1982).

References

Aarsleff, H. (1967) *The Study of Language in England 1780–1860*, Princeton NJ: Princeton University Press.

—— (1982) *From Locke to Saussure: Essays on the Study of Language and Intellectual History*, London: Athlone Press.

Baldick, C. (1983) *The Social Mission of English Criticism 1848–1932*, Oxford: Clarendon Press.

Doyle, B. (1989) *English and Englishness*, London: Routledge.

Eagleton, T. (1983) *Literary Theory*, Oxford: Blackwell.

Foucault, M. (1991) 'Governmentality', in G. Burchell *et al.* (1991) editors, *The Foucault Effect: Studies in Governmentality*, London: Harvester-Wheatsheaf.

Hunter, I. (1988) *Culture and Government: The Emergence of Literary Education*, London: Macmillan.

Kay-Shuttleworth, J. (1980) [1866] 'Popular education', in D.A. Reeder (1980) editor, *Educating Our Masters*, Leicester: Leicester University Press.

Laqueur, T.W. (1976) *Religion and Respectability: Sunday Schools and Working Class Culture, 1780–1850*, New Haven: Yale University Press.

Lord, A. (1960) *The Singer of Tales*, Cambridge Mass: Harvard University Press.

Melton, J. Van Horn (1988) *Absolutism and the Eighteenth Century Origins of Compulsory Schooling in Prussia and Austria*, Cambridge: Cambridge University Press.

Schiller, Friedrich (1967) *On the Aesthetic Education of Man*, trans. E.M. Wilkinson and L.A. Wiloughby, Oxford: Clarendon Press.

Ward, A. (1974) *Book Production, Fiction and the German Reading Public 1740–1800*, Oxford: Clarendon Press.

Zimmern, A. (1900) 'Literature as a central subject', *Journal of Education* September: 557–9.

ANJALI MONTEIRO

AND K.P. JAYASANKAR

THE SPECTATOR-INDIAN: AN EXPLORATORY STUDY ON THE RECEPTION OF NEWS[1]

What actually will happen afterwards.... the viewers cannot say ... people like us ... whether he will really say something or not ... from this you can understand what this is all about ... (R.G.)

Introduction

Doordarshan, India's state-owned television network was instituted in the sixties, in the context of media policies informed by modernization theory, specifically the communication approach to development. This model is based on the neo-Weberian transformation school of social change, which sees underdevelopment as a product of internal cultural barriers (Krippendorff, 1979). 'Development' involves the transformation of simple homogeneous folk societies through the agency of a benevolent, Western-educated élite, into modern capitalist growth-oriented nation-states. The cure for underdevelopment calls for a massive injection of modernization through the mass media, aimed at breaking down traditional values, disseminating technical skills, fostering national integration and accelerating the growth of formal education (Open University, 1977: 56). In a country characterized by bewildering linguistic and cultural diversity, where less than a quarter of the population are native speakers of Hindi, the national language, an ambitious agenda was set for the media, the attempt being to foster a pan-Indian identity based on secularism.[2]

The pair modernity/development set up a 'natural' antinomy: tradition/underdevelopment. With 'tradition' being identified as the chief enemy, media policies and programmes aspired to reinforce the legitimacy of a new set of discourses pertaining to the body, the family, the population, production techniques and the institutions of the state. In defining the Third World peasant as backward and lacking in all the attributes necessary for development, modernization theory posited a site for the intervention of a range of development experts, with television being seen as a potent vehicle for this intervention.

The research that has addressed itself to these issues has been broadly of

two kinds. The first approach is exemplified by the SITE studies,[3] which, having internalized the legitimacy of the developmental paradigm and its implementation, was geared towards designing more efficacious ways of achieving the objectives set by this paradigm. The second approach, which could loosely be termed the cultural-dependency model, draws on Marxist dependency theory to critique the notion of development at a global level, attempting to reduce microlevel phenomena to macrorelations of power and domination. Both the approaches are convinced of the need for development *per se*, but have opposing notions of the causes and solutions for underdevelopment. The desirability of 'progress' with rational, secular Western civilization as the *telos* is taken as self-evident, natural and historically inevitable.[4] The former theoretical stance views the truth of development as extraneous to power, development as neutral and emancipatory; the latter is bent on exposing the repressive forces attendant on these truths. It is against this background that this study is situated. The attempt is to draw on some of the key concepts of Michel Foucault in order to explore possible strategies for understanding television reception in the Indian context. This relatively nascent endeavour at invoking notions from Foucault's work, specifically his notion of power, is not unproblematic, given that the Indian socio-cultural and political context cannot be conflated with that of modern, Western societies. This study does not purport to use this category of power in all-encompassing, transhistorical fashion to examine all orders of power relations, for instance, within the extended family, the *jati*/caste hierarchy and so on. Rather, the authors deem it strategic to employ this category to interrogate the corpus of knowledge and practices pertaining to 'development' that have been transposed on to the Third World,[5] and which have informed the introduction and expansion of television in India. This regime of truth about modernization accords a central role on its agenda to the transformation, through the mass media, of irrational indigenous subjectivities, located in simple societies placed at the lower end of a Social Darwinian scale. Foucault's work, with its focus on the formation of subjectivity in and through relations of power/knowledge thus appears relevant to the present study.[6]

As opposed to a juridical, repressive notion of power, Foucault sees power as productive, for it is in and through relations of power that 'subjects' are constituted.

> The individual is not a pre-given entity which is seized on by the exercise of power. The individual, with its identity and characteristics, is the product of a relation of power exercised over bodies, multiplicities, movements, desires, forces. (Foucault, 1980: 73–4)

Foucault conceives of power not as originating from a unified monolithic source, but as a 'complex strategical situation' (Foucault, 1984: 93) in any society, actualized from numerous sites, implicit in all relationships, economic, epistemological and sexual. It is generated at the level of the smaller orders of the hierarchy, e.g., the familial, the communal. The larger orders of power such as the state are the effect of the configurations of these

local orders. The relations of power are marked by resistance, for these relations stay in an eternally unstable equilibrium. The channels of resistance are also multiple, never extraneous to the forms of power exercised.

Foucault thus rejects all forms of theoretical totalizing and concerns himself with specific systems of discourse/practice by which, in modern Western societies, individuals are 'made subjects'. These systems of discourse are seen as marking out the 'conceptual terrain in which knowledge is formed and produced' (Young, 1981: 48).

> In every society the production of discourse is at once controlled, selected, organized and redistributed according to a certain number of procedures, whose role is to avert its powers and its dangers, to cope with chance events, to evade its ponderous, awesome materiality. (Foucault, 1972: 216)

This conception of knowledge/power, which sees knowledge not merely as an instrument of power, but as a form of power, assumes relevance in the present-day information society.[7] Foucault identifies three 'modes of objectification which transform human beings into subjects': the 'sciences', which constitute the subject as an object of inquiry; dividing practices, wherein divisions such as mad/sane, sick/healthy, criminal/law-abiding are used to objectivize the subject; and technologies of the self whereby individuals turn themselves into subjects (1986: 208).

Foucault sees the state as a new distribution and organization of an old power technique originating in the Church, namely, pastoral power (1986: 213). The state becomes a 'structure in which individuals can be integrated, under one condition, that this individuality would be shaped in a new form and submitted to a set of very specific patterns' (214). The state's power is thus both 'individualizing and totalizing' and works towards the constitution of 'subjects'.

Population control programmes in the third-world context illustrate these notions of power.[8] These strategies mark out a site of power/knowledge which legitimizes a regime of truth regarding population growth and its scientific study. In specific terms, this involves a marriage between neo-Malthusian theories and demographic surveys which, in turn, aspire to establish scientifically the phenomenon of third-world population growth as an issue of global concern and the main cause of underdevelopment. These epistemological enterprises set the norms for the reproductive behaviour of the third-world subject. The thrust of the attendant campaign has been to equate individual 'benefits' at one level with the collective good at the other. The forms of power/knowledge displayed by these campaigns bear witness to the pastoral modes of power. The dichotomy developed/developing, which forms the *raison d'être* of the population-control campaigns in particular and the strategies of the Third World State in general, involves a self-perception of inferiority and lack both at the collective and the individual level which legitimizes these strategies (Du Bois, 1991). At a global level, these strategies are of prime concern because of the alleged

depletion/degradation of the natural resources and environment. The policy pronouncements of the developed world in this regard continue to be unquestioningly premised on the threat posed by the fast-breeding third-world populace, notwithstanding the fact that the Northern hemisphere accounts for the bulk of the world's energy consumption, greenhouse emissions and waste.

Given this perspective, television in India forms a crucial site wherein the discourses of development have been produced, circulated and consumed within the local networks of power at the level of the family, graduating into large orders. This stance is what obviates the ascribing to television of the role of a neutral vehicle of development communication or of a conspiratorial enterprise foisted on an unsuspecting populace. It is with these concerns in mind that this paper takes up for analysis a single interview, with R.G., on his reception of news.

R.G. could be regarded as a young (thirty-one), upwardly mobile urban Indian male. He comes from a lower middle-class, scheduled caste[9] background, his father being a peon in an institute of social sciences in Bombay. R.G. himself started off as a peon in the same institution and has worked his way up the hierarchy, presently occupying the position of a senior technical assistant in the media department. Alongside, he has also upgraded his educational qualifications, acquiring a Bachelor's degree, a diploma in photography and a Master's degree in Economics. He is the eldest son and the most educated in his family. Married since 1987, he has a four-year-old son. His wife is a matriculate and a clerical worker in a school. Their household income would be approximately Rs 4,200 (approximately $140) per month, which would place them in the middle-income group. R.G. has lived on the campus of the institute for most of his life, including the first three years of marriage, when he and his wife lived with his extended family. His parents live in a one-room apartment, along with his younger brother (recently married, with one child) and his married (but separated) sister, with two children. Some time after his brother's marriage, R.G. set up home separately, in a rented house in a satellite township 15 kilometres away. He and his family still maintain close ties with his extended family. R.G.'s mother tongue is Marathi. He can read and write Hindi fluently, and has also studied English, in which he is relatively less fluent.

In order to contextualize the discussion of the interview with R.G., certain structural, situational and discursive features (Jensen, 1991: 5–6) of television in India need to be outlined.

Television in India

The growth of television in India could perhaps be broadly divided into two phases, the first phase consisting of the period up to 1980. It was during this period that the SITE was introduced in order to arrive at a relevant prototype for the use of television in development. SITE was geared to the rural audience and was disseminated through community television sets. The production of programmes was undertaken under the aegis of a state-run

development communication organization: the thrust was primarily on educational and information-based programmes in the areas of agriculture, health and family planning. The structure and content of SITE reflected the dominant national credo of the sixties and early seventies; self-reliance, 'socialism' and progress through technological inputs (green revolution).

Up to the early eighties, the television network in India had a negligible viewership. In 1983, while the reach was 210 million (28 per cent of the population), the viewership was 30 million (4 per cent of the population) (Singhal and Rogers, 1989: 66). The introduction of colour television, liberalization of television imports, and the installation of the satellite Insat 1-B marked a qualitative change in both state policy and the structure of television viewing. With this, one sees an abandoning of the old development paradigm in favour of a commercial variant: more marketing techniques invoked to sell development as well as commercial sponsorship of programmes. This trend can, perhaps, be related partly to the crisis within the development paradigm itself[10] (Singhal and Rogers, 1989: 20) both at the global and at a local level, where inadequacies in infrastructure and extension services, as well as audience resistance (Sinha, 1985: 122) resulted in a failure to make the projected impact. Another factor that led to this shift was the redefinition of the national agenda in the direction of the country emerging as a regional power in South Asia. The 'India of the twenty-first century' was conceived of as a technologically advanced and growth-oriented nation, overcoming its underdevelopment through scientific intervention and management.[11]

The new development approach involved changes at the level of production structures, modes of reception and programming. With the introduction of commercial sponsorship of TV serials in 1980 and of private software production in 1984, with the shift in emphasis from community television sets to a proliferation of individually owned sets, the stage was set for a new phase in programming and reception. The soap opera *Hum Log* (We People)[12] marks a turning point. Based on the Mexican pro-development soap operas, the success of *Hum Log* demonstrated, firstly, audience receptivity to the use of the family as a site for working out problems and presenting messages and models; secondly, *Hum Log* underlined the commonality of interests and strategies between 'development' and 'marketing', and the possibility of using marketing strategies for effective development communication.

The state strategy of 'going commercial' with television, has been regarded by many researchers as a dilution of its development goals (Chowla, 1985). However, it is precisely this strategy that has made possible the entry of the state into the familial space, in the process redefining the viewers' relationship to both the public and private spheres. The marketing approach used for development communication was also extended to the political arena where, for the first time in the 1984 general elections, the Indian National Congress and other parties relied heavily on media campaigns designed by advertising agencies. The televisual presentation of politics in terms of human interest drama can be seen as an extension of the

state's entry into the family and the use of marketing strategies. The first portrayal in this genre that captured the popular imagination was the funeral of Indira Gandhi, in 1985. For two days, families sat glued to their television sets, experiencing perhaps for the first time a sense of 'being there', of being witness to the making of history as members of the nation-as-family.

With an estimated viewership of 378 million by the year 2000 (Srivastava, 1987), television has considerably changed the face of urban popular culture. The film industry in the country, which commanded considerable viewership, has had to resort to strategies to check video piracy and has begun to explore the commercial possibilities offered by television. This has also contributed to a transposition of the language of popular cinema into television soap operas.

Owning a television set, preferably a colour TV, is very high on the priority of an average urban Indian, despite its high cost.[13] A recent phenomenon that poses a major threat to Doordarshan is the emergence of transnational networks like CNN, STAR, BBC, etc. Private cable networks bring these programmes to many households at a very nominal cost. These networks have made considerable inroads into Doordarshan's viewership in a city like Bombay, but their impact is yet to be assessed and studied.[14]

The programming patterns of Doordarshan on a typical weekday are indicated in the Appendix. There is only one channel except in the four major cities which have a second channel catering to various regional language groups. The programmes with maximum viewership are the soap operas in Hindi, telecast between 8.00 p.m. and 10.00 p.m. The regional language serial between 7.30 p.m. and 8.00 p.m. would rank next in popularity. At the bottom of the list would be the information-based programmes in the regional language (5.45 p.m. to 7.30 p.m.)

Films, both regional and Hindi, telecast on weekend evenings, have perhaps the maximum viewership. These are programmes that people go out of their way to watch; it is like a ritual and people with no access to TV sets go to other people's homes to watch. The mythological TV serials *Ramayan* and *Mahabharat*, that used to be telecast on Sunday mornings, enjoyed the same status.

The pattern in many households is to switch on the TV at 7.30 a.m. or 8.00 a.m. and to keep it on until 10.00 p.m. or later.[15] Television news is watched as a part of this flow, often by only the male members of the household. The main categories of daily news programmes are: the regional news, national news in Hindi (repeated later in English) and parliament news (including a reportage and an edited version of the proceedings). The percentage in relation to total transmission time is 1.8% for the regional news, 4.2% for the national news in English/Hindi and 6.55% for parliament news and proceedings. *The World This Week* is a weekly news magazine in English with relatively high urban élite viewership. There are also some current-affairs programmes which cannot boast of much viewership.

R.G.: the spectator

Drawing on the notions of the technologies of the self and dividing practices, referred to in the introduction, this section attempts to understand the strategies brought to bear by R.G. in constituting himself vis-à-vis the discourses of television, which forms a fecund resource in his life. The constitutive practices organize themselves over a range of overlapping sites from the familial to the political, the identities ranging from a father (adult) to a spectator (citizen).

The centrality of television as a cultural resource in R.G.'s life is borne out by the fact that his leisure time and energies are organized around television watching. His day starts with the morning transmission:

> When I wake up, if it's after 7, then TV has started . . . news or whatever . . . I ask for the TV to be turned on. . . . meaning programmes . . . until 8, I watch whatever programmes are there . . . without doing any work, that is, lying on the bed, I watch till 8. Then after 8, I start getting ready. News is around that time, only after watching it, I do this . . .

As soon as he gets back from work, he puts on the TV again ('after 7.30, after that . . . TV remains on') till he goes to bed around 11.00 p.m. TV does not remain a background flow, but commands R.G.'s total attention: he sits down in front of the TV to the exclusion of all other activities:

> But once I put on the TV . . . 7.30 p.m., then I don't get out of my chair . . . even if she asks me to get something . . . whatever the programme be.

R.G. cites two reasons for the centrality of TV in his life. The first is the absence of social interaction in the neighbourhood, which is a new satellite township on the outskirts of Bombay. The second is that TV helps him to recuperate from the strains of work and commuting, a pattern that he sees around him:

> around here, there's nothing else, there's only TV. There are no friends around . . . almost everyone . . . I feel . . . they all go a long distance to town for work and come back and do the same.

Owning a TV is very high on R.G.'s list of priorities. It was after shifting away from his extended family that he purchased his own TV. In the urban Indian context, having one's own place is a milestone, marking a movement from the extended to the nuclear family, an option not available to most, given the housing situation. This transition is crucial in terms of R.G.'s passage to adult malehood, as the head of a household. At one level, ownership of a TV holds the promise of entry into the middle class. Apart from this, TV is also a significant totemic marker of the nuclear familial space.

In the extended family, R.G.'s position within the familial networks of power constituted him as a spectator-son, subject to a different set of norms of TV viewing. Living in a 10×15 ft room with six other adults and three children placed its own limits on his 'freedom' as a spectator. Without these

constraints in his own nuclear household, he could become the arbiter of laws, deciding the extent and nature of consumption of TV. He is the one who, either by choice or default, 'ask(s) for the TV to be put on' even before getting out of his bed in the morning. In the evening, he switches it on after he returns from work. R.G. almost appears to luxuriate in his new-found 'freedom' to watch TV as he pleases. He can indulge in practices *vis-à-vis* TV which would have been impossible within the context of the extended family. R.G.'s new-found 'freedom', signified totemically by TV, alters his relationship with it and extends both his repertoire of televiewing as well as his position within the hierarchical order of the family. There were programmes that he could not have possibly watched with ease as a spectator-son. As a spectator-father, he can not only watch these pro-grammes, but also begin to wonder about the consumption of television by his son.

His televiewing strategies as the head of the household bring into being a new set of dividing practices. He defines himself as different from his wife who, for instance, does not watch television news except to admire the clothes of the female newsreaders:

> Now women . . . my wife . . . to them news is not important . . . but . . . sometimes . . . when the news starts, our neighbours, they call out . . . they have colour TV . . . those girls . . . they shout out to my wife . . . I couldn't understand the reason why. My wife would go and return . . . start working again . . . but later I understood . . . the (news) reader . . . what saree she was wearing, that was of importance of them. They don't watch the news.

In spite of his coaxing, she fails to show interest and he attributes it to her lack of 'knowledge'. In contradistinction to his son, R.G.'s wife as a member of the opposite sex stays in a relationship of metonymy.[16] His son, who shows the potential of becoming a spectator-adult, has the projected capability of metaphorically substituting R.G. His wife's metonymic gender identity is also reinforced by the division of labour within the household. Though both of them go out to work, it is his wife who does all the domestic chores. By attributing her lack of interest to a lack of 'knowledge', R.G. perhaps overlooks the power relationships implicit in the division of labour; even if she were interested or knowledgeable, she could not have possibly watched TV. R.G. is aware that his wife is not happy with this division of labour, but can afford to take it lightly:

> No, I always sit . . . in the evenings . . . and watch [smiles] because of that she complains . . . 'you don't do any work . . . just sit and watch'.

The aetiology of these relationships of power remains elusive: R.G. would regard himself as a husband who 'occasionally' helps his wife ('Cuts vegetables') and as one who encourages his wife to watch TV. R.G. cannot be seen as a repository of power within his nuclear household; power does not originate from a unified monolithic source, but is a 'complex strategical situation' (Foucault: 1984: 93).

As opposed to R.G., who, like other men in his neighbourhood, commutes long distances and returns to recuperate in front of his TV, his wife seems to have closer personal ties in the neighbourhood. Rather than watch TV, she would prefer to spend her leisure time chatting with the neighbours.

The metonymic relationship assigned to women also renders them insignificant spectators in R.G.'s scheme of things; at best they could be watching 'useful' programmes related to cookery, flower arrangement and the like. R.G. feels, for instance, that there is no need to have news or news-based programmes during the daytime. The gender differences in viewing preferences and watching routines form part of a wider distinction between the spheres of the public and the domestic.[17] R.G.'s interest in news is a marker of his relationship to the public sphere, his status as a responsible citizen who has to keep himself abreast of social and political events, whereas he regards his wife as situated firmly within the domestic space; her viewing interests and concerns pertain to the trivial and, at best, the sensational:

> Sometimes I tell her . . . 'there's a good programme . . . come to watch' but she doesn't always watch . . . only if it's something she likes. Now what they show about the parliament sessions . . . now even I understand a little about the issues and watch a bit . . . now, my wife, she may not know about the parliament and all that . . . [laughs] but the fighting that goes on there . . . that interests her. So when that is on, she keeps on coming in between to see who is talking . . . what fighting is going on.

It is apparent from this that R.G.'s wife does not accept his definitions of what is worthy of being watched. She has her own hierarchy of interests and resists his attempts to extend his order of priorities. In contrast, R.G. perceives his son as a young spectator, who displays the potential to grow into a spectator-adult:

> If he sits down to watch, he watches everything [. . .] He is also interested in TV . . . not like my wife.

R.G. is not very sure of the direction this interest will take, whether it is positive or negative. However, he sees TV as playing a crucial role in moulding his son into an active human subject:

> Whatever the effect, they become smart . . . active . . . I feel that . . . sometimes it may be bad . . . or it may be good, I don't know, but they begin to understand, they become sort of active . . . they are not 'soft'. Whatever you show on the TV, even if it is not good for children, they understand it . . . they understand the media[sic].

R.G.'s son's relationship to the larger world is mediated by advertising which opens up not only a world of consumer goods, but also of dominant cultural and signifying practices and norms of behaviour:

> The advertisements that are there . . . he knows all of them, because of TV. One day he said something about life insurance policy. I didn't understand it at first . . . some big word he said . . . then later I understood . . .

'beautiful dreams' . . . something like that. So even difficult words . . . even if they don't understand the meanings, they can . . . they know the words.

R.G. feels the need to arbitrate this process of media absorption, to screen out elements which the young spectator cannot handle. Referring to the advertisement spots on contraception, he relates the embarrassing situations that he has faced:

It's better that they talk about rather than show it, because the pictures, they show . . . sometimes there are misunderstandings [laughs] condom packets . . . children sometimes think that they are something else . . . like chocolates. They don't know . . . Sometimes my son even asks, 'I want chocolates like that'.

The difference between the young spectator and the spectator-adult are particularly manifest in domains such as sexuality. It is an area where no dialogue between the generations exists, where even watching images with latent sexual connotations (e.g., music videos) together becomes an embarrassing proposition:

But there is one problem with this Western music . . . such programmes . . . when one is watching at my parents' place, their dresses and all that . . . one wonders whether one should watch . . . their dresses . . . it's all different . . . so one feels that it's not quite right to watch. Now at my own place . . . I watch.

R.G.'s transition into the role of a householder, a responsible adult head of the family, has been marked by an increase in his interest in news. He sees this interest as part of growing up, and as his responsibility as a citizen:

Actually as far as possible, I never miss the news . . . means . . . if I am at home I watch the news. I want to compare . . . when we were small . . . then TV . . . when the news came, we used to take it as a break in between the film and we would go off. When the news got over . . . when 2–3 mins were left, we would come back and wait for the picture . . . Even then, we never paid any attention . . . we would impatiently wait for the news to get over. But now . . . after growing up . . . beginning to understand things . . . 'picture' [film] I may not see . . . but news I watch . . . it's like that.

The exercise of this responsibility is facilitated, R.G. asserts repeatedly, by TV more than any other medium. Television to R.G. reveals a facile, seamless, unmediated picture of the world, a world that is monolithic and without ambiguities.

Actually . . . I understand more . . . sitting at home . . . easily . . . The second thing is . . . there are visuals also. Actually in newspapers, there may be a stray 'photo' . . . but here . . . the war and all . . . we would never see it from up front . . . but on TV, they used to show it all . . . So you could understand . . . these earthquakes . . . all in details . . . you understand . . . because of the visuals. I feel that in 10–15 mins you get

complete information. When I go back from work . . . now, I come to work in the morning, go back in the evening and have to go back again next morning, so I don't know what is happening in my neighbourhood . . . but, just relaxing . . . I get to know what is happening.

Consistent with his belief that politics is full of 'goons', who are in a hurry to perpetuate subterfuges, he finds television as an instrument that could possibly demystify these frauds:

That . . . they all make assurance . . . that's all. Out of 10 leaders, one might do something . . . work genuinely . . . others just exaggerate . . . stretch matters. And ever since they have started showing the parliament sessions on TV . . . since then, I have confirmed my opinion. They say anything to each other . . . one feels that they are doing it just to show people. Whatever I felt before, that they were a sham . . . that I feel is true now . . . just showmanship.

Life before television evoked little interest in politics; one had to wade through mazes of conflicting newspaper reports and viewpoints, not only in a specific newspaper, but also across an array of newspapers, which R.G. suspects to represent various political interests. In addition to the vested political interests, newspapers have to market themselves effectively and, hence, R.G. feels, are forced to include stories that are sensational rather than 'true':

On TV . . . it is more or less closer to what it is . . . TV is . . . unlike newspapers, TV doesn't have to sell itself by giving any news . . . at least I don't feel that. But newspapers . . . sometimes it is like that . . . for sales they do that [. . .] This happens many times . . . just to sell. And . . . but . . . there is 'crossing' [opposing viewpoints] between newspapers . . . different political parties . . . I feel that in news . . . even if it is there, it is finally the same news.

With its built-in and state-guaranteed credibility, having no compulsion to sell itself, TV news comes across as a consistent and relatively objective discourse. TV's univocality, rather than detracting from its credibility, enhances it, imbuing it with a ring of truth. R.G. feels that TV can transgress its mandate, but feels that there are mechanisms that could be invoked to control these excesses:

But people also are aware, no? They can go to the TV centre . . . if a serial is little this . . . they can go . . . and they do . . . take out a *Jatha* [protest rally] so there are some checks on them [on the TV authorities].

An additional feature of TV news which makes it easily digestible is that it excludes retroactive reading, occurring as a continuum in real time that leads the viewer through a whole gamut of news of varying types and degrees of importance, with edited visuals:

It is already laid out . . . in the beginning, political issues . . . or some big accident . . . they will tell about that . . . then, the less important things . . .

then sports. Then finally . . . about the temperature. All this is laid out . . . and because of that . . . suppose some important sports event is going on . . . I watch to see that . . . or if there's a war or some other issue . . . there's something or the other which is of importance to me . . . among the current issues. Now when World Cup is going on, one has to watch to see that event, if there's no other issue . . . or there's something else . . . in 10–15 minutes you come to know easily.

TV not only offers the spectator a ringside seat, but also has devices which can break the event into its constituent elements, giving the viewer a sense that he knows exactly what happened, enhancing his voyeuristic pleasure:

> Things one can never otherwise see, can be seen . . . cars, scooters in slow motion . . . in slow motion, you can make out what's happened. Sometime back they had shown about a motorcycle . . . after it was hit, the man and the motorcycle both went flying. He couldn't retain his seat . . . then in slow motion . . . first he hit the ground, then the motorcycle fell on him . . . it was terrifying. But you can make out, exactly how he fell [. . .] You feel if he'd known that this was going to happen to him, if he'd fallen a little to one side . . . but that no one can tell. He fell down and the motorcycle fell on him.

The syntax of the specific elements in the news discourse obfuscates their relative weightage. As when R.G. watches *The World This Week*, a human-interest story about a psychopathic killer assumes great importance, on a par with world events of the week. R.G. even wonders why this item was left out of the regular news programmes:[18]

> Even . . . there was a close-up also. His eyes were tremendously. . . . at that time I felt . . . really this man must have done this . . . And absolutely . . . unbelievable it was. That in yesterday's . . . means I felt it was an important news . . . in 'News makers'.

R.G.'s conscious participation in political processes is minimal; he feels that his life experience has not necessitated any direct involvement in politics. His conception of statecraft and political parties has undergone a change, a change that has been brought about by his spectator status. Television has not only kept him in touch with the changing political issues, but has also changed his notions about the structures and mechanisms that underlie the working of the state. For instance, he had no clue as to how the elected representatives participated in policy-making. His conception was that elected representatives worked towards problem-solving in their own constituencies, in accordance with the policies formulated by the ruling party, based in Delhi. The ruling party was seen as a repository and source of power and the elected representatives as the mediating agents who have at their disposal resources, granted by the centre, that could be utilized for redressing local grievances. The opposition were seen as parties that are defeated and had no role to play in the scheme of things:

> Before I didn't know anything . . . I used to feel that the decisions are made by the ruling party . . . no concept of the opposition. Even . . . I thought

... opposition meant those who lost the election. Those in opposition who were elected ... I thought are only for that area. Now ... after seeing ... I know that the opposition is also there.

The realization, that there is conflict and dissent within parliament, has not convinced him of the democratic credentials of the government. Rather, he is filled with a sense of revulsion at the lack of decorum:

Once what happened ... a visitor had come ... from Afghanistan or some Islamic country ... and they had taken up the *Mandir-Masjid* [Temple-Mosque] issue and in front of him, they began loudly ... Actually it was very ... the Vice President, Shankar Dayal Sharma was there at that time ... presiding ... and before the visitor ... this issue came up ... and he was also a Muslim and because of that he [the Vice President] got up and walked off ... the Vice President ... Shankar Dayal Sharma ... means, even in front of others, they have no ... and he had come specially to see how the parliament session goes on and in front of him they behaved like this.

Having acquired a more complex picture of how the parliament operates, R.G.'s norms continue to invoke the notion of a family. The government is seen as an extended family, and any dissent as essentially disruptive. A multiplicity of viewpoints are regarded as confusing to the spectator, obfuscating the truth. (This can be related to R.G.'s opinion of TV versus newspapers, where a similar notion of an absolute truth, free from ambiguity and partisanship, is seen to operate.) For instance, in the Bofors issue, the controversy regarding alleged kickbacks to influential political figures appears to R.G. as another futile exercise. He would expect a conclusive verdict on the matter made available to him by the government, so that he does not have to rack his brains to infer for himself and could continue to retain his status as a spectator-citizen:

But actually, once the truth is discovered, you can give it as much coverage as you like ... whoever is guilty, if you expose him and finish him off, then that's fine. As long as nothing is proved, there are two sides ... what this one says and what that one says ... what the reality is no one knows. Instead of that, once it is proved, they should give full coverage ... show what happened right from the beginning. This issue was there before and then there was nothing in between and now again, it has come up. So, we the viewers, feel that it's their party stand that they keep bringing it up again and again, for their own ends. Up to now the truth has not come out.

The fact that this final verdict on the matter is also open to interpretation and questioning and the possibility of it being 'biased' is something that R.G. does not seem to take into account. Whatever be the goings-on in politics, R.G. has faith in a core of power underlying the state, a power centre that is neutral and omnipotent, which rises above vested political interests to deliver the goods. It is this aspect that perhaps reinforces his spectator status: R.G. as a consumer, a consumer of goods and news. The elusiveness of

political news makes it less palatable than the reassuring certainty of hard facts which can be seen and shown:

> Actually, accidents, criminals and all . . . in such cases . . . suppose somewhere lots of people have died – the figures may be more or less, but they have died, the event has taken place, it has actually happened, that much is the absolute truth. Political issues, I have no interest . . . that is, there are accusations and counter-accusations, I don't find it that . . . there's no truth in it.

In relation to his wife, and the 'common people' who watch Hindi films, R.G. constitutes himself as one who knows. Thus, within his family, he alone is able to appreciate the significance of Satyajit Ray and his contribution to 'art cinema'. His superior understanding of the medium of television also allows him to see through the games of politicians who use TV for self-promotion. As mentioned earlier, R.G.'s critical stance is situated within the framework of a basic acceptance of the legitimacy of state power, and its manifestation in the televisual discourse.

The regime of truth, into which R.G. is inserted as a rational, informed male citizen-spectator, is premised upon a set of concerns related to the self and the world. Within the family, these concerns are his alone; underlying them is the unarticulated belief and desire to identify with a club of spectator-citizens, an 'us' versus a 'them' of urban and rural poor, who require to consume TV to rise above their condition.[19] The social awareness advertisements on the government programmes of family planning, literacy, women's status and health harp on this polarity:[20] poor/rural/illiterate/fast breeding/superstitious/traditional/unhealthy/oppressive to women versus middle-class/urban/literate/fertility-conscious/rational/modern/healthy/ tolerant towards women. The bulk of television viewers can easily situate themselves within this scheme. This is the major dividing practice R.G. invokes to constitute himself as a spectator-citizen.[21]

The dividing practices that effect a construction of 'us' versus 'them' take place in and through relations of power. While, in the main, the identification of 'us' is congruent with the power sites offered by televisual discourse, there are moments when this division becomes fuzzy. The inconsistencies within R.G.'s discourse point to a possible smudging of the equations of power, not as power emanating from a source, incident on 'subject', but as a no man's land criss-crossed by resistance. These moments of resistance, where R.G. questions the televisual discourse, are not extraneous to the flow of power, but lies latent within it. Though R.G. is convinced of the objectivity, credibility and the basic mandate of the televisual discourse, he finds it lacking when more immediate issues are discussed. He feels that more discussion on the issue of unemployment, according to him the most pressing problem, is called for. He also stumbles on the possibility of the televisual discourse being 'biased', specifically when he discusses the coverage accorded to the Narmada project displaced:[22]

> Narmada, yes . . . they show less . . . orally, they talk about it . . . they show the government viewpoint more . . . not people's opinion. They

show more of the government, because our TV media . . . because of the World Bank and all . . . but local problems . . . they don't show. Their interviews [local people] . . . those who suffer . . . they won't show these. I have seen this programme called *The Price of Progress* . . . from that you get an idea how huge the dam is.

He perceives these lacunae more as technical lapses rather than strategies underlying which are interests at work: this belief is what perhaps precludes the possibility of this realization being employed to effect a critique of the institution of television. There are moments when R.G. talks about these strategic reasons: 'the World Bank and all that', but attributes this realization to a chance exposure. Even when he is critical of televisual discourse, R.G. does not connect the specific lacunae in order to project a consistent stance *vis-à-vis* Doordarshan and the state, because these larger relationships of power are refracted and rarefied through the immediate modes of power that lie adjacent to R.G. His resistance is restricted primarily to the most adjacent forms of power that impinge on his life, the ones 'closest' to him. The most immediate and pervasive forms of power are the familial and, hence, he tends to judge the state itself by the norms that constitute an extended family:

The first thing is . . . the Speaker . . . they themselves elect him . . . they don't listen even to him . . . however much he requests them . . . they don't listen . . . what's the meaning of electing him . . . such a big parliament . . . and what respect is there to the speaker . . .? This is what bugs me the most . . . in the court they bang that thing . . . 'Silence, silence' . . . here nobody bothers.

The propriety and decorum that apply to politics and statecraft are similar to the norms of behaviour within a family. His explanation of the overall malaise affecting politics and a possible solution are also in individual moralistic terms.

Actually if those elected are educated . . . it's good . . . otherwise these goons . . . sometimes people are forced to vote for them . . . so they get elected and behave like this . . . this should not be so. They should elect sensible people. Sometimes it so happens that even sensible people go there and start fighting.

Unemployment, which he sees as the most pressing problem, can be traced back to the actions of individual family units.[23] This is consistent with his conception of the state itself as a large congregation of family units:

My opinion [smiles] . . . frankly . . . many women also work . . . many households with double income . . . In some houses, double income . . . and in others, no income. Job-seekers are more these days . . . Earlier, women used to be at home . . . in our community, many women now opt for jobs . . . women are free to go out of their houses . . . some do it out of

interest, others out of necessity. Both educated and illiterate seek jobs, even small children . . . the population has also increased.

Even larger issues like price rises or the economic reforms are seen as something precipitated and mediated by individual action:

> The prices are rising anyway, for other reasons also. Sometimes, they look at the customer and raise the prices . . . I went there, to Mysore, there were watermelon pieces on sale. When I asked him, he said 2 rupees. I took 2 pieces, and stood there, eating them . . . When I gave him a 50-rupee note, afterwards, he took 3 rupees a piece. I told him – you said 2. He said – that was for a different piece. Actually he cheated us. My wife said – you gave him a 50-rupee note, that's why he did that. So they look at the customer and increase prices . . . you can't ask them why are you increasing prices . . . you can't say a thing . . . that's what people do.

His concept of his right of information restricts itself to his role as a consumer and a taxpayer. Even information related to weather and secessionist movements acquire relevance only within the context of his vacation plans:[24]

> Whatever the terrorists do in Punjab, Kashmir, it's good that they show it, because even if one has no connection with it, sometimes . . . Now we were supposed to go for a holiday to the North, but I changed my plans. After I saw all about Kashmir in the news . . . how terrorists come with training from Pakistan and all and there's lot of trouble . . . we didn't go there.

These practices of apprehending the whole through the framework of personal life experiences do not obviate his constitution as a proud citizen. Intrusions by transnational television networks are regarded with ambivalence[25] because of their possible impact on cultural identity.

Through the interpretation of R.G.'s interview, this exploratory study attempts to focus on the specific modes by which R.G. constructs himself as a subject in relation to the televisual discourse. This process of construction, achieved through a set of dividing practices, takes place in and through relationships of power. In R.G.'s constitution of himself as a spectator-Indian *vis-à-vis* the news discourse, one sees at play both the individualizing and totalizing aspects of pastoral power. In defining himself as an individual, a critical, informed, rational citizen, R.G. defines his relationship to the totality. At one level, R.G.'s interview emphasizes the manifold exegetic possibilities attendant on news reception; at another level, it points to how this reception process and its possible use is mediated in and through relationships of power that lie adjacent to the receiver of news.

Appendix: Doordarshan channel I programme schedule on a typical weekday

Timing	Programme
6.30–7.00 a.m.	ETV for distance education
7.00–9.00 a.m.	Breakfast chat show interspersed with *Yesterday in parliament* (45 mins)
	News in English and Hindi (5 to 7 mins each)
	Short serials
	Documentaries and interviews
9.00–10.00 a.m.	Educational programmes for school students
1.00–2.00 p.m. and 4.00–5.00 p.m.	Countrywide classroom for college students
2.00–3.00 p.m.	Afternoon transmission
	Chat show for women interspersed with News in English and Hindi (5 to 7 mins each)
5.45–7.30 p.m.	Regional telecast in Marathi for farmers, workers, parents, women, children etc. (informative programmes)
7.30–7.45 p.m.	Regional news in Marathi (15 mins)
7.45–8.10 p.m.	Sponsored serial in Marathi
8.10–8.40 p.m.	Film songs or short Marathi plays
8.40–9.00 p.m.	News in Hindi (15–20 mins)
9.00–9.30 p.m.	Sponsored serial in Hindi
9.30–9.50 p.m.	News in English (15–20 mins)
9.50–10.00 p.m.	Parliament News in Hindi (10 mins)
10.00–10.30 p.m.	Current affairs programme/documentary/serial in Hindi
10.30–10.40 p.m.	Parliament News in English (10 mins)
10.40–11.00 p.m.	Programme of music/dance/documentary
11.10 p.m. onwards	Telefilm or late-night film (on specific days)

Notes

Both the authors have contributed equally to the writingof this paper, an earlier version of which was presented at the seminar 'News of the World', Perugia, Italy, in June 1992. The authors gratefully acknowledge R.G.'s contribution, which has made this paper possible.

1 The paper is based on one interview, with R.G., conducted in Marathi by the authors (A.M. and J.S.) and translated into English. The duration of the interview was approximately two hours.
2 For a critique of the notion of 'secularism' in terms of the political hierarchy underlying it and the hegemony it reproduces, see Nandy (1988) and Madan (1987).
3 Satellite Instructional Television Experiment (SITE) was conducted in 1975–6 to cover 2,330 villages of six states. SITE had an in-built programme for social evaluation, involving multidisciplinary inputs into formative, process and summative research, conducted before during and after the experiment. In the process, quantitative and qualitative survey data and village ethnographies were generated. The SITE research effort, with its emphasis on the 'holistic approach' (Sinha, 1985) departed from some of the simplistic assumptions of the communication approach to development insofar as it brought to the fore the

interpretative strategies of viewers as well as the socio-cultural contexts in which they were situated.

4 The emancipatory role of knowledge is a premise that has defined post-enlightenment discourses, both liberal and Marxist. Operating within a framework which conceives of human activity in terms of 'man' using 'reason' toprogressively change the 'world', these discourses tend to have the following broad consequences: firstly, they invent a universalist subject (e.g., the Marxist proletariat), secondly, they view reason as a neutral tool and science as approximating truth and, thirdly, they accept the notion of progress, with its teleological promise of an ultimate utopia, beyond power and domination. For a detailed discussion, see Jayasankar (1989).

5 A discussion of the congruencies and disjunctures between the Foucauldian category of power and those sites of power is beyond the scope of this paper.

6 For a wide-ranging critique of development using Foucauldian categories, see Escobar (1984 and 1987).

7 Mark Poster coins the term 'mode of information' to draw attention to the fact that at the present juncture, 'technologies of power', from electronic surveillance to the mass media to psychoanalysis take the form of linguistic experiences that

> constitute the historical conditions for a method of analysis that gives due recognition to the discursive nature of practice, that conceptualizes truth in relation to power, that detotalizes the historical-social field and that sets strict limits to the scope of reason. (1984: 167–8)

8 For a detailed discussion on this, see Du Bois (1991).

9 The scheduled castes are the former untouchable caste groups, which have been accorded a special status in the Constitution of India. R.G. belongs to the 'Mahar' community, a scheduled caste. The community was converted to Buddhism by Dr B.R. Ambedkar and is relatively well organized, more militant and demanding of recognition than other scheduled caste groups.

10 The revised version of the developmental paradigm which stresses people's participation is a strategic shift to increase effectiveness without departing significantly in its notion of development from the earlier model. See Du Bois (1991).

11 From the mid 1980s onwards, the Indian state appears to be redefining its cultural interventions, playing a more active role in the construction of new cultural and national identities through the use of television, Festivals of India, patronage of traditional art forms and so on. The 'commercialized' lifestyles and images embedded in the televisual discourse are not at variance with the State's vision of the 'India of the twenty-first century' – a movement away from the era of Nehruvian socialism towards a more *laissez-faire* model, where paradoxically the dismantling of licensing, import and other economic controls coexists with increasing state intervention in the familial and cultural space; so much so that the state becomes a provider and arbiter of welfare and norms for 'the masses'.

12 *Hum Log*, telecast in 1984–5, dealt with a middle-class family, covering issues such as family planning, women's status, national integration, corruption and so on. It achieved high popularity ratings. For a further discussion, see Singhal and Rogers (1989: 88–121).

13 A colour TV set presently costs between Rs 16,000 and 21,000 ($533 and $700), which would amount to approximately 4 to 5 times R.G.'s monthly family income.

14 According to a MODE survey, quoted in the *Times of India* (28

September 1992: 7), 71% of the urban population own TVs, but do not have access to cable channels and only 4% say they are likely to subscribe to cable in the near future. According to a National Television survey, quoted in an Internews documentary on Doordarshan recently, the urban viewership figures are: Doordarshan 82%; video 10.5%; cable 10.4%; and satellite 1.3%, and 3% of the entire Indian viewership has access to cable TV. However, these figures are rapidly changing in the urban context, where there is a flood of cable operators, and middle-class audiences are getting hooked on to STAR TV soap operas (*Times of India*, 28 September 1992: 1).

15 See Monteiro A., 'The spectator-subject: television and the construction of identity, doctoral thesis under perparation. This viewing pattern is also confirmed by R.G.'s interview.

16 Metaphor and metonymy are:

figures of 'equivalence' in that they characteristically propose a different entity as having 'equivalent' status to the one that forms the main subject of the figure [. . .] Broadly speaking metaphor is based on a proposed similarity or analogy between the literal subject [. . .] and its metaphorical substitute [. . .] whereas metonymy is based on a proposed contiguous (or 'sequential') association between the literal subject [. . .] and its 'adjacent' replacement. (Hawkes, 1977: 77)

17 The immurement of women within the sphere of the domestic should not be taken to mean that they do not exercise power. For a discussion of this, in particular women's decision-making role in forging marriage alliances and in money transactions related to this, see Das (1976) and Ifeka (1989). The power of women in other spheres is often exercised covertly, through refusal, denial and subtle manoeuvring, getting the desired outcomes without upsetting the patriarchal hierarchy of power relations.

18 *The World This Week* is presented by an anchorperson. In spite of R.G.'s exposure to video production, he chooses to view the anchorperson as 'free' to improvise, as opposed to the newsreaders, who 'can't add their own'.

19 The proliferation of television has expanded the ambit of 'us' versus 'them' and helped extend the legitimacy of the pro-development discourses to ever-widening sections of the population.

20 For instance, in a family-planning advertisement, a woman from a Delhi slum speaks of how sterilization after two children would enable her to educate her son and make him an 'officer'. In another advertisement spot on literacy, a maidservant, reflecting on the difference between herself and her upper-class mistress, comes to the conclusion that she too can make it, if she becomes literate. The representation of the whole process is amazingly simplistic: the maidservant asking the question 'What is the difference between her and me?' turns around to find the mistress reading the newspaper and arrives almost instantaneously at literacy as the prime difference. The final shot shows her walking into a literacy class.

21 The 'benefits' of family planning and literacy are taken for granted by 'us', justifying whatever the means necessary to persuade the ignorant 'them'. R.G. narrates an incident where an illiterate villager is cajoled and coerced into attending literacy classes, against his initial reluctance. The implication that 'we' know better what is right for 'them' is obvious.

22 The Narmada project is a massive World Bank funded multipurpose project, involving the construction of approximately 300 dams on the river Narmada,

displacing about one million people. The institute at which R.G. works has played a role in monitoring and evaluating the impact of the project. Moreover, some of the anti-project activists are ex-students of the institute, and personally known to R.G. This is what makes this issue 'immediate' and 'close' to R.G.

23 When talking about the unemployment situation, R.G. reluctantly admits that the situation is so bad that even law-abiding citizens like him ('even I') are constrained to make moral compromises, to pay bribes to get a job.

24 R.G. and family went on a long trip to South India recently. This is considered significant, for it was the first time he and his family undertook such a long vacation trip. It is not often that such trips are undertaken by a lower middle-class Indian family.

25 R.G. willingly grants Doordarshan the power to act as an arbitrator, to ensure that programmes broadcast are in national interests as opposed to the commercial interests of private producers and transnational networks. The state monopoly of television is seen as natural and desirable, and what R.G. fears is the monopoly of commercial interests which might be harmful.

References

Chowla, N.L. (1985) 'Business by the box', in *The Statesman* 24 November: 9.

Das, Veena (1976) 'Masks and faces: an essay on Punjabi kinship', in *Contributions to Indian Sociology* 10 (1) (new series): 1–30.

Du Bois, Marc (1991) 'The governance of the Third World: a Foucauldian perspective of power relations in development', in *Alternatives* 16: 1–30.

Escobar, Arturo (1984) 'Discourse and power in development, Michel Foucault and the relevance of his work to the Third World, in *Alternatives* x: 377–400.

—— (1987) 'Power and visibility: the invention and management of development in the Third World', unpublished doctoral thesis, University of California, Berkeley.

Foucault, Michel (1972) *The Archaeology of Knowledge and the Discourse on Language*, New York: Pantheon.

—— (1980) *Power/Knowledge*, New York: Pantheon.

—— (1984) *The History of Sexuality*, Harmondsworth: Penguin.

—— (1986) 'Afterword: The subject and power', in Dreyfus, H.L. and Rabinow, P. (1986) editors, *Michel Foucault: Beyond Structuralism and Hermeneutics*, Sussex: The Harvester Press.

Hawkes, Terence (1977) *Structuralism and Semiotics*, London: Methuen.

Ifeka, Caroline (1989) 'Hierarchical woman: the "dowry" system and its implications among Christians in Goa, India', in *Contributions to Indian Sociology* 23 (2) (new series): 261–84.

Jayasankar, K.P. (1989) 'The speaking subject: a preamble to Vedanta', unpublished doctoral thesis, Indian Institute of Technology, Bombay.

Jensen, Klaus Bruhn (1991) 'News of the World', project proposal, mimeograph.

Krippendorff, Sultana (1979) 'The communication approach to development', in Lent J.A. (1979) editor, *Third World Mass Media: Issues, Theory and Research*, Williamsburg, Virginia: Dept. of Anthropology, College of William and Mary.

Madan, T.N. (1987) 'Secularism in its place', in *The Journal of Asian Studies* 56 (4): 747–59.

Nandy, Ashis (1988) 'The politics of secularism and the recovery of religious tolerance', in *Alternatives* XIII: 177–94.

Open University (1977) *Mass Communications in Cross-Cultural Contexts: The Case of the Third World*, Mass Communication and Society, Unit 5, Milton Keynes: The Open University.

Poster, Mark (1984) *Foucault, Marxism and History*, Oxford: Polity Press.

Singhal, A. and Rogers, E.M. (1989) *India's Information Revolution*, New Delhi: Sage.

Sinha, A.K. (1985) *Mass Media and Rural Development*, New Delhi: Concept.

Srivastava, U.K. (1987) 'National cost of television in the year 2000', in *Media Asia* 14 (3): 136–44.

Young, R. (1981) editor, *Untying the Text: A Post-Structuralist Reader*, London: RKP.

Notes on contributors

ANNE BALSAMO teaches in the School of Literature, Communication and Culture, Georgia Institute of Technology, USA ... JODY BERLAND teaches in the Department of Humanities, Atkinson College, York University, Toronto, Canada ... MICHAEL X. DELLI CARPINI teaches in the Department of Political Science, Barnard College/Columbia University, USA ... BARRI COHEN teaches film studies in Toronto, and writes and produces documentary films ... ROSS GIBSON's latest book is *South of the West: Postcolonialism and the Narrative Construction of Australia*, published by Indiana University Press ... IAN HUNTER is the author of *Culture and Government: The Emergence of Literary Education* and the coauthor (with David Saunders and Dugald Williamson) of *On Pornography: Literature, Sexuality and Obscenity Law*, recently published by Macmillan and St Martin's Press. He is currently an Australian Research Council research fellow, attached to the Faculty of Humanities, Griffith University, Australia ... K.P. JAYASANKAR is a Senior Producer at the Tata Institute of Social Sciences, Bombay, India ... ANJALI MONTEIRO is a Reader at the Tata Institute of Social Sciences, Bombay, India ... JENNIFER DARYL SLACK teaches in the Department of Humanities, Michigan Technological University, USA ... CAROL STABILE is a Visiting Professor at the University of Illinois at Urbana Champaign, and is completing a book on feminist cultural studies, technology and the politics of the environment ... McKENZIE WARK lectures in Communications at MacQuarie University, Australia ... LAURIE ANNE WHITT teaches in the Humanities at Michigan Technological University, USA ... BRUCE A. WILLIAMS teaches in the Department of Political Science, University of Kentucky, Lexington, USA.

Other journals in the field of cultural studies

There has been a rapid increase in the number of journals operating both in the field of cultural studies and in overlapping areas of interest. *Cultural Studies* wants to keep its readers informed of the work being done by these journals. After all, cultural studies is a collective project.

BORDER/LINES (The Orient Building, 183 Bathurst Street, Suite No. 301, Toronto, Ontario, Canada M5T 2R7.)
Tel: (416) 360–5249. Fax: (416) 360–0781
Issue 27, 1993
Contents: *Michael Hoechsmann & Alan O'Connor.* **Editorial**; *Marcia Cruz* Black Woman, White Image; *Sonia Riquer* Women's Radio In Mexico City; *Néstor García Canclini* Studies of Communication and Consumption: Interdisciplinary Work In Neoconservative Times; *Susana Quiroz* Here Come The Punk *Chavas*; *Francisco Ibañez* It is not WHAT you do, but HOW you do it: Cultural risks and HIV/AIDS in Chile; *Rubén Martínez Corazón del Rocanrol*; *Pilar Riaño* The *Galladas of the Barrios* of Bogota: Actors in Space and Time; *Silvia Delfino* We Haven't Had Time to Be Guilty: Youth Culture in Argentina; *Jesús Martín-Barbero* Communication: A Strategic Site For The Debate On Modernity.

Reviews: *Nick Witheford* Jesús Martín-Barbero, *Communication, Culture and Hegemony: From Media To Meditation*; *Michael Hoechsmann* William Rowe & Vivian Schelling, *Memory and Modernity: Popular Culture in Latin America*; *W.F. Santiago Valles* Anna Grimshaw, ed., *The C.L.R. James Reader*; *Alan O'Connor* John Tomlinson, *Cultural Imperialism*; *Alison Hearn* Celeste Olalquiaga, *Megalopolis*.

Issue 28, 1993
Contents: *Stan Fogel, Joe Galbo & Sophie Thomas* **Editorial**; *Alex Ferentzy* Schizophrenia and Family Values; *Jeremy Stolow* Multiculturalism in the ESL Bureaucracy; *Joe Galbo & Miriam Jones* Rethinking Rethinking Marxism; *Nicholas Packwood* Browsing The Apparatus; *Robyn Gillam* Australian Cultural Theory; *Laura Millard* Images of Canada: Canadian Bank Notes; *Jo Anna Isaak* What's To Be Done?; *Mary Bryson, Suzanne de Castell, Celia Haig-Brown* Gender Equity/Gender Treachery.

Reviews: *Jim Ellis* On *Male Subjectivity At the Margins*; *Jean-Francois Coté* On *The Limits of Interpretation*; *Sophie Thomas* On *Semiotext(e)/ Architecture*; *Richard Ashby* On *The Culture of Nature*.
Plus: Rampike literary supplement/pull out

COLLEGE LITERATURE (West Chester University, 554 New Main, West Chester, PA 19383, U.S.A.)
Tel: (215) 436–2901. Fax: (215) 436–3150
General Issue 20.2 (June 1993)
Contents: *Cary Nelson* Facts Have No Meaning: Writing Literary History in the Shadow of Poststructuralism; *Henry A. Giroux* Disturbing the Peace: Writing in the Cultural Studies Classroom; *Erin Mackie* Lady Credit and the

Strange Case of the Hoop-Petticoat; *Joel Haefner* (De)Forming the Romantic Canon: The Case of Women Writers; *Michael Cohen* Empowering the Sister: Female Rescue and Authorial Resistance in *The Heart of Midlothian*; *Susan K. Harris* Vicious Binaries: Gender and Authorial Paranoia in Dreiser's 'Second Choice', Howells' 'Editha', and Hemingway's 'The Short Happy Life of Francis Macomber'; *Patrick McHugh* Metaphysics and Sexual Politics in Lawrence's Novels; *Joline Blais Qui est Lá*: Displaced Subjects in *Wide Sargasso Sea* and *Le ravissement de Lol V. Stein*.

JOURNAL OF COMMUNICATION INQUIRY (205 Communications Center, University of Iowa, Iowa City, Iowa 52242, U.S.A.)
Tel: (319) 335–5821
Issue 17(1) Winter 1993
Contents: *Janice Peck* Selling Goods and Selling God: Advertising, Televangelism and the Commodity Form; *Hazel G. Warlaumont* Visual Grammars of Gender: The Gaze And Psychoanalytic Theory In Advertisements; *Lisa McLaughlin* Chastity Criminals In the Age of Electronic Reproduction: Reviewing Talk Television and the Public Sphere; *David Sholle* Buy Our News: Tabloid Television and Commodification; *Mark Fenster* Queer Punk Fanzines: Identity, Community, and The Articulation of Homosexuality and Hardcore; *Bonnie Brennen* Newsworkers in Fiction: Raymond Williams and Alternative Communication History; *Yung-Ho Im* Critical Communication Studies In South Korea; *Catherine Mallia* Mass Communication Research In Italy.

CULTURE AND POLICY
Issue 4, 1992
Contents: *Deborah Stevenson* Urban Re-enchantment and the Magic of Cultural Planning; *Sophie Watson* Contested Spaces: Cross-Cultural Issues in Planning; *Belinda McKay* Constructing a Capital: Rome Towards 2000; *Ken Worpole* The Forms of Civic Renewal; *Christine Sayer* The City of Glasgow – An Arts-led Revival; *Richard Brecknock* Public Art – Public Places – Public Money; *Gail Reekie* Women and Heritage Policy; *Kay Ferres* A Practised Place: Sex and Citizenship. Brisbane 1850–1890.

Reviews: *Ken Butler* Power and Politics in Local Government; *Mark Finnane* The Business of Heritage; *Ciaran O'Faircheallaigh* The Politics of Land Rights I; *Annie Holden* The Politics of Land Rights II; *Peter Backhouse* Doctors, Politics and Health Policy; *Jeni Warburton* Grey Policy; *Kosmos Tsokhas* Removing the Scales.

DISCOURSE Center for Twentieth Century Studies, University of Wisconsin-Milwaukee, P.O. Box 413, Milwaukee, Wisconsin, 53201, U.S.A)
Tel: (414) 229–4141
Special Issue 15(2) Winter 1992–93: The Emotions, Gender, and the Politics of Subjectivity
Contents: *Marianne Hirsch* Family Pictures: *Maus*, Mourning, and Post-Memory; *Kathleen Hulley* Contaminated Narratives: The Politics of Form

and Subjectivity in Marguerite Duras's *The Lover*; *Kathleen Green and Laura Roskos* Packaging the Personal: An Interview with Nancy K. Miller; *Maurizia Boscagli* A Moving Story: Masculine Tears and the Humanity of Televised Emotions; *Ilsa J. Bick* To Be Real: Shame, Envy, and the Reflections of Self in Masquerade; *Kathleen Woodward* Grief-Work in Contemporary American Cultural Criticism; *Iwao Iwamoto* Spring Snow; *Lynn Worsham* Emotion and Pedagogic Violence; *Martha Rosler* Of Soaps, Sperm, and Surrogacy: A Response to Maureen Turim.

Reviews: *Eileen E. Schell Femininity and Domination: Studies in the Phenomenology of Oppression* by Sandra Lee Bartky; *Catherine Benamou Israeli Cinema: East/West and the Politics of Representation* by Ella Shohat; *Jim Collins Cinema without Walls: Movies and Culture after Vietnam* by Timothy Corrigan; *Linda R. Krause City of Quartz: Excavating the Future in Los Angeles* by Mike Davis; *Susan Manning Critical Theory and Performance* ed. Janelle G. Reinelt and Joseph R. Roach; *John Mowitt Strangers to Ourselves* by Julia Kristeva; *John Tulloch Promotional Culture: Advertising, Ideology and Symbolic Expression* by Andrew Wernick.

Issue 15(3) Spring 1993

Contents: *Kaja Silverman* What Is a Camera?, or: History in the Field of Vision; *Harun Farocki and Kaja Silverman* To Love to Work and to Work to Love – A Conversation about *Passion*; *Harun Farocki (Peter Wilson, trans.)* The Industrialization of Thought; *Harun Farocki* Commentary from the Film *Bilder der Welt und Inschrift des Krieges* (Images of the World and Inscription of the War); *Christopher Lane* Managing 'The White Man's Burden': The Racial Imaginary of Forster's Colonial Narratives; *Bernard Gendron* Moldy Figs and Modernists: Jazz at War (1942–1946); *Fran Bartkowski* Travelers v. Ethnics: Discourses of Displacement.

Reviews: *Elena del Río The Architectural Uncanny: Essays in the Modern Unhomely* by Anthony Vidler; *Stanley Fogel Travel as Metaphor: From Montaigne to Rousseau* by Georges Van Den Abbeele; *Ruth Hottell To Desire Differently: Feminism and the French Cinema* by Sandy Flitterman-Lewis.

POLYGRAPH

Issue 6/7, 1993

Contents: Introduction: Marxism beyond Marxism?; *Dipesh Chakrabarty* Marx After Marxism: Subaltern Histories and the Question of Difference; *Peter Hitchcock* Workers of the World ____!; *Paolo Virno* Notes on the 'General Intellect', *Kenneth Surin* 'The Continued Relevance of Marxism' as a Question: Some Propositions; *E. San Juan, Jr.* Toward Marx and Beyond: Problems and Prospects of Socialist Transformation in the Philippines; *Maurizio Viano & Vincenzo Binetti* What Is To Be Done? Marxism and Academia; *Paul Smith* A Memory of Marxism; *Franco Berardi* A Zigzag Starting From Marx; *Stephen Resnick and Richard Wolff* The Specter Still Haunts; *Leslie Sklair* Democratic Feminist Socialism: An Alternative to the

Global Capitalist System; *Arif Dirlik* Post-Socialism/Flexible Production: Marxism in Contemporary Radicalism; *Fredric Jameson* Actually Existing Marxism.

Responses: *Maivân Clech Lâm* A Resistance Role for Marxism in the Belly of the Beast; *Caren Irr* Realism and Utopia; *Rey Chow* Response; *Andrew Neather* Work and Socialist Strategy: Theory, Academics and the Politics of Post-Marxism; *Robert Seguin* Some Brief Reflections on Class in the Postmodern Context; *Roberto Schwarz* An Audacious Book; *Romano Luperini* On Marxism Today; *Paula Rabinowitz* Materialist-feminism: marxism beyond Marxism.

Fiction & poem: *Rob Wilson* The Last Communist; *Marcel Cohen* Selections from *Miroirs*; *Ge Fei* The Lost Boat.

PUBLIC CULTURE (Society for Transnational Cultural Studies) (1010 East 59th Street, Chicago, Illinois, 60637, U.S.A)
Tel: (312) 702–0814. Fax (312) 702–9861
Issue 5(2) Winter 1993
Contents: *Benjamin Lee* Going Public; *Miriam Hansen* Unstable Mixtures, Dilated Spheres: Negt and Kluge's *The Public Sphere and Experience*, Twenty Years Later; *Greg Urban* Culture's Public Face; *Michael M.J. Fischer* Is There a Difference between Public Culture 1789 and 1989? A Reply to Greg Urban; *Marilyn Ivy* (Ef)facing Culture: A Reply to Greg Urban; *Greg Urban* Rube Replies; *Nicholas Garnham* The Mass Media, Cultural Identity, and the Public Sphere in the Modern World; *Craig Calhoun* Civil Society and the Public Sphere; *Ping-hui Liao* Rewriting Taiwanese National History: The February 28th Incident as Spectacle; *Mayfair Yang* Of Gender, State Censorship, and Overseas Capital: An Interview with Director Zhang Yimou; *Janelle S. Taylor* Non-Sense in Context: Xu Bing's Art and Its Publics; *Jane Ying Zha* Excerpts from 'Lore Segal, *Red Lantern*, and Exoticism'; *Dai Qing* Raised Eyebrows for *Raise the Red Lantern*; *Manthia Diawara* On Tracking World Cinema; *Johann Gottfried Herder* Genealogy: Do We Still Have the Public?.

REPRESENTATIONS (University of California Press Journals Division, 2120 Berkeley Way, Berkeley, CA 94720, U.S.A)
Tel: (510) 642–4191. Fax (510) 643–7127
Issue 41, Winter 1993
Contents: *Daniel Boyarin* Paul and the Genealogy of Gender; *Henry Staten* How the Spirit (Almost) Became Flesh: Gospel of John; *Timothy Hampton* 'Turkish Dogs': Rabelais, Erasmus, and the Rhetoric of Alterity; *Lorna Hutson* Fortunate Travelers: Reading for the Plot in Sixteenth-Century England; *Gordon Teskey* Mutability, Genealogy, and the Authority of Forms; *Ines G. Županov* Aristocratic Analogies and Demotic Descriptions in the Seventeenth-Century Madurai Mission.

Special Issue 42, Spring 1993: Future Libraries
Contents: *R. Howard Bloch and Carla Hesse* Introduction; *Geoffrey*

Nunberg The Places of Books in the Age of Electronic Reproduction; *Roger Chartier* Libraries Without Walls; *Jane C. Ginsburg* Copyright Without Walls?: Speculations on Literary Property in the Library of the Future; *Dominique Jamet and Helene Waysbord* History, Philosophy, and Ambitions of the Bibliothèque de France; *Gerald Grunberg and Alain Giffard* New Orders of Knowledge, New Technologies of Reading; *Emmanuel Le Roy Ladurie* My Everydays; *Prosser Gifford* The Libraries of Eastern Europe: Information and Democracy; *Cathy Simon* A Civic Library for San Francisco; *Anthony Vidler* Books in Space: Tradition and Transparency in the Bibliothèque de France.

Books Received from Publishers
Spring 1993 (through 1 July 1993)

Aronowitz, Stanley (1993) *Roll Over Beethoven: The Return of Cultural Strife*, Hanover and London: Wesleyan University/University Press of New England.

Alcalay, Ammiel (1993) *After Jews and Arabs: Remaking Levantine Culture*, Minneapolis and London: University of Minnesota.

Bailey, F.G. (1993) *The Kingdom of Individuals: A Essay on Self-Respect and Social Obligation*, Ithaca and London: Cornell University.

Banta, Martha (1993) *Taylored Lives: Narrative Productions in the Age of Taylor, Veblen, and Ford*, Chicago and London: University of Chicago.

Barth, Fredrik (1993) *Balinese Worlds*, Chicago and London: University of Chicago.

Bourdieu, Pierre (1993) *The Field of Cultural Production: Essays on Art and Literature*, edited by Randal Johnson; New York: Columbia University.

Buckingham, David (1993) *Children Talking Television: The Making of Television Literacy*, London and Washington, DC: Falmer.

Carmichael, Virginia (1993) *Framing History: The Rosenberg Story and the Cold War*, Minneapolis and London: University of Minnesota.

Chambers, Ross (1993) *The Writing of Melancholy: Modes of Opposition in Early French Modernism*, Chicago and London: University of Chicago.

Ciesla-Korytowska, Maria (1992) editor, *The Slavs in the Eyes of the Occident, The Occident in the Eyes of the Slavs*, Krakow: Boulder 'Universitas'; distributed, New York: Columbia University.

Crafts, Susan D., Daniel Cavicchi, Charles Keil and the Music in Daily Life Project (1993) *My Music*, Hanover and London: Wesleyan University/University Press of New England.

Damon, Maria (1993) *The Dark End of the Street: Margins in American Vanguard Poetry*, Minneapolis and London: University of Minnesota.

Deleuze, Gilles (1993) *The Logic of Sense*, translated by Mark Lester with Charles Stivale; edited by Constantin V. Boundas; New York: Columbia University.

Dyson, Michael Eric (1993) *Reflecting Black: African-American Cultural Criticism*, Minneapolis and London: University of Minnesota.

Fox, Richard Wightman and T.J. Jackson Lears (1993) editors, *The Power of Culture: Critical Essays in American History*, Chicago and London: University of Chicago.

Gilbert, James (1992) *Writers and Partisans: A History of Literary Radicalism in America*, New York: Columbia University Press.

Gillison, Gillian (1993) *Between Culture and Fantasy: A New Guinea Highlands Mythology*, Chicago and London: University of Chicago.

Goodson, Ivor (1993) *School Subjects and Curriculum Change*, 3rd ed., foreword by Peter McLaren; Washington DC and London: Falmer.

Hitchcock, Peter (1993) *Dialogics of the Oppressed*, Minneapolis and London: University of Minnesota.

Jones, John Paul III, Wolfgang Natter and Theodore R. Schatzki (1993)

editors, *Postmodern Contentions: Epochs, Politics, Space*, New York and London: Guilford.

Kauffman, Linda S. (1993) editor, *American Feminist Thought at Century's End: A Reader*, Cambridge MA and Oxford: Blackwell.

Kristeva, Julia (1993) *Nations Without Nationalism*, translated by Leon S. Roudiez; New York: Columbia University.

Lyotard, Jean-Francois (1993) *The Postmodern Explained: Correspondence 1982–1985*, translation edited by Julian Pefanis and Morgan Thomas; translated by Don Barry, Bernadette Maher, Julian Pefanis, Virginia Spate and Morgan Thomas; afterword Wlad Godzich; Minneapolis and London: University of Minnesota.

Manuel, Peter (1993) *Cassette Culture: Popular Music and Technology in North India*, Chicago and London: University of Chicago.

Penley, Constance and Sharon Willis (1993) editors, *Male Trouble*, Minneapolis and London: University of Minnesota.

Poster, Mark (1993) editor, *Politics, Theory and Contemporary Culture*, New York: Columbia University.

Roberts, John (1992) *Selected Errors: Writings on Art and Politics 1981–90*, London and Boulder: Pluto.

Robbins, Bruce (1993) editor, *The Phantom Public Sphere*, Minneapolis and London: University of Minnesota.

Slobin, Mark (1993) *Subcultural Sounds*, Hanover and London: Wesleyan University/University Press of New England.

Walser, Robert (1993) *Running with the Devil: Power, Gender, and Madness in Heavy Metal Music*, Hanover and London: Wesleyan University/University Press of New England.

Ward, John Powell (1993) *Thomas Hardy's Poetry*, Buckingham and Philadelphia: Open University.

Whyte, William Foote (1993) *Street Corner Society: The Social Structure of an Italian Slum*, 4th ed., Chicago and London: University of Chicago.

Williams, Raymond (1992) *Television: Technology and Cultural Form*, introduction by Lynn Spigel; Hanover and London: Wesleyan University/University Press of New England.

Wolfenstein, Eugene Victor (1993) *Psychoanalytic-Marxism: Groundwork*, New York and London: Guilford.

Wolfenstein, Eugene Victor (1993) *The Victims of Democracy: Malcolm X and the Black Revolution*, New York: Guilford.

If you are interested in reviewing any of these (or other) books, contact Jennifer Daryl Slack, Department of Humanities, Michigan Technological University, 1400 Townsend Drive, Houghton, MI. 49931–1295, USA.